Sidney Littlefield Kasfir is Associate Professor of Art History at
Emory University in A
Michael C. Carlos Mu
Physics before embar **SOUTH NATOMAS LIBRARY**
then managed the Nc **1620 WEST EL CAMINO AVENUE**
PhD on African Art at
University of London, **SACRAMENTO, CA 95833**
the University of Oxfo **APR**
between teaching and ........ 2000
Kenya and Uganda. She was editor of the anthology *West African*
*Masks and Cultural Systems* and is working on a study of the
colonial and postcolonial transformation of Idoma and Samburu
art. She has also written many articles and essays.

D0962775

# World of Art

This famous series provides the widest available range of
illustrated books on art in all its aspects. If you would like
to receive a complete list of titles in print please write to:

THAMES & HUDSON
181A High Holborn
London WC1V 7QX

In the United States please write to:

THAMES & HUDSON INC.
500 Fifth Avenue
New York, New York 10110

Printed in Singapore

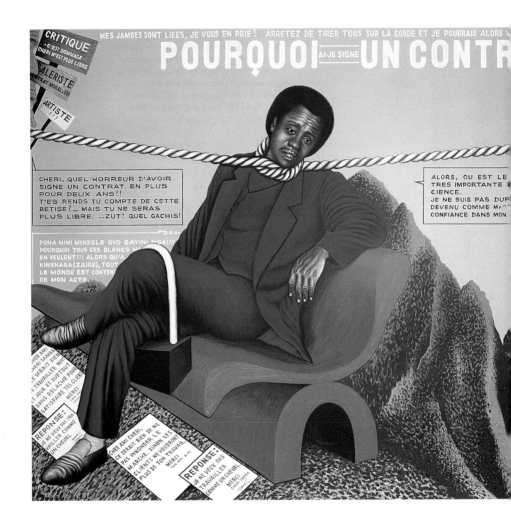

1. **Cheri Samba**, *Why Have I Signed a Contract?*, 1990

Sidney Littlefield Kasfir

# Contemporary African Art

180 illustrations, 74 in color

THAMES & HUDSON

*In memory*
*of Thomas Mukarobgwa, 1924–99*

## Acknowledgments

The original suggestion that I write a book on contemporary African art came from Rick Powell, author of *Black Art and Culture in the 20th Century* in the World of Art series, to whom I am much indebted. His own book served as an inspiration for this one. I wish to thank Obiora Udechukwu, Wosene Kosrof, James Meyer and my graduate students Elizabeth Gron, Sunanda Sanyal, Jessica Taplin and Krista Thompson for critical suggestions on various sections of the manuscript and Nikos Stangos, my editor, for his strong support and advice throughout. Elspeth Court, Pip Curling, Michelle Gilbert, Heidi Ernst-Luseno, Ilse Noy, Zoe Strother, Sylvester Ogbechie, Chris Steiner and Clémentine Deliss generously contributed photographs or information from their own research materials. Elizabeth Gron also compiled the index and Jessica Taplin the initial bibliography. Many artists in Africa lack telephones, fax machines and e-mail addresses, making the quest for illustrations a daunting project. Therefore, the greatest debt of gratitude is owed to the artists who offered illustrations of their work and, where possible, interviews. André Magnin kindly made available many works from the Jean Pigozzi Collection, and without the further assistance of numerous museums and galleries in African countries and abroad, a fully illustrated book would not have been possible. Finally, I thank Emory University for supporting my travel to Kenya, Uganda, Zimbabwe and South Africa for interviews with artists in 1996 and 1997.

First published in paperback in the United States of America in 2000 by Thames & Hudson Inc., 500 Fifth Avenue, New York, New York 10110

Library of Congress Catalog Card Number 99-70939
ISBN 0-500-20328-8

Designed by Liz Rudderham

Printed and bound in Singapore

# Contents

NATOMAS

7    Preface

9    Introduction

Chapter 1
18   New Genres: Inventing African Popular Culture

Chapter 2
48   Transforming the Workshop

Chapter 3
64   Patrons and Mediators

Chapter 4
102  Art and Commodity

Chapter 5
124  The African Artist: Shifting Identities in the Postcolonial World

Chapter 6
166  The Idea of a National Culture: Decolonizing African Art

Chapter 7
190  Migration and Displacement

214  Bibliography
218  List of Illustrations
222  Index

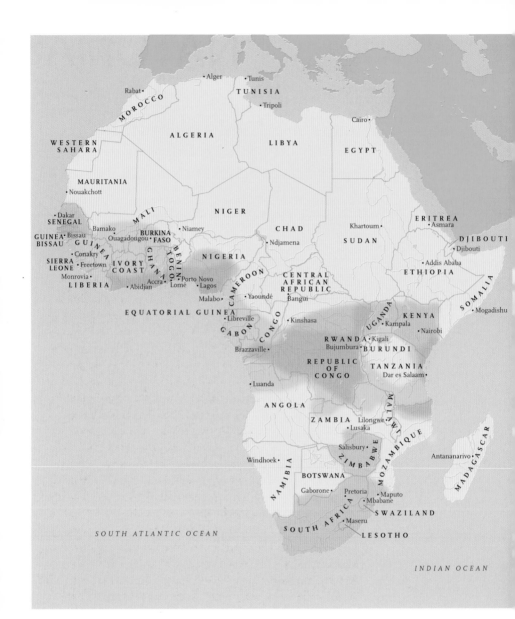

The shading indicates the following:
**orange** major areas of precolonial sculpture in wood
**blue** major areas of new postcolonial genres
**blue/orange** overlapping types of production

# Preface

This book was planned originally as a companion volume to Frank Willett's now classic, but still indispensable *African Art: an Introduction* (also in the World of Art series), but it is organized differently and describes both a more limited time period (the 1950s to the 1990s) and a broader artistic geography. It also focuses more centrally on the artist and the process of artmaking as well as the patrons who were responsible for bringing this art to the world stage. The twentieth century and the advent of colonial rule were a time of major disruption for traditional institutions, for governments and also for art and religious practice. It has been commonplace to treat this period as a time of decline and disintegration in the traditional arts, but this book assumes that even as old forms of art patronage that served indigenous authority were being suppressed, new avenues of artistic expression were opening up. While here the major concern is the postcolonial period, this cannot be explained without recourse to the art forms and artistic practices which preceded and were also transformed by the colonial incursion.

The most intractable problem when discussing contemporary art is the continent's extreme cultural diversity. While colonialism and postcolonial state-building have attempted to weave eight hundred or more language groups into fifty-plus national identities, there is still a major problem in trying to write about the art in the second half of the twentieth century in so broad a region. Other recent studies have tried to deal with this problem by focusing on the seven or eight best-known movements or workshops (Jean Kennedy's *New Currents, Ancient Rivers: Contemporary African Artists in a Generation of Change*, 1992), following Ulli Beier's earlier pioneering study (*Contemporary Art in Africa*, 1968) or by dividing the continent's recent art forms into categories based primarily on the patrons for whom the art is made rather than on history or geography (Susan Vogel's *Africa Explores: 20th Century African Art*, 1991). More recently, André Magnin and Jacques Soulillou (*Contemporary Art of Africa*, 1996) selected about sixty artists from all over the continent and divided them into three groups ('Territory', 'Frontier' and 'World') according to the scope of each artist's vision, while the curators of *Seven Stories about*

*Modern Art in Africa* (held at the Whitechapel Art Gallery in London in 1995) rejected the idea of coverage altogether. They went back to most of the same movements or experiments treated by Beier and later Kennedy, but presented them from the perspective of African curators, some of whom were artists who had participated in the movements they wrote about. This study, while making use of each of these approaches and drawing liberally upon them as sources, is organized thematically. Each chapter attempts to deal with a major issue surrounding the history of contemporary African art since the 1950s, such as patronage and other forms of mediation, formal training versus the dynamics of the workshop, the development of new genres, the commodification of art, postcolonial art and national consciousness, and the effects of globalization. Because of this organizational scheme, certain cases appear in more than one chapter – the examples used to illustrate these major themes alternate between published literature and material drawn from my own experience during three decades as a curator, gallery director, university teacher and field researcher in Nigeria, Uganda and Kenya, or during briefer sojourns in a dozen other African countries. The effect of its thematic structure is also that many important artists, new and old, fall outside the framework of the book's organization. To them I offer an apology and the hope that more specialized studies will rectify this imbalance in the future.

# Introduction

*Contemporary or modern?*
Contemporary African art did not just appear from nowhere towards the end of the colonial period, but people often see it that way – as a response to bombardment by alien cultural forms or as an outcome of colonialism, pure and simple: Africa 'Digesting the West'. But, in reality, contemporary art in Africa has built through a process of *bricolage* upon the already existing structures and scenarios on which the older, precolonial and colonial genres of African art were made. It is in this structural sense, and in the habits and attitudes of artists towards making art, rather than in any adherence to a particular style, medium, technique or thematic range, that it is recognizably 'African'.

What this book describes are the major transformations that occurred within African artistic practice as a result of the colonial incursion, with an emphasis on the period beginning in the 1950s with the transition from late colonialism to political statehood – for most anglophone and francophone African colonies this occurred in the early 1960s, but for the Portuguese-speaking colonies it was in the 1970s and for South Africa as recently as 1994. While this is the same time-frame used to describe Western 'contemporary' art, the reasons for the importance of the mid-1950s to mid-1960s as a watershed decade are different – this was when political independence was gained, when colonialism was cast off and when the enormous intellectual and creative euphoria which this engendered emerged. Thus 'contemporary' African art is quintessentially postcolonial in terms of its dates, but just as with 'contemporary' Western art, it cannot be explained or even described adequately without reference to its historical context. For African art this history encompasses not only the colonial period (coinciding with the 'modern' period in the West), but also much older kinds of artistic practice which in many parts of the continent have weathered colonialism and still exist today as 'contemporary traditional' art – masks, figure sculpture, weapons, tools, ornaments, pottery, textiles and architecture, to name only the major art forms.

In Western art history, the term 'contemporary' connotes the art of the present and the recent past, often beginning with Abstract Expressionism in the 1950s, while the much broader and more weighty term 'modern' encompasses an ideological break with academic practice which crystallized late in the nineteenth century in France and the subsequent rise of an avant-garde art in Europe and America with its various movements and localized developments during the first half of the twentieth century. In African art, however, these terms of reference need to be reinterpreted to fit African historical experience. A major rupture in artistic practice occurred in both Europe and Africa in the late nineteenth and early twentieth centuries, but for different reasons. The change happened in sub-Saharan Africa not in response to a small group of artist-intellectuals, but as a result of the colonization by European powers following the Berlin Conference of 1884–85. At the same time, the impact of Darwin's theory of evolution had created the phenomenon of the natural history museum and also a popular ideology which saw the African colonies as opportunities for specimen-collecting. African sculpture, in its early role as specimen, began arriving in France and Germany and because of its anti-naturalism was assimilated into an avant-garde ideology which rejected academic formulas of representation. It therefore serves as a bridge between two different twentieth-century art histories, played out on very different stages with very different actors and audiences. The other important bridge between these two art histories are the collectors and patrons, who in both cases have been mainly Westerners.

*The modern and the colonial*
If modernism in Western art refers to a quite specific historical interlude which, in critic Clement Greenberg's famous phrase, linked the newly emergent avant-garde to the bourgeoisie by 'an umbilical cord of gold', in Africa it has been far more encompassing, but less particular. There 'the modern' came hand in hand with colonialism, and is closely identified with the imposition of social and economic transformation based upon colonialist theories of 'improving the native'. Sociologist Anthony Giddens defines modernity as a new kind of civilization which has swept away all previous social orders. To Marxian cultural theorists, modernity is the 'action-horizon' of a system of global capitalism, and ideologies of modernization are the tools of Western dominance through forms such as colonialism. But to the typical African citizen, whether artist, entrepreneur or ordinary farmer, modernity is a mixed bag,

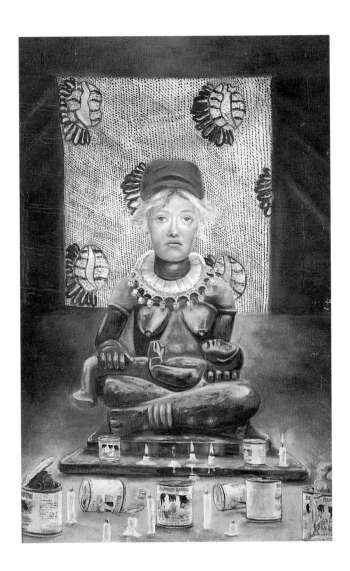

2. **Trigo Piula's**, *Materna*, 1984, uses witty juxtapositions of art and commodity to parody attempts at modernity. This kind of visual pun requires a self-conscious distancing of the artist from both the traditional and the modern as practices.

containing both good things (education, medical care, consumer goods) and bad (greed, corruption and excesses of power which all serve to undermine traditional values). It is therefore something to be sampled, but not necessarily embraced.

Similarly, while Western cultural theory asserts that globalization has created a world in which vast territories, including both Europe and its postcolonies, are interconnected through the circulation of goods, money and ideas, there are still many places in rural Africa where an artist can spend a productive lifetime without connecting with a global art market. In African cities such

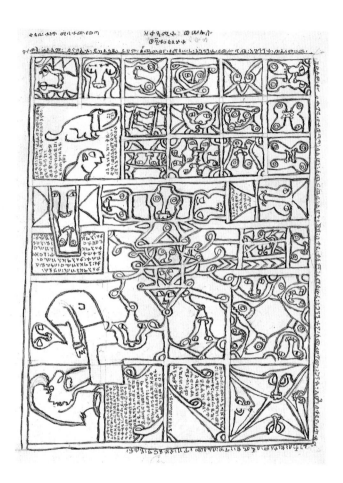

3. **Gedewon**, *Cherchebbi*, 1977. This ink drawing was intended as a talisman which protects the client by swallowing up demons when it is invoked. It is named after the prayer which is inscribed in five of the twenty-seven panels outlined in black and red ink.

as Nairobi or Abidjan where linkages to global patronage through galleries and cooperatives are clearly visible, individual artists still make choices about the audiences to whom their work will be directed. In this balancing act, local, national and transnational identities are determined not only through the varieties of patronage artists are able to attract, but by their points of reference on the compass of the postcolonial world. The output of an African artist working in London or California is filtered through a very different everyday reality from that of a counterpart in Lagos or at an even greater distance, in an upcountry village in the same nation-state. And as practising African artists, they should all lay equal claim to our attention. But art books and catalogues are written and read in New York and Los Angeles, Paris and London, not in upcountry African towns, and increasingly the focus of critical attention has come to rest on

those artists, transnational yet also African, who inhabit this larger and distant art world. For these diasporic Africans, versed in the current debates of cultural theory, but also far from home, curator Okwui Enwezor (himself a Nigerian intellectual living in the USA) speaks of the tension between here and there, the 'seeing eye' and the 'remembering mind'. This double vision is not a part of the artistic experience for artists who have not migrated, and for whom the most pressing issue is marginalization in their own home countries.

## The postcolonial and the postmodern
The majority of African artists have been affected deeply by the colonial and postcolonial condition, most obviously in their continued economic dependence on foreign or local European patronage. But to refer to contemporary art exclusively as 'postcolonial' is to deny it any deeper history and connection to what came before the colonial incursion – colonialism in most African countries only represents about sixty years out of an art history extending back at least two thousand years in some places. Admittedly, the colonial era was a period of turbulence and very major change, but arguably, it was no more important than other major historical changes, such as the spread of metallurgy, the Islamic conquest or the slave trade. The network of social relations in which art-making is implanted – the workshop, the apprenticeship system, the deference to experience and authority – is in many ways still similar to that which existed before colonialism, but with the interesting addition of a colonial model of art education for élites and their reaction to it, which since 1970 has come full circle back to a newly found respect for precolonial modes of practice.

There is also the question of postmodernity: how 'postmodern' is contemporary African art? Above all, postmodernism presumes a conscious awareness of modernism, its accomplishments and its limitations. This consequently reduces the discussion to that small sector of the artist community in a position to offer a critique of modernism, which is to say, those who have strived for and achieved it, but found it wanting, those who have examined it, found it irrelevant to their purposes and have chosen to bypass it in favour of an alternative vision of the world, and finally those who, to quote the curator Richard Hylton, critique it by 'wittily question[ing] the linearity of history and identity'. Hylton was speaking of Yinka Shonibare (see Chapter seven), a London-born Yoruba artist, but the same description could apply to Trigo Piula (b. 1950s), who lives and works in Congo-Brazzaville. In his painting *Materna*

1

3

2

*13*

(1984), a visual *double entendre* on Kongo images of maternal power and the 'magic of consumerism', imported evaporated milk tins and the face of a European milkmaid become the icons of modern Kongo motherhood. But given the very different modernities that African artists experience, their formulations of the postmodern are bound to be sporadic and highly individual. Finally, while the postmodern as a condition continues to unfold, 'postmodernism' as a set of strategic practices was identified with the art of the 1980s in the West. It is therefore already 'historical' rather than contemporary in a strict sense.

The Ghanaian scholar Kwame Anthony Appiah has asked, is the 'post' in postcolonial the same as the 'post' in postmodern? The answer is both 'yes' and 'no'. Many of the same philosophers and cultural studies theorists who define modernity as the spread of global capitalism also identify the postcolonial condition with the postmodern, especially since modernity was seen to be the engine that drove colonialism. While a tidy formulation, it ignores the problem that there have been very different colonialisms, both globally and within Africa itself. In some, the sheer brutality of early colonizing practices created an unbridgeable abyss between colonizer and subject. In others (such as the British in Africa) white cultural superiority was more subtly enforced through the educational and social system. The result was a wide range of postcolonialities once the Belgians, French, Germans, British and Portuguese packed up and left. In rural locations, where most Africans live, modernity itself only began to be a possible cultural choice in the postcolonial period, and has remained highly selective and fragmentary.

Therefore the most striking similarity between the postcolonial and the postmodern has been this very condition of hybridity – Samburu warriors with spears and Christmas ornaments in their hair, or educated lawyers and government bureaucrats videotaping themselves in traditional performances in their own natal villages. And as Appiah points out, both also share the central premise of commodification of artwork and the dominance of an international art market. On the other hand, he argues that much of African popular culture is uncritical of the seemingly limitless appetite for imported media and genres, and therefore offers no critique of either colonialism or modernity. In that sense, it is neither postcolonial nor postmodern.

4. (opposite) **John Goba**, *Odeh-E-Lay (No. 1)*, 1992. Although derived from much older mask genres, Ode-lay masks developed into a form of urban street theatre in Freetown, Sierra Leone, in the 1970s, with youths' associations asserting rival claims to political legitimacy and territory through public performances of masks such as this one.

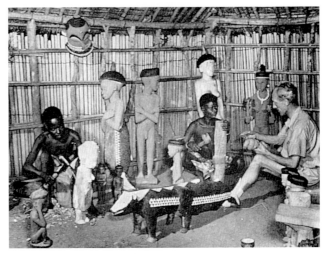

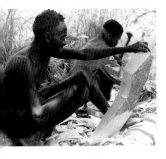

5. (above, left) Pende blacksmith Ngoma Kandaku Mbuya has taken off his shirt to work more freely on a mask (Thengu ya lukumbi) for the boys' initiation. He is working with such quick assurance that his adze has blurred out of sight. Chief Kende, who commissioned the work, hovers in the background. Note the pot of food between the two men. Ngoma would not begin until the chief had offered food and palm wine to 'encourage' him in his work. Ndjindji, Democratic Republic of the Congo. Photo Z. S. Strother. July 6, 1987.

6. (above, right) A colonial period news agency photograph of the Pende sculptor Kesaya-Ntambwe at work on the left while the European visitor M. R. Verly scrutinizes the work of an apprentice. Pende sculptors have produced art for both Pende and European patrons since the early colonial period. Ngonji, Congo, pre 1958.

## The new art map of the continent

'All other things being equal, the new will arise where the old simply does not exist', that is, where it does not have to compete with a tradition already in place. Therefore, since the primary kinds of art production in the well-known sculpture-producing regions of West and Central Africa continue to emulate or revise older forms, many of the new genres of contemporary African art have sprung up elsewhere. And although, with a few exceptions, the older types of African art originated in a social order which was kinship-centred and based in traditional patterns of authority, the new ones are more likely to occur in urban contexts and be lodged in an emerging class structure. The places where new art is being produced in the greatest variety and quantity therefore fall into two categories: cities everywhere and several regions of the continent which have not been major sites of precolonial image-making. Countries such as Zimbabwe, Senegal, South Africa, Kenya and Uganda that are seldom represented in museum collections of traditional sculpture are major locales for the production of new forms. By the same logic, a substantial proportion of artists in Mali, Nigeria, Sierra Leone, Côte d'Ivoire and the Congo continue to be involved in the production of masks and figures, some of which are still intended for local use and others for a global market. New art has also developed in these countries, but here its formation must take place within a milieu of existing practices, producing hybrid images and reflexive content which uses or comments upon them. These range from John Goba's

5, 6

(b. 1944) exuberant Ode-lay masks which combine paint-store pigments and porcupine quills – used by the Ode-lay society, in masquerades in the 1970s in urban Freetown, Sierra Leone – to the sophisticated reworking of *adinkra* (hand-stamped Akan funeral cloth) and *kente* (strip-woven Akan royal cloth) designs in the relief pieces of Ghanaian sculptor El Anatsui. The following chapters attempt to achieve a balance between the critical re-examination of frequently discussed artists, groups or workshops from several of these countries and the introduction of less publicized or more recent material. Wherever possible, I have allowed artists to speak with their own words.

7. **El Anatsui**, *Patches of History III*, 1993. The sculptor, discussed in Chapter six, experiments here with narrow strips of wood as if they were strip-woven textiles, burning in designs reminiscent of cloth patterns.

# Chapter 1    New Genres:
# Inventing African Popular Culture

*Urban arts and colonialism*
The Introduction considered the continual renegotiation of the past with the present in relation to precolonial art forms. This chapter introduces new genres of art that owe their emergence to three of the social processes which accompanied European colonialism in Africa: urbanization, the introduction of Western technology and material culture, and the expansion of literacy through formal schooling. To these must be added a fourth, considered fully in Chapter four, but underlying all of these changes: the development of an 'art market' under European patronage. The first three set the stage for the development of a new, town-and-literacy-based popular culture, while the fourth pronounced certain of these developments 'art' and introduced them into institutionalized artworld settings.

The creation of large urban centres where none existed before, as well as the transformation of older, precolonial cities, brought together people from a plethora of ethnic groups and with very different visual and performing traditions. While most city dwellers in Africa have continued to retain strong ties to the upcountry communities where they originated, they are no longer, like their relatives in the rural areas, essentially self-sufficient. Instead, they depend upon salaries, wage labour or various forms of entrepreneurship to provide them with food, clothing, rent money and school fees, as well as whatever luxuries they can afford. While African cities have produced a large class of unemployed and underemployed workers, they have also created a distinctive urban class of consumers whose tastes and aspirations are different from those in rural cultures and are frequently shaped by ideas and goods from the colonial (and ex-colonial) metropole. These ideas and goods, however, are creolized and reinvented in an African cultural setting which is distinctively different from the European one from which they originated. Not only are Western ideas and goods appropriated, but extensive cultural borrowing and reinterpretation also

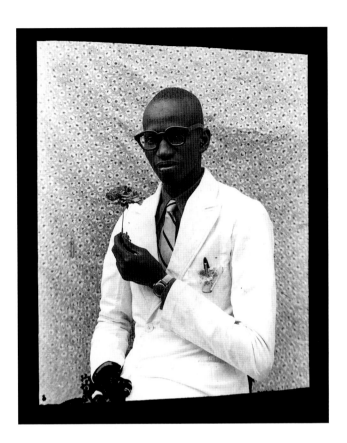

8. **Seydou Keita**, untitled portrait of a man from Bamako, Mali, 1958. This young man in a double-breasted white suit, heavily bespectacled and holding a flower, has become the most frequently reproduced work by Keita. It sums up the aspirations towards modernity in late-colonial Bamako and their connections to French, as well as indigenous, models of beauty, conduct and status.

occurs among the many indigenous subcultures which make up the urban centre. To add further to the complexity, these cultural imports no longer come only from the former colonizing countries in Western Europe – since independence, African markets have also been saturated with cheap manufactured goods from China and other Asian countries and from Eastern Europe. And in many respects, it is America and the African diaspora that are the source of the most powerful images of modernity: not only clothing, hair-styles and luxury goods, but also musical styles such as reggae and rap, and in the colonial period, jazz.

New arts and goods, new political awareness and daily contact with imported media were part of this urban sub-culture right from its late nineteenth-century beginnings – radios, newspapers, Bibles, telephones, postal systems, identity cards, imported foods (both crops and cuisine), bars and Western fashion all took root and in due course were transformed into local versions, some highly distinctive and others emulations of their European

8

counterparts. In recent years, imported films (often produced for Third World consumption) and pirated music tapes have become ubiquitous in African cities, while both imported and locally produced television programmes and video recordings have found a ready market among urban consumers. Countries such as Nigeria, Ghana and South Africa have their own music and video industries. Indigenous filmmaking for international audiences has been limited mainly to South Africa and francophone West African countries such as Mali, but is sporadically developing elsewhere. In Nigeria, for example, the emerging film industry began with Ministry of Information documentaries and locally produced television dramas, which, in turn, were modelled on live performances of plays by local theatre troupes.

These new visual genres, like their counterparts in literature and oral culture, call for their own modes of interpretation which are inevitably different from those applicable to older forms. Not only are the new genres frequently created out of materials and techniques which were not used in older ones, but they may also involve different production conditions. To paraphrase Elizabeth Tonkin's argument about oral performances, while genres have certain 'repeatable and stereotypic features', they will be misunderstood if they are treated solely as expressive forms in themselves, detached from these production conditions. This is one reason why exhibitions of contemporary African art are so frequently misunderstood by both critics and public, who see them only as 'detribalized' aberrations from tradition.

One major difference between francophone and anglophone countries in Africa stems from their distinctive colonial policies. The British policy of Indirect Rule, constructed by Lord Lugard after World War I, stated that 'native peoples' (as they were described in the colonial documents) should be allowed to accept change at their own rate and in their own way. To implement this, their colonies were to be governed by their own indigenous rulers at district and local level. Indeed, where there were not any such local rulers, the colonial government created them by appointing salaried 'white men's chiefs'. Among other things, this meant there could be little British influence on everyday life and material culture. The French, on the other hand, tried consciously to acculturate Africans in their colonies, making them citizens of France, which is readily seen today in the French influence on styles of dress, food and entertainment in urban areas. The Congolese *sapeur*, who imitates the latest Parisian men's fashions in dress down to the smallest detail, has no counterpart in anglophone countries. The difference

9. Hausa trader selling brightly dyed leather horse trappings in the Kurmi Market, Kano, Nigeria, 1989. Kano is the terminus of an ancient trade route across the Sahara and Kurmi (Hausa for 'jungle' which refers to its sprawling maze-like layout) is one of the largest traditional craft markets in West Africa and one of the few to sell decorations and equipment for the well-caparisoned horse. This type of leatherwork has survived mainly because it does not have to compete with imports from abroad.

between French and British territories was most obvious when a single people was divided between the two. The Hausa homeland, for example, includes both northern Nigeria (a former British colony) and southern Niger (a former French colony). On the Niger side of the border, French baguettes were still being sold on street corners by Hausa traders in 1980 while on the Nigerian side, street vendors hawked traditional Hausa sweetmeats. Conversely, Hausa architecture is much better preserved on the Niger side, due to French enthusiasm for mosque preservation programs inspired by Viollet le Duc, while in Nigeria buildings are crumbling, subject to the vicissitudes of weather and local politics.

Goods from abroad have had at least two major effects: they have turned Africans into global consumers and they have in certain areas strongly undercut local manufacturing traditions. This is most noticeable with locally made pottery, weaving and ironworking, all of which have been partly displaced by imported enamelware and plastic, factory-made cloth and mass-produced hoes and other iron implements. Goods that have survived this competition have been specialized and particular to local cultures – certain types of prestige cloth used in ceremonies, elaborate leatherwork for horses, or ritual pottery and iron ornaments, with which foreign manufactured goods cannot compete. Where patrons have continued to demand them, these types of goods are still being made. Hand-made crafts also survive, and occasionally flourish, in areas far from urban markets where manufactured goods are expensive and hard to come by. What has disappeared on a large scale, on the other hand, have been local goods which are easily and relatively cheaply replaced – hand-made, but strictly utilitarian, clay pots for cooking and carrying water, or knives and hoes made by local blacksmiths have given way in most cities and also rural areas to aluminium pots, plastic jerrycans and hoes imported from China. However, both old and new types do often coexist in the same community and even the same household.

Urban Africans are not only consumers and patrons of the new visual media, they are also its producers. In African cities, the majority of workers are employed in what economists call the Informal Sector which includes all those businesses and industries, usually small scale and conducted in the alleys and market places rather than in factories or offices, which operate without formal structures. Among them are the sign painters, furniture makers, blacksmiths, tailors, photographers, builders, drum makers, woodcarvers, street painters, jewelers and producers of all manner of curios from banana-fibre pictures to soapstone

9

10, 11

elephants. Recyclia, goods handmade from previously used materials, account for a good deal of this production: some is traditional (cow tails transformed into fly whisks), some ingenious (Christmas tree decorations used as hair ornaments), some merely cheaper substitutions (plastic replacing ivory ornaments) and some driven by utility (suitcases made from discarded rolled sheet metal). In Kenya, all these forms of material culture production, as well as related kinds of small-scale artisanship such as bicycle and radio repair, are known collectively as *Jua Kali* (Swahili: 'hot sun') which refers to the informal outdoor spaces where they are practised.

To understand fully that urban forms are simultaneously art and commodity, historian Bogumil Jewsiewicki argues, one must re-examine the assumptions implicit in most critical discourse in the West. The most deeply grounded of these is the belief that an artwork ought to be singular – a one-of-a-kind creation. The other assumption is that an artwork is not a commodity (see Chapter four). But much of the art being produced in Africa, especially in urban workshops, is marketed unpretentiously as merchandise. It only begins to take on an 'art' status when it becomes part of Western or élite collections.

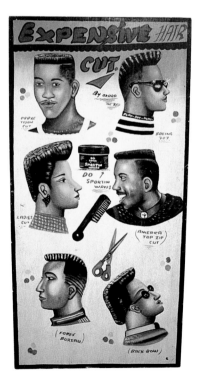

10. 'Expensive Cut' barber's sign, Ghana, advertising men's 'flat-top' hairstyles fashionable in the USA in the early 1990s, with glimpses of the 'correct' clothing as well as tools of the trade: comb, scissors and a jar of pomade.

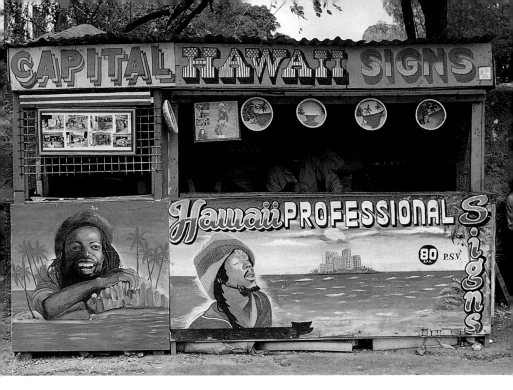

11. Signpainter's kiosk on Government Road in Mombasa, Kenya, 1991. Mombasa is an old Swahili Coast port city where successive waves of immigrants have introduced a multitude of styles and genres over the centuries. One of the most recent is Rastafarianism, here in the form of paintings for the home (left) and tailgate murals (right) which have been hybridized with a mythical 'Hawaii' instead of Jamaica.

## Flour-sack painters in the Congo

Perhaps the best-documented example of a quintessentially urban genre enjoying both art and commodity status are the flour-sack paintings of Kinshasa, Kisangani and Lubumbashi, Congo (then Zaïre), during the 1970s. The artist-entrepreneurs who made them originally created pictures for a clientele not very different, in economic and social terms, from themselves. Paintings on flour sack stretched over a frame were carried about and marketed on the streets, often by young boys working for the painters, and were intended for a local audience of urban workers and clerks. But given the vast distances and poor communications in a country such as the Congo, both the thematic content and the primary audience for this *art populaire* varied from place to place.

In Kisangani, the major city in north-east Congo, the invasion of paratroopers during the attempted Katanga secession became a popular theme for urban paintings. Historical themes such as this and the 1961 assassination of the Prime Minister Patrice Lumumba have been more characteristic of the eastern mining-zone cities than of Kinshasa. Even though there is little or no tourist or foreign patronage, a market for paintings has also

*23*

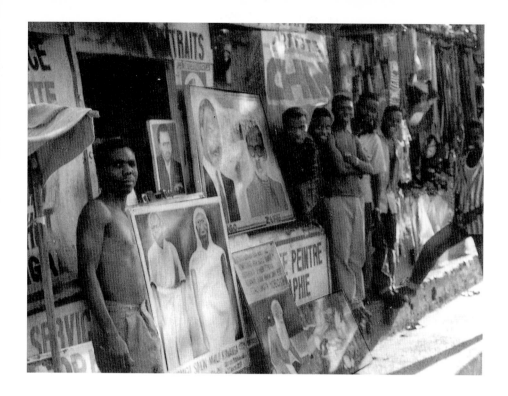

12. Chin in front of his workshop, Kinshasa, Congo, 1990. The front of a popular painting studio with advertisements in the form of completed portraits and signage. Young boys like those in the background are employed to hawk such pictures in busy streets and markets, blurring distinctions between paintings and other forms of merchandise.

developed among an emergent entrepreneurial class involved in gold trafficking. Much more recently, a parallel genre has begun to develop at Kilembe copper mines in western Uganda. In Kinshasa, both themes and patronage have been more wide ranging. Gradually as a few foreigners – scholars, journalists, resident expatriates – noticed and purchased the work of these street painters, it became known among a small group of cognoscenti and its status grew from straightforward decoration for the clerical worker's rented rooms to collectible art. By this process of recognition, a few such artists gradually developed an international clientele as well as a local one.

The most widely known of these, Cheri Samba (b. 1956), has emerged in critical circles as a highly successful painter following his inclusion in the *Magiciens de la Terre* exhibition in Paris held in 1989. Prior to his 'discovery', Cheri Samba created flour-sack paintings for a Kinshasa audience. In his early work, moralizing was already a dominant theme and was played out in popular stories such as that of La Sirene (the mermaid or Mamba Muntu, or in West Africa, Mami Wata, 'mother of the water'). In La Sirene

the central icon is a voluptuous mermaid accompanied by snakes, who is usually represented in opposition to such symbols as the Bible, while the moral dilemma is explained in Cheri Samba's work by text panels at the top or bottom of the picture – if one follows her one will become rich easily, but a high price will have to be paid for the transgression of moral principles which this implies. Cheri Samba also places himself in the narrative by including a self-portrait which is speaking or reading the Bible near the upper edge of the picture space. Johannes Fabian's explanation of the popularity of this theme in urban settings has been that it actually represents colonial power itself – distant and foreign (La Sirene is often depicted as a European woman), capricious and arbitrary. Unlike the African rural farmer or herder who is largely self sufficient, the urban worker is much more dependent upon the largesse and competence of the government (whether colonial or postcolonial) which controls the prices of basic commodities, local transportation, the water supply and many other things which can make the worker's life either comfortable or miserable. La Sirene symbolizes, among other things, this unstable and unpredictable aspect of urban life.

From the late 1980s, Cheri Samba's developing reputation among collectors allowed him to begin painting in acrylic on canvas.

13. **Tshibumba Kanda-Matulu**, *The Historic Death of Lumumba*, 1970s. Beginning in 1973, Tshibumba Kanda-Matulu made a series of one hundred paintings on the history of Congo (then Zaïre) for the anthropologist Johannes Fabian, expounding to Fabian the historical events which each picture narrated. Some, such as the capture and assassination of Prime Minister Patrice Lumumba in 1961, were made in multiple versions. He told Fabian, 'in my view, Lumumba was the Lord Jesus of Zaire. Above I painted six stars, because he died for unity.'

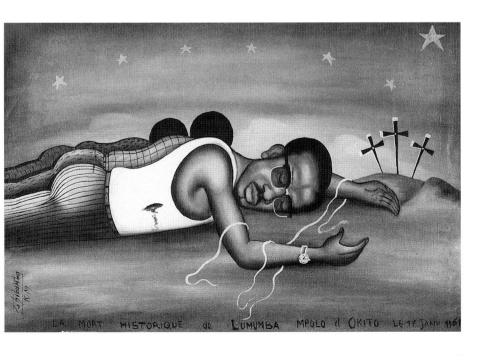

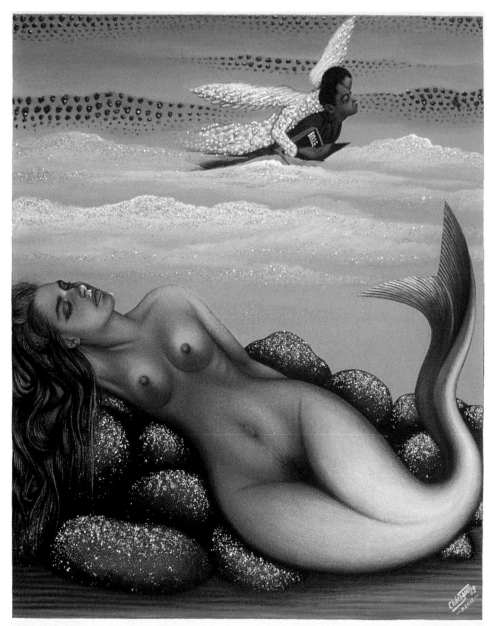

# LA SEDUCTION
## & LA FIDELITE A LA BIBLE

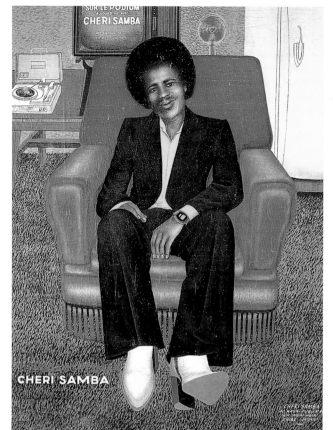

14. (opposite) **Cheri Samba**, *La Seduction*, 1984. While La Sirene appears as a seductive, long-haired European, the artist hovers above, propelled by angel's wings and holding his main weapon of resistance, a Bible. On another level, the work subverts the law against the public depiction of nudity by couching it in immoral terms.

15. (right) **Cheri Samba**, *The Draughtsman Cheri Samba*, 1981. Cheri Samba has always been his own best subject and this work, filled with the earnest symbols of Congolese 'vernacular modernity' of the seventies – bellbottom trousers, Afro hairstyle, platform shoes, record player, electric fan, refrigerator – bears comparison with the older and wiser self portrayed in plate 1.

CARICATURAL DRAWING IS NOTHING ,CAUSE ANYBODY EAN DOIT BUT IT IS RICH CAUSE IT TELLS YOU A MESSAGE ESPECIALLY THERE'ARE TEX: I PERSONALLY USE TWO TECHNICS, "CARICATURE ( HUMOUR) AND PORTRAIT." THIS GIVERS A LESSON TO THE ONES WHO ONLY MAKE HUMOUR. YET, I'M A SELF-TAUGHT PERSON.
LE DESSIN CARICATURAL N'EST RIEN,CAR N'IMPORTE QUI PEUT LE FAIRE, MAIS IL RENFERME UNE RICHESSE CAR IL TRANSMET UN MESSAGE SURTOUT S'I Y A DES BULLES.
MOI, J'UTILISE DEUX TECHNIQUES, "CARICATURE (HUMOUR) ET PORTRAIT ? CELA , POUR FAIRE UNE LEÇON A CEUX QUI NE FONT QUE DES HUMOURS. POURTANT, JE SUIS ARTISTE AUTODIDACTE . NAYEMAKA NA NDENGE YA KOSEKISA PE NA NDENGE YA KOBIMISA ELONGI YA MOTO LOKOLA NAMONELI YA NDE PO NA KOPESA NDAKISA NA BAYE BASALAKA KAKA B'AVENTURES, NZOKA,NGAI NAYEKOLA EPAI YA MOTO MOKO TE. NABOTAMA MOYEMI.

Many of his themes have continued to deal with the problems of urban life in Africa, from prostitution and AIDS to potholed streets. He has also commented eloquently on the desire for the acquisition of European goods – television sets, upholstered furniture, fashionable clothes – as well as on the dangers for Africans of European social behaviour. Both moralist and humourist, he has made himself the subject of his own incisive visual commentaries, as in his 1990 painting, *Why Have I Signed a Contract?*, in which the artist, well dressed and now obviously successful, is being pulled in opposite directions by ropes tied around his neck which plainly represent the shackles imposed by an exclusive gallery contract.

15

1

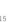

16. (below) **Moke**, *Motorcade with Mitterand and Mobutu*, 1989. The two leaders ride in a motorcade amidst modern power symbols and a crowd of onlookers choreographed to wave the French and Zaïrean flags at the right time. The artist reserves comment.

17. (opposite) **Stephen Kappata**, *A Country without Her Own Traditional Culture is Dead Indeed*, 1987. Makishi masqueraders, who appear at boys' initiations, perform for Zambians and expatriates as President Kaunda and his entourage look on approvingly.

While Cheri Samba is the best known of the Kinshasa painters, his international success and his original choice of thematic subject matter make him atypical. Many themes popular with painters and their audiences in the 1970s and 1980s (the period when most of the work discussed here was collected) represented the inequalities of power under the colonial regime and subsequently in the postcolonial era. The subjects of urban Congolese painting encompass a wide repertory, from the idyllic representation of rural life in an unspecified time past, to parables of the colonial condition and postcolonial dictatorship spelled out in narrative and couched in a form which draws upon the collective memory of ordinary citizens. Unlike the work of Cheri Samba, paintings such as Moke's *Motorcade with Mitterand and Mobutu* (1989) with its

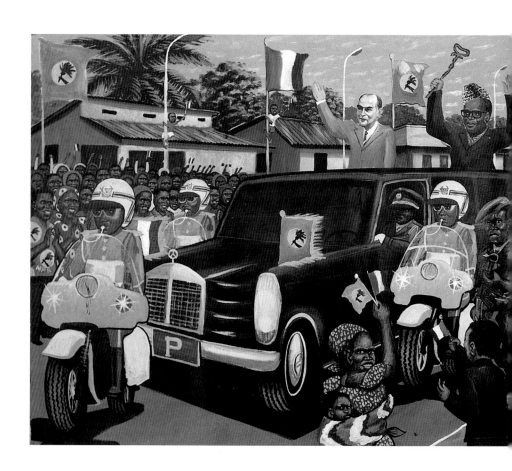

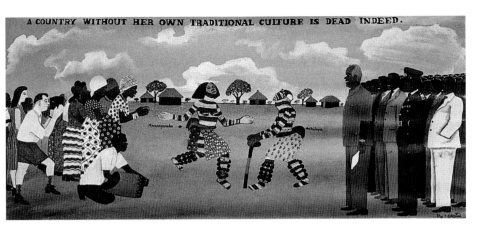

A COUNTRY WITHOUT HER OWN TRADITIONAL CULTURE IS DEAD INDEED.

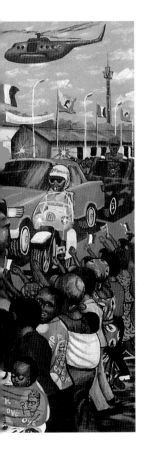

threatening symbols of sinister authoritarian power are not about the encounter with modernity as epitomized by city life and material goods, but stand as witness to the political violence of the twentieth century. Zambian artist Stephen Kappata (b. 1936) has explored the same range of pictorial themes as Moke and Cheri Samba, from his recollections of the late-colonial experience in Barotseland to the encounter between modern Zambian politicians and 'traditional culture' in the 1980s. Kappata employs the flat perspective and linear narrative associated with 'naive' painters, but with a self awareness that is usually missing in their work.

In contrast to these genres, the depiction of an idealized Africa undisturbed by change and epitomized in scenes of rural domestic life has had a wide currency with urban painters far beyond the borders of the Congo. Not only are such subjects very popular with tourists and expatriates, but they are also equally common in the homes of the African middle classes. Furthermore, they are painted by street artists ('autodidacts') in such places as Congo, Uganda, Kenya and Zambia and by workshop and academically trained artists as well. The street genres have been translated into banana fibre and batik, which have become the quintessential media for tourist versions of these themes. But it would be short sighted to assume that their predictable appearance on the urban scene throughout the continent is entirely market-driven. We must also explain why Africans themselves wish to display these pictures, and why they have currency for artists who do not view their work as merchandise. Scholars such as Fabian and Bennetta Jules-Rosette see the idealized rural village as part of a larger phenomenon involving the historical and political themes

17

18

19

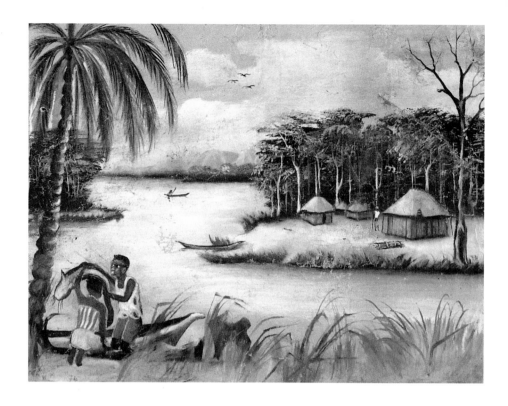

18. *Landscape*, early 1970s. Although signed by Tshibumba Kanda-Matulu, this painting of an idyllic lakeside village with fishermen is more likely to be by Burozi, the oldest of the Shaba (former Katanga) flour-sack painters from whom Tshibumba Kanda-Matulu learned the trade, according to Bogumil Jewsiewicki. As a genre, it has proved very durable since it mirrors the nostalgic fantasies of several different audiences, both local and foreign.

of Zairian urban painting, so the village scenes are assimilated into a visual history of the past which extends from mythic time through colonialism and up to the present. They operate in a similar way to the images of La Sirene or Mami Wata – they can be read purely as narrative description (the way they would be read by an outsider such as a tourist), but they symbolize something else for their local audience. Regardless of where in Africa they are made, idyllic rural narrative paintings can lay claim to several possible readings which vary according to the experience of the viewer – for instance, a collective social memory of an actual rural past (a recent experience for many urban dwellers), nostalgia for 'tradition' (a quite different reading requiring social, spatial or temporal distance on the part of the viewer), a cultural ideal of harmony couched in a rural family idiom, an escape fantasy driven by grinding urban poverty, or even a symbolic rejection of anything Western. It is this shifting quality – the ability to be interpreted on several levels – which has made the rural genre scene a viable choice for so many types of artists and audiences in so many places.

*Recasting the boundaries of popular art*

An important question raised by the case of the Kinshasa painters, and especially by the success of Cheri Samba, is what is 'popular' painting in the African context? If popular art is indeed something produced by 'the people' (in the sense of *wananchi*, i.e., ordinary non-élites) and for 'the people', one would have to conclude that financial success in the form of gallery patronage would exclude an artist from this category. The *Magiciens de la Terre* exhibition and Cheri Samba's début there created an international audience for whom he was a major 'discovery'. In turn, this audience, composed of foreign collectors, scholars and critics, is fundamentally very different from the flour-sack painters' original audience – urban petite bourgeoisie. Artists in Africa are both driven by, and limited by, the patronage they are given. Cheri Samba and others lucky and talented enough to be 'discovered' abroad have found new themes and techniques, as well as new financial success, and inevitably this has meant that their audience has shifted from a 'popular' one (in the sense of ordinary urban dwellers) to a more international one. This is not to say that such artists no longer feel attuned to the local scene and people – Cheri Samba has been emphatic that he is a 'Kinshasa man' – but that the focus of their creativity may alter to include other issues and arenas, and if they wish to maintain their ties to a local clientele, they must adopt a two-tiered strategy for making, pricing and marketing their work. The result may embrace two different genres being produced by the same artist – a practice discussed in Chapter four.

In the marketing of popular music in countries which have been 'discovered' by Western performers, impresarios and audiences an almost identical situation has arisen. Recording stars such as Alhaji Chief Ayinde Sikiru Barrister and King Sunny Ade in

19. **Joel Oswaggo**, *The Stoolmaker*, c. 1987. One strategy employed by untrained artists is to approach painting as a form of documentation of local tradition, in this case the maker of mortars, pestles and stools. Oswaggo, who comes from western Kenya, has said, 'All my drawings are based on the ancient times and how those ancient people lived.'

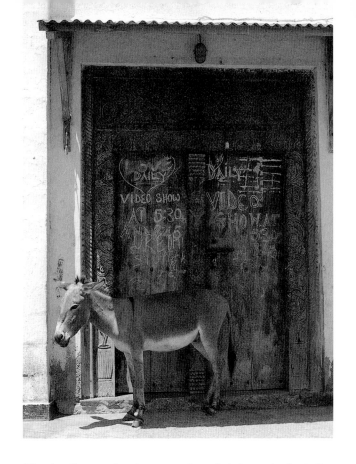

20. This nineteenth-century carved Swahili door of a house on Lamu Island off the coast of northern Kenya bears the chalked message advertising a video showing, one of the marks of modernity that has filtered into the narrow streets along with reggae music and soccer.

Nigeria often produced one version of their music (both live performances and tapes) for local consumption and another for export, each geared to the tastes of the target audience. The production and marketing of exported music has become inter-twined with the Western-based 'world music' industry in such a way that reflects former connections between colony and metropole: Salif Keita (Mali) and Angelique Kidjo (Benin) make their export recordings at sound studios in Paris and under contract to Western producers. In the same way, successful artists such as Cheri Samba have found themselves enmeshed in the Western gallery system to exhibit and market their work. This often has unexpected consequences, usually to the dismay of the African artists involved. Commercial galleries abroad frequently hold unsold work by African artists for years without either returning it or compensating them financially. Because artworks that circulate abroad are usually one of a kind, they are vulnerable to unscrupulous practices in ways that musical productions are not,

though the latter also fall foul of contractual obligations which often replay the former economic inequalities of colonialism.

While 'popular' cultural production in the newly postcolonial Africa of the 1960s and 1970s was intended for newly literate audiences of urban workers with strong ties to rural cultural idioms and values, popular culture has been moving steadily in the past twenty years towards an increasingly more sophisticated audience with strong interests in electronic media such as videotape and television. The most stunning example of this media shift has been the Yoruba travelling theatre phenomenon. They started as a group of itinerant troupes who staged their repertory of plays in towns all over south-western Nigeria, but nowadays it is mainly video-taped performances of the plays which travel from town to town.

How has this happened in a space of twenty years? Part of the explanation lies with video cassette recorders (VCRs), which have proved to be enormously popular in urban Africa just as in other parts of the world. Africans fortunate enough to travel abroad brought them back home as a way to circumvent the limited programming on local television and even more limited film offerings in cinemas. With Yoruba popular plays, the new technology was given its initial impetus through locally produced music videos which are in turn a by-product of a large and competitive Nigerian music industry. Furthermore, any African community urban enough to have electricity can have a 'video theatre', which is often simply a room with chairs and a VCR attached to a television

20

21. **Mark Anthony**, *Farmer Saved by an Angel*, 1995. Poster advertising the play 'Some Rivals Are Dangerous' by Super Yaw Ofori's Band, Ghana. The story is about a husband who goes to farm with his senior wife's child. His junior wife (a witch) sends a giant to kill the boy, but God sends an angel to save him.

screen. A second factor has been Nigeria's downward economic spiral since the oil boom of the late 1970s. Under such conditions, it made perfect sense for the Yoruba travelling theatre troupes to cut their production costs and videotape their performances, which can now be seen by a much wider audience, including Yoruba communities in other parts of Nigeria and even beyond. Not only that, the videocassette can, in the words of one Nigerian performer, 'walk on its legs' from town to town. Itinerant theatre and music have numerous forms in Africa, most of them a good deal more low-tech than videotapes. Popular theatre performances in Ghana are part of larger entertainments known as Concert Parties and have produced a distinctive poster art which is used to advertise the performances and draw customers. As such it is both commodity and expressive vehicle for the play. The road life of a poster (known locally as a 'cartoon') is short, as it must be stowed in the back of a lorry, but the best artists, such as Mark Anthony, also paint smaller versions on flour sacking which are intended for an art market of foreign collectors.

*Painted vehicles and signage*
Film and video have made major inroads into non-performative visual media as well. The urge to decorate a flat surface has led, as the Congo example shows, to murals being painted on the walls of urban buildings such as bars, hotels and cinemas, and to painting buses and lorries. In Nigeria the painted or low-relief decoration of mud-wall surfaces in rural settings was usually an art practised by women as an extension of their activity as potters and house builders or as body-painting artists, but these new genres of mural

22. Anonymous tailgate mural depicting Django, the Italian cowboy film hero, late 1970s, northern Nigeria.

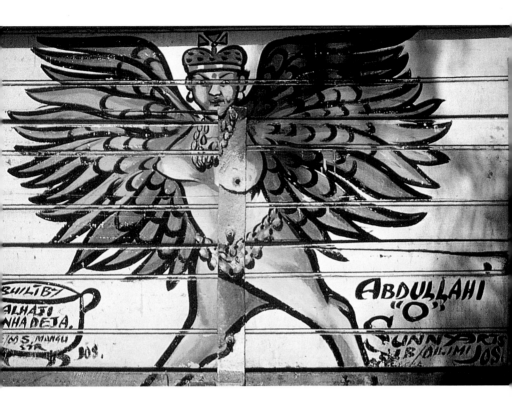

23. **Abdullahi "O"**, tailgate mural of *mikiya*, a durable power symbol in the Islamic north, Jos, Nigeria, late 1970s. While the symbolism is different, it derives its power as a visual image from the same combination of human and animal features as La Sirene or Mami Wata elsewhere.

painting are largely the province of young men raised on *Kung Fu*, cowboy and *Rambo* films. As film characters move in and out of fashion, so too do their images as a subject of tailgate mural art. Thus Django, a popular hero of Italian Westerns in the 1970s, who was depicted on Nigerian lorries of that period pulling his coffin containing his deadly machine-gun, has faded from the truck art repertory of the 1990s, as has the deadly shark inspired by the film *Jaws*.

22

Other representations that employ local images of power and violence such as lions and elephants rather than imported ones of weapons and fighting are more durable. In Kano and Kaduna in northern Nigeria – important centres for long-distance trade and hence lorry construction – these images include *mikiya*, a well-known representation throughout Muslim Africa, and the hawk, the subject of Hausa folktales. In Yorubaland (south-western Nigeria and Benin), the lion has long been a common subject of lorry painting. In the 1960s the lion was usually heraldic in form – derived from the nineteenth-century Afro-Brazilian architecture in Lagos – but gradually, under the influence of

23

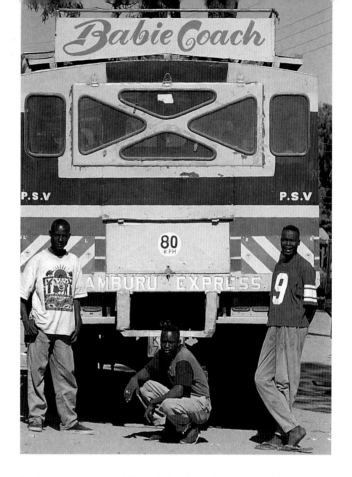

24. *Babie Coach*, Maralal, northern Kenya, 1996. Three members of 'Plastic Boys', a group of young Turkana entrepreneurs, help to load and unload 'Babie Coach', a bus that carries passengers and goods along the dusty track between Maralal and Wamba – towns which, despite their small size, unpaved streets and remoteness from the capital, represent modernity in an area inhabited by nomadic cattle pastoralists.

books, magazines and films, it has been incorporated into narratives of action. A second kind of power image employs the paraphernalia of real or imagined Western material culture – radio cassette players, bicycles, sleek motor vehicles, or pistols, ammunition belts and holsters. A third, more prosaic, type of truck art straight-forwardly advertises the products the vehicle transports, such as perfect giant carrots or tomatoes. Even these, however, take on a specifically local character in their use of signage to contextualize the imagery.

Painted tailgate murals are not found everywhere in Africa, but the ubiquitous passenger vehicles such as mini-vans, lorries and buses are themselves icons of modernity and have become moving representations of urban culture. In Nairobi, the *matatu* (mini-van) is the fastest and most convenient mode of transport between city and suburb, but passengers are submitted to the brash behaviour of touts and loud popular music played on the

driver's tape deck. One could say without exaggeration that buses and lorries in Africa serve as portable stages for the encounter with modernity. In cities, they blend into an already hetero-geneous mix of people and goods; in the hinterland, their appear-ances herald the arrival of an urban, commodity-driven way of life and serve as magnets for small-town youth. 24

Due to the influx of various print media since the beginning of the colonial period and the widespread impact of literacy, text messages are often combined with visual images on these vehicles as well as in other mural work and smaller-scale paintings. Language is powerful whether spoken or written, and everywhere in Africa, lorries and buses display slogans and messages. In Nigeria, many are Islamic or Christian: 'Allah ya kiyaye' (Allah Protect Us), 'Jesus My Protector', or more cryptically, 'Psalm 100'. These reflect the dominance of Hausa Muslims from Kano and Christian Igbo traders from Enugu in the long-distance trucking business, but also the real danger which road travel represents. Accidents are frequent and unlike in most countries, wrecks in Nigeria are left at the roadsides indefinitely, grisly reminders to other drivers and passengers of the possibility of sudden death.

Other slogans refer to the film characters depicted in the mural images: 'Rambo', 'Challenger', or to the lorry or passenger vehicle itself struggling against the odds presented by threadbare tyres, worn-out parts and untarred, potholed or flooded roads: 'Road Warrior', 'No Fear' (both Kenya). Others offer popular philosophy: 'God's Case, No Appeal' (Nigeria), 'No Condition is Permanent' (both Ghana and Nigeria), 'Fear Woman' (Ghana) and 'No Molest' (Nigeria). In response to the frustrations of travel, or life in general, there is 'No Hurry in Africa' (Kenya), or the verbal shrug, 'Ba Kome' (No Matter) in Hausa (Nigeria) or 'Hakuna Matata' (No Problem) in Swahili (Kenya and Tanzania). The most recent genre of messages and slogans in eastern Africa relate to the dangers of AIDS and reflect the fact that its main path of propagation there has been the truck route around Lake Victoria which passes through Kenya, Uganda and Tanzania: 'One Man, One Wife', 'Think First', and 'Zero Grazing' which literally means, keep cows at home instead of putting them out to pasture, but in Kenyan popular speech, is a reference to marital fidelity.

Related to these mural forms and slogans on vehicles are the adverts that appear on roadsides, bars and hotels. Advertising art has two very different forms in most African countries – the fea-tures and layouts on television, roadside billboards (hoardings) and in glossy magazines, which closely emulate their Western

counterparts, substituting African élite subjects for Western subjects, and the locally produced sign art which, like vehicle murals and slogans, reflects more directly the encounter between modern life, commodity form and the African artistic imagination. While this kind of advertising would be expected in the unplanned urban sprawl of colonial cities like Nairobi and Johannesburg, it has also become a part of the visual environment in old cities like Mombasa and Lamu in Kenya, Djenne in Mali and Zaria in northern Nigeria. While some representations are homegrown and relate to local customs, people and places, many others are hybrids borne of Western cinematic images and imported music such as reggae, which has its own visual symbols associated with Jamaican Rastafarianism, but is itself a creolization of African symbols.

Sign artists rarely achieve an artworld reputation – despite the popularity of signage, particularly barbers' and hairdressers' signs, among collectors of contemporary African art, the work is not usually connected to a named individual artist when exhibited. Most commonly, it is treated as anonymous folk art, which allows it to be absorbed into either the notion of commodity suggested above or a fictionalized Western colonial-period idea of 'the primitive artist' as being one without individuality of style or even a traceable identity. Sign artists are firmly situated in the informal sector, on the street, and within a matrix of entrepreneurial activity which surrounds so much urban popular art. One example of this was a painter who signed his work 'Abdullahi "O"' and was part of a lorry-painting firm based in Jos called SunnyArts. Abdullahi, whose specialities were Kung Fu and cowboy figures, was known all over northern Nigeria in the 1970s and 1980s because of the mobility of his artform.

The work of Middle Art (Augustine Okoye), from Onitsha in eastern Nigeria, came to the attention of Ulli Beier, an important patron of Nigerian artists who was then at the University of Ife, so Middle Art was lifted out of obscurity in the 1960s and his work exhibited as art rather than commodity. Sign art, when recontextualized in an art gallery, becomes aestheticized and moves closer to genres such as popular paintings that contain text messages. While the content of signage texts is usually an advertisement for goods or services, and that of textualized paintings is usually an explanatory device to heighten their visual narrative, they both rely on an interplay between visual and verbal messages in an effort to attract an audience which is newly literate. It is not surprising then that Middle Art was able to cross this somewhat blurred boundary between the two genres and produce images

25. Middle Art (Augustine Okoye), 'Oh! God Bring Peace to Nigeria' said Bello in Praying, 1970s. Sir Ahmadu Bello, one of the early nationalist leaders of Nigeria, is shown in Northern dress holding a gigantic string of Islamic prayer beads. His head is framed by a saintly halo into which his name and title have been printed and from which rays of light radiate outwards.

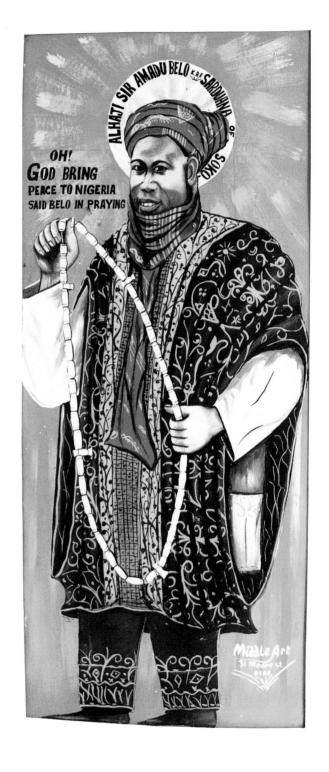

which were no longer tied to advertising, such as his commemorative painting of Ahmadu Bello, the Sardauna of Sokoto – a full-length portrait painted on plywood in which the head is probably based on one of the official photographs of the Sardauna found in shops and homes in Nigeria's northern Emirates. Middle Art's style combines a strong concern with the accuracy of small details such as the Sardauna's garments with a lively realism achieved partly through the placement of the main figure very close to the viewer's space, and partly through the careful modelling of the face after a photographic likeness. The very strong presence this creates is then placed within a narrative framework through the message of the text.

The urban sign artist's work is marked by its place of origin. Middle Art's home and usual place of business was Onitsha, a sprawling town on the Lower Niger River which was both home to a historically important precolonial Igbo state and at the same time the site of one of the largest markets in West Africa prior to the Nigerian Civil War. Thousands of small-scale traders, as well as large-scale ones, and hucksters, as well as honest entrepreneurs, made their living here, and signwriters and mural painters were in constant demand. Middle Art, like Cheri Samba, was a moralist and specialized in cartoon-strip story pictures which emphasized the values of honesty and clean living while graphically depicting the evils which could befall a person if not vigilant. Later, after the Civil War (1967–70), his painting developed a visionary aspect, with depictions of heaven and hell and even angels dwelling on the moon and singing to the world through microphones, 'We are angels of the moon. We are always happy. Your good acting will bring you here to enjoy with us.'

Still other forms of visual art production reflect the intersection of popular urban culture with tourism in the form of souvenirs of all kinds. All of these have close counterparts sold in street fairs and Africa-centred boutiques throughout the African diaspora from London to Los Angeles. The term 'Afrokitsch' has been coined to describe some of these artefacts which appear in Western markets, though this term, which defines them in relation to a largely foreign clientele, obscures their connection to a vibrant urban African culture where they are purchased by local people to decorate their homes. It is also a reminder of the artificiality of separating some types of 'popular' art from 'tourist' art. Both are largely urban, both exist in the streets and markets, usually (though not always) outside the gallery-museum circuit, and both are produced as unselfconscious commodities by people

who usually think of themselves as artisans (unless they happen to develop an élite audience). While art historians such as Susan Vogel have held out for the exclusion of tourist art from the ranks of authentically 'popular' art production because it is not made primarily for a local clientele, anthropologist Karin Barber argues that all such genres are manifestations of popular culture, it is just that some are more commercially motivated than others. In doing so, she locates popular art and culture in an indeterminate, continually negotiable space between traditional and high culture, both of which are largely in the hands of élite patronage.

*'Transitional art'?*
The development of new popular genres in most African countries has initially taken place against a background of local patronage, with occasional outside interventions in the form of 'discoveries' of artists by foreign collectors, scholars and curators. Much of it – bar murals, advertisements, theatrical productions – is not collectible in any case. South Africa is somewhat different in that it alone has a largely indigenous, mainly white and educated, patron/collector base. It also has artificially created 'homelands' which became repositories of 'authentic' African culture for white city dwellers. It has more galleries, curators and other artworld institutions than any other African state and has a class of vigilant intellectuals who, long having been unwilling participants in the apartheid system, are prone to continual self-examination and the search for a 'real' South African art. Beginning in 1980, certain new productions which until then had only been available to visitors to the rural homelands were brought into the gallery circuit and labelled 'transitional art', in the sense of being neither 'traditional' (i.e., intended for ritual or domestic use), nor 'modern' (i.e., being part of high-art notions of uniqueness). The formative moment was the 1985 *Tributaries* exhibition in Johannesburg curated by Ricky Burnett which brought the work of Noria Mabasa, Dr Phutuma Seoka, Jackson Hlungwane and several others to the attention of the gallery-going public, decontextualizing and reframing their work not as tourist curiosities or rural souvenirs, but as legitimate art. So is 'transitional' just another term for what Barber called 'popular'? Or is it, in critic Colin Richards' words, a convenient 'form of invisible mending [in which] rends in the cultural fabric...are magically made good'? The artists' histories have been important in this framing. Noria Mabasa, a Venda sculptor, first began making clay figures in 1974, drawing on images from local Venda life and from television, such

26 and 27. **Dr Phutuma Seoka**, *Dog/Leopard*, 1989 (above) and **Mutunga**, *Cheetah Chair*, 1998 (below). Seoka's piece is part of the artworld category that has been dubbed 'transitional art' since around 1980 in South Africa and has been admitted to art-gallery circles, while the animal chair by the Kamba artist Mutunga still lingers in the ambiguous space which exists in Kenya between 'good tourist art' and 'serious art' sold in galleries.

as the highly publicized Siamese twins who were separated in a Soweto hospital. Although her work is commodified (as multiples of the popular clay figures) in much the same way as the flour-sack painters in Kinshasa, she is presented by galleries as a serious artist, usually by focusing on her one-of-a kind wood sculptures and the fact that they are inspired by dreams. She appears to have two modes of working, one (the clay figures) which she sells in large quantities and which resembles high-end tourist art, and the other which is singular, private, and not easily commodifiable.

Dr Phutuma Seoka by contrast is the consummate entrepreneur, a herbalist doctor and maker of patent medicines who started carving objects to sell to tourists back in the 1960s. He draws very freely on the work of other artists, aggrandizing styles and subjects, but is best known for his corkwood animal sculpture which is both humorous and threatening. Jackson Hlungwane, like Seoka, lives in the northern Transvaal, but represents the other polarity seen in Mabasa's work – that of the visionary directed by dreams. He is a preacher in the African Zionist Church and has spent the last thirty years building an edifice to God where he both preaches and sculpts on a monumental scale. Is there something uniquely South African about the work of these artists? Or is it the South African art audience which differs from that of other countries? Animal sculptures very like Phutuma's are made by a few Kamba carvers in Kenya, and a disabled artists' workshop makes

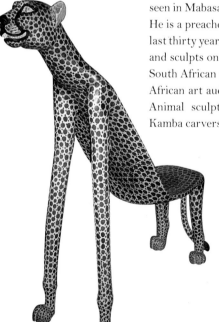

28. (opposite) **Jackson Hlungwane** (also Hlungwani), *Throne*, 1989. The exhibition of Hlungwane's large-scale sculptures in a gallery setting such as this transforms them into artworld 'installations'. Seen in their outdoor setting, they are changed into sacred art once again, in this case the seat becomes a throne and the vertical element behind it a sentinel-like form, alert and pointing heavenwards.

29. **Sunday Jack Akpan,** *Traditionally Dressed Figure, Soldiers, Businessman.* These sculptures in front of the artist's studio depict a man in traditional Cross River dress, two soldiers and a bureaucrat in a modern suit and necktie, Ibesikpo-Uyo, Nigeria, 1993. Akpan's innovative and extraordinarily skilful work fits comfortably into an Ibibio and Cross River visual grammar in which highly naturalistic representations are found in certain well-known mask genres such as *ikem* and figure types such as Mami Wata.

whimsical pottery figure groups which could rival Mabasa's, yet they lack the critical apparatus which might reframe them as 'real art' so are only seen in the curio markets. Nor are they publicized as the work of named individuals with known histories, another important step in breaking free from the tourist art mould. One can safely assume that there is plenty of 'transitional art' outside South Africa, but for the most part it lacks the backing necessary to propel it into gallery circles.

There are other kinds of art that should be considered 'transitional' – new genres that are nonetheless based on ideas already socially embedded in local communities. Unlike Mabasa's or Seoka's work these other genres were not originally produced for the art market, nor were they the ephemeral products of *art populaire*. Both the late Kane Kwei (and now his son Samuel Kane Kwei) in Ghana and Sunday Jack Akpan in Nigeria make funerary art for their own communities. While their pairing has become an art-world cliché since the *Magiciens de la Terre* (1989) and *Africa Explores* (1991) exhibitions, their work is very different. Monumental shrine and funerary sculpture in clay has an established history in central and southeastern Nigeria and neighbouring parts of Cameroon. When cement became available as a building material it gradually began to replace clay and while art historians have rightly mourned the loss of spontaneity with the use of cement, local people prefer it for its permanence. Akpan's innovation lies in his uncanny likenesses which are cast and then overmodelled in wet cement.

Kane Kwei's coffins, on the other hand, do not have the same grounding in tradition. Coffins themselves were only introduced

2

in the colonial period as a part of Christian burial practice, and Kwei's represent ebullient innovation and a monument to his clients' worldly prestige based on this relatively new form. The first coffins were made for local burials, but their development as an art form has to be seen in a wider context since in the early 1970s they were 'discovered' by a California gallery owner. In contrast, the patronage of Akpan's cement funerary portraits has remained largely local and Nigerian.

As these last examples demonstrate, new genres produced for a local clientele need not be crudely fashioned, inexpensive to own, or ephemeral. On the contrary, they can also be costly status symbols, available only by commission, and like high-art categories in the West, an important investment for the owners. Another such genre which has flourished almost everywhere is portrait photography. While much of this work is yet to be documented, that of Seydou Keita has become widely known. As of 1998, he was the only African photographer represented by a major New York gallery and the only one to have had an exhibition at the National Museum of African Art in Washington, D.C. His work has also been the subject of a complete catalogue by André Magnin and has been included in several anthologies and group

30

30. Workshop of **Samuel Kane Kwei**, Teshie, Ghana, 1993. Two unfinished coffins, one in the shape of a Mercedes Benz, the other a modification of the standard type with window-like inserts which are often filled with coloured papers to resemble stained glass. The Mercedes, which has become the workshop's favourite with both Ghanaian clients and foreign collectors, was originally produced by Kane Kwei senior for the burial of the owner of a taxicab company.

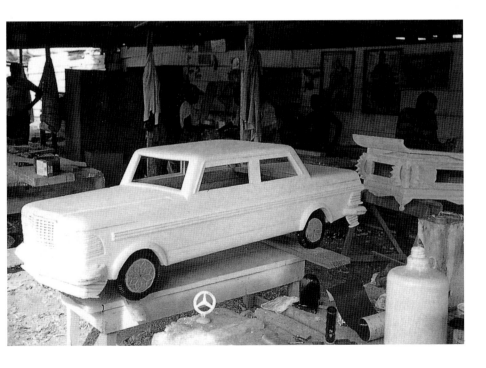

shows. All of this critical attention leads one to ask if Keita was the
Henri Cartier-Bresson of Bamako, the city in Mali where he was
active from the end of World War II until the 1960s, or whether
there were dozens of others like him across the continent, as yet
undiscovered and uncelebrated? If the latter is the case we shall
be fortunate indeed, because Keita's work is both technically
brilliant and deeply evocative of late-colonial Bamako through
the portrayal of its indigenes. Working with a large-format
camera inherited from the photographer Mountaga Dembélé (aka
Kouyâté) in 1949, his studio props included a radio, a telephone, a
fountain pen and a wristwatch as well as European-style men's

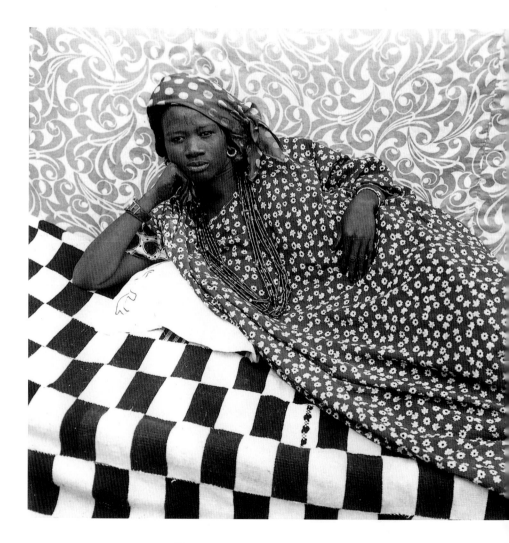

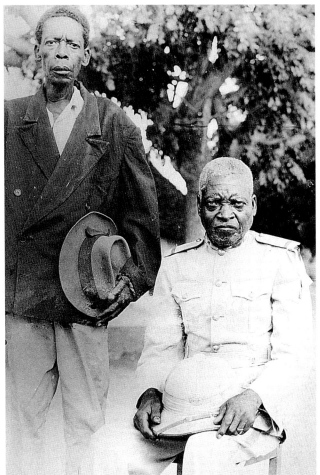

31. (below) **Seydou Keita**, *Untitled Portrait of a Woman*, Bamako, Mali, 1956–57

32. (right) *Soba ou Autoridade Tradicional (A Traditional Chief or Authority)*, Benguela, Angola, 1958. CITA photographer unknown.

suits. But most seductive in these pictures is the play and juxtaposition of light and pattern against skin, most fully realized in the portraits of women with large expanses of textiles in counterpoint to his own cloth backdrop of flowers, leaves or arabesques. Portrait photography in Africa is indeed a 'popular' genre, but one which in the hands of an artist such as Keita was capable of a new kind of representation. The late-colonial African subject was also documented in large-scale photographic projects by government bureaus such as CITA (the Information and Tourism Centre) in Angola which between 1949 and 1975 captured thousands of Angolans on film. While many are simply visual records, others are powerful evocations of age and class, race and privilege.

31

32

# Chapter 2    Transforming the Workshop

To even begin to chart the complex spectrum of work being produced by African artists one must deconstruct the important differences in training, knowledge, attitude and types of artistic production among untrained artists (so-called autodidacts), those who are informally trained (usually in workshops or cooperatives), and those formally schooled in universities or independent art schools (some of whom spend all or part of their careers outside Africa). Different critics and curators have identified the cultural production of one or another of these groups as the significant African art of the twentieth century, while relegating the other two to secondary importance. Such arguments are caught up in both authenticity debates and the economics of the art market. Untangling these issues is one of the aims of this book. Although they occupy different class positions, trained and untrained artists live in and react to the same world and many of the same collective experiences. The linkages of history and social differentiation form the warp and the weft of a single fabric.

Colonialism forced a restructuring of existing artistic practice, but did not do away with it. We know, for example, that in Yorubaland, Areogun (1880–1954), who was perhaps the greatest of the Yoruba sculptors from Ekiti of his generation, spent some sixteen years in his apprenticeship before he left his master. But since Areogun's time, apprenticeships have had to compete with academic and vocational training schools and new forms of artisanship such as radio and car repair. By 1980 they typically lasted no more than four years and were preceded by (or even ran concurrently with) a primary school education.

The late Lawrence Alaye, an Ekiti Yoruba sculptor who was active in Ile-Ife in the 1970s, was typical of the first postcolonial generation of Yoruba carvers who bridged the gap between the old apprenticeship system and the new. Initially he learnt the traditional Ekiti forms such as Epa masks from his uncle, but he was also sent to Areogun's son Bandele (Bamidele) of Osi to learn to carve Christian subjects that had been developed in the workshops run by Father Kevin Carroll in Oye Ekiti (discussed below). He was also patronized by the academic community at the University of Ife (now

Awolowo University). To show his repertory to this wide variety of potential clients, he kept a photograph album in the workshop showing pieces he had made. Both of his apprentices, then in their early teens, had been to primary school and spoke English. The several kinds of patronage Alaye received illustrate the beginnings of the modern workshop or cooperative which, although given over to new genres, was still faithful to the master-apprentice model. It is these continuities in practice, and not just a particular mix of genres, that help define twentieth-century African art.

*Informal training and the workshop*
Other traditional training practices have been less structured than the Yoruba apprenticeship model. In the Niger Delta in the 1960s, young Kalabari boys had a hands-on, informal training period as members of the junior Ekine society during which they learned to fabricate mask ensembles. Similarly informal methods

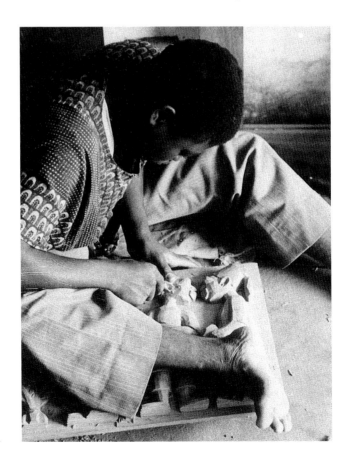

33. Teenage apprentice of the late Lawrence Alaye at work on a relief panel in his workshop, Ile-Ife, Nigeria, 1978. Although relief panels formerly appeared in registers on Yoruba palace doors, they are now produced for a wider clientele in many formats.

of training have continued to play a major role in many kinds of artmaking. The essential ingredients are just three: aspirants with a need or desire to learn a fairly circumscribed set of procedures (whether mask assemblage or an imported technique such as linocut printing), an environment in which the skills can be acquired in a relatively short time (days or weeks), and a facilitator convinced of its importance. Once, that facilitator was the community or one of its important institutions (such as a masquerade association), but after the onset of colonial administration, the facilitator was just as likely to be an individual and an outsider to the culture. In the famous and high-profile examples such as the workshops run by Ulli and Georgina Beier and their colleagues in Oshogbo, Nigeria, in the early 1960s, the founders were primarily (though not exclusively) expatriates and were impelled by a conviction that African creativity was a latent force, locked inside numerous (usually male) individuals, but fettered by the new social conditions imposed upon them through the demise of traditional society under colonial rule. The purpose of the workshop was, on a practical level, to provide would-be artists with skills that would enable them to be practitioners. But philosophically, the workshop's purpose was to release the creative energies which were thought to lie deep within these individuals. This belief has its historical and intellectual origins in Rousseauian ideas of a highly integrated culture which is destroyed by the civilizing process – in this case represented by the colonial experience. It idealizes the 'state of nature' and 'traditional society' as pure sources of artistic inspiration while devaluing forms of cultural expression which arise out of conquest. Colonialism then becomes a kind of bondage from which the workshop artist breaks free. But ironically the particular brand of consciousness required to set this in motion (and more importantly, the contacts and resources) must inevitably come from the colonizing culture.

Among the expatriates who set up workshops were Frank McEwen, founder of the Salisbury Workshop School in Rhodesia (see Chapter three) and Pierre Romain-Desfossés whose Atelier d'Art 'Le Hangar' was founded in Elisabethville (now Lubumbashi) in 1953 during the last decade of Belgian rule in the Congo. Believing that his Katangais students would be contaminated by exposure to Western art and the 'uniformizing aesthetics of White masters', Romain-Desfossés sought to imprint on them a new visual sensibility at the crossroads of African creativity and late-colonial modernism. He insisted that they look around them and learn from what they saw. His rhetoric was familial: they were his 'children', he their 'father', but as V. Y. Mudimbe, Congolese philosopher and

34. **PiliPili Molongoy**, *Termites and Birds*, c. 1970

cultural critic, has pointed out, it was also oracular – they were his disciples. The painters he trained, such as PiliPili Molongoy,  Mwenze, Bella and Kabala, developed individual styles based on a finely detailed representation of flora and fauna on a flat pictorial surface. Romain-Desfossés' students were not the first or the last Congolese artists to adopt this style and subject matter – it has an innocuous, dream-like appeal which makes it easily acceptable to a European audience, a Douanier Rousseau in Central Africa.

Both Romain-Defossés in the Congo and McEwen in Rhodesia embraced the Jungian notion of a collective unconscious in which artists retained deeply ingrained archetypal ideas of form, imprinted as cultural memory. Even though neither worked with artists who were practising in traditional genres when they joined the workshops, both men wrote that traditional forms would always be retrievable from the memory. Such ideas were also current in the United States from the 1930s to the late 1950s, among New York artists and intellectuals such as Jackson Pollock who studied and collected Native American art. In both Romain-Defossés' and McEwen's schools and among the New York avant-garde the tribal artist was seen as someone living in a familiar relationship to a mythic past, only superficially touched by the colonial experience (in Africa) or realities of the 'folkloric' art market (in the USA).

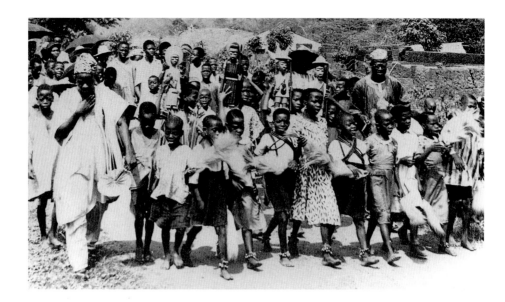

35. Yoruba children carrying
Christian images at Christmas,
Oye Ekiti, Nigeria, 1951

However, in places where a fully realized visual art tradition (e.g., wood sculpture) had withstood the transformations of the colonial period, it was not necessary to retrieve long-forgotten mythologies and artistic practices under nurturing conditions. The challenge was to find a way to introduce new genres in an artistic environment dominated by ritual sculpture produced in family workshops. Therefore the dynamic at work in the Yoruba workshops which were founded by expatriates was a different one from that in Romain-Desfossés' and McEwen's. As Ulli Beier himself once put it, if McEwen's project 'could be compared to an Israeli farmer fertilizing the Negev', working in Oshogbo was 'more a case of trying to tell the wood from the trees'. Both Father Kevin Carroll of the Society of African Missions and Ulli and Georgina Beier found themselves supervising enterprises which did not require either Jung or Rousseau to understand, though they differed sharply from each other. A third Yoruba project begun by an outsider, the reconstruction of the sacred shrines around Oshogbo, was instituted by the Austrian-born artist Susanne Wenger. While Wenger's project could not be called a workshop, it overlapped the Beiers' in time and space and so can be compared with the others.

Something different was happening in each of these situations. The carvers (including the subsequently famous Lamidi Fakeye) who trained at Father Kevin Carroll's workshop at Oye Ekiti were engaged in a variant of the Yoruba apprenticeship system – they

were learning a new artistic genre under the tutelage of Areogun's son Bandele of Osi, but using traditional Ekiti carving styles and techniques to create Christian subjects suitable for use in the Church. By definition then, there could be no wholly new inventions. Similarly, there was no notion of the artist 'unfettered', breaking loose from the shackles of colonial thinking. Instead, Carroll wanted to draw upon what he saw as the deep integrity of an established artistic practice in service of the sacred. Despite the enormous differences in their personalities and artistic philosophies, he and Wenger had this in common. She, too, took up the task of creating a new kind of sacred art in partnership with a small group of Yoruba artists, though everything about it contrasted with Carroll's undertaking.

The shrines in the sacred forest groves outside Oshogbo, each consecrated to a different Yoruba *orisha* (deity), had fallen into disrepair and were threatened by the encroachment of farms and businesses. Wenger rebuilt these shrines during the 1960s and 1970s with the help of local artists Buraimoh Gbadamosi, Adebisi Akanji, among others. Wenger was very critical of conventional missionary teaching and instead embraced Yoruba religion, becoming an initiate and later a priest. To sceptics, including many Yoruba academics and intellectuals, she was simply one of the odd, but predictable, side-effects of colonialism, in search of a life untainted by the corruptions of the West. But to sympathizers, including her friends and associates in Oshogbo – she was a charismatic artist with a life-long commitment. As she aged, she commanded the respect that Yoruba culture accords to powerful older women.

36. **Lamidi Fakeye**, *Flight into Egypt*, detail of a panel carved in the doors of St Mary's Roman Catholic Church, Oke Pade, Ibadan, 1956. Although he was trained initially in the Igbomina style of his father, Lamidi adopted the more angular, compressed and sharply detailed Ekiti carving style after serving as an apprentice under Bandele (Bamidele) at Oye Ekiti.

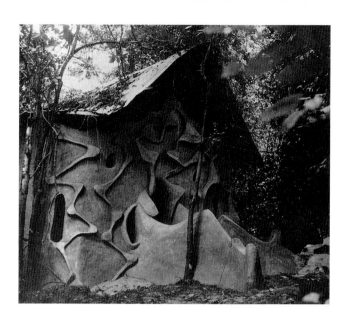

37. **Susanne Wenger**, *Temple of Obatala, Oshogbo*, Nigeria, 1966

Wenger's style and techniques bore no relationship to traditional Yoruba sculpture. In *The Timeless Mind of the Sacred*, written initially in German, she propounded a religious philosophy that focuses upon the mystical nature of the sacred. Translated into shrine sculpture, this became a series of non-representational organic curves and wave-like forms, created first in the adobe-like mud used for housebuilding and later coated with cement, giving them both permanence and a very light colour uncharacteristic of African wood sculpture. Unlike the practice of both Carroll's and traditional workshops, her methods sought to tap into something other than Yoruba artistic convention. An early example of this was the wall surrounding the Oshun grove, rebuilt by two bricklayers, Ojewale and Lani. Wenger encouraged them to draw in the wet cement, and even though they did not think of themselves as 'artists', they created a long frieze of whimsical low-relief figures.

Another more talented bricklayer and cement mason, Adebisi Akanji, became Wenger's principal assistant in the shrines project. He was one of the first generation of Oshogbo artists of the early 1960s who established themselves through a close relationship to Ulli and Georgina Beier or Wenger. The initial 'discovery' of Akanji as a sculptor is described by Ulli Beier in his book *Contemporary Art in Africa*, published in 1968. It reveals how contingent an artist's recognition is upon not only talent, but also meeting the right patron at the right time. In 1962, while

38. **Susanne Wenger**, *Shrine for Iya Mapo at Ebu Iya Mapo near Oshogbo*, Nigeria, 1970s

organizing an exhibition of Nigerian 'folk art' to be held in Ibadan, Beier invited a group of Oshogbo bricklayers to try their hand at making the decorative cement lions found on older Yoruba 'Brazilian-style' houses which were no longer being made. Akanji proved to be the most talented of these young 'folk artists', but what does one do with a cement lion? At first he was patronized solely by staff at the University of Ibadan who ordered his cement animals as garden sculptures, but this work (in Beier's words, 'producing garden toys for intellectuals') was very limiting for Akanji, both in the scope it offered him to develop as an artist and in the number of possible commissions he could receive.

At this point, only an act of cultural entrepreneurship could move the artist beyond this stage. Beier had decided to construct a museum of popular art in Oshogbo and seeking another avenue for Akanji's talent, asked him to make a cement screen of animals and figures at the entrance to the museum. This was technically difficult, but Akanji came up with a solution whereby he made a perforated cement screen with multiple registers of flattened figures, attached at the top and bottom of each register, but otherwise freestanding in space. This was a new genre and lent itself easily to architectural forms, but could also work as sculpture on its own. In the most widely known example of his cement-screen technique, an Esso Petrol Station in Oshogbo, the registers sport scenes from the creolized town culture of the mid-1960s –

39

40

motorcars, palm-wine drinkers and masquerades. In one scene, the artist plays on the idea of the car and petrol pump as living beings by depicting a real snake slithering across the car's roof while an attendant pumps petrol through a hose, another 'snake'. But Akanji was also able to adapt his whimsical icons and cement medium to the low-relief decoration of solid walls and in the same year that he made the petrol station screen he also completed the entrance to the Oshun grove which Wenger had rebuilt. It did not matter to him that one was a 'secular' and the other a 'sacred' commission, nor did it matter especially that he was a Muslim. Although such loyalties can come into conflict – a fact attested by the twentieth-century decline in active followers of the *orishas* – they still continue to coexist for many people.

We can say then that there were several types of cultural mediation operating simultaneously in the Oshogbo experiment of the 1960s: one had to do with artists and patrons, another with the religious and cultural idiom in which the art was produced, and a third with the interplay between educated intellectuals, some of them expatriate and others Nigerian, and an emergent class of urban skilled workers (the artists) in Yoruba society.

39. (above) The artist Shangodare standing before a cement screen by Adebisi Akanji at Susanne Wenger's residence, Oshogbo, 1978

40. (right) **Adebisi Akanji,** detail of a petrol station screen, Oshogbo, 1966

41. **Adebisi Akanji,** *Entrance Gate to the Oshun Grove,* 1966

*Polly Street and Rorke's Drift*

Lack of training opportunities for prospective artists was common everywhere in Africa in the colonial period, but began to be rectified in the late 1950s and early 1960s when the majority of East, Central and West African countries achieved political independence. In Southern Africa it was a different situation – the minority white government was dissolved in Mozambique in 1975, in Zimbabwe (former Southern Rhodesia) in 1980 and in South Africa in 1994. The latter's Bantu Education Act of 1953, a logical extension of *apartheid* policies of separate development, stressed literacy and vocational training. The South African government saw no reason to encourage black artists to pursue academic study, but on the other hand encouraged the development of 'craft' production in rural areas because it fitted conveniently into a divide-and-rule Bantustans policy of emphasizing cultural distinctions among ethnic groups. But by establishing racially segregated residential areas, the government also created the conditions under which African township art would develop in the cities during the 1950s, 1960s and 1970s. In the townships, the informal workshop has been a vital aspect of artmaking and it has been where black artists have developed not only their technical knowledge base, but also their consciousness of themselves as artists.

The most widely known of the early workshops was the Polly Street Centre in Johannesburg, which opened its doors in 1949 as part of a community centre programme for black township youths (see Chapter three). Its success in training young artists in the 1950s and 1960s made it a model for other community centres, many of whose workshops were begun by Polly Street 'graduates'. The term 'workshop' can mean several things, since the Polly Street classes or sessions (and those following its model) were organized to take place weekly or twice weekly over an extended period of time, while the Ibadan and Oshogbo workshops in Nigeria were annual, intensive two-week sessions, and the Salisbury Workshop School in Rhodesia (see Chapter three) went through continuous transformations over many years. Their common grounding lay not in their periodicity or duration, but in the informal nature of the interaction between the participants and the organizers. This was not just an article of faith but a necessity, in that the artist-participants lacked the educational qualifications that might have

42. **Dan Rakgoathe**, *Mystery of Space*, 1975

43. **Azaria Mbatha**, *The Greetings – Nativity*, 1964

gained them entry into more formally structured academic training. The workshops also had a common aim in that they were goal-oriented and in this sense resemble today's cooperatives – they are about facture, not philosophy.

The Swedish-sponsored Evangelical Lutheran Art and Craft Centre at Rorke's Drift in rural KwaZulu-Natal was another important training centre for black South African artists. It ran concurrently with Polly Street in the 1960s, but outran it, lasting into the early 1980s. If Polly Street resembled a workshop, Rorke's Drift was more like a formal training school. Courses (in pottery, textile design, weaving and fine arts) were fulltime and lasted two years after which the student received a certificate. The fees were, however, very low and anyone could apply in keeping with the practical goal of its organizers Ulla and Peder Gowenius to provide the students with the means of making a living. Rorke's Drift's most celebrated graduates have been printmakers, among them John Muafangejo, Cyprian Shilakoe, Dan Rakgoathe, Dumisani 42 Mabaso and Lionel Davis. One of the key figures was Azaria 43 Mbatha who was not a graduate, but one of the earliest teachers and a strong influence on other graphic artists who passed through the school before he left in 1970 to live in Sweden. Though perhaps more ebullient and wedded to the use of text, Muafangejo's linocuts such as *Zulu Land* (1974) owe much to Mbatha in their composition- 44 al strategy, the grouping of figures and their narrative format. By the 1980s, university art training was opening up to black students

44. John Muafangejo, *Zulu Land*, 1974

and the fine arts section at Rorke's Drift (which had been kept afloat financially by the more lucrative craft departments over the years) closed its doors.

## Kuru and Schmidtsdrift

Although the cultural setting could hardly be more different, many of the same issues first seen at Oshogbo in the early 1960s have been in play at two workshops founded in the 1990s. The Kuru Project in Ghanzi District of Botswana and the !Xu and Khwe Cultural Project of the Northern Cape in South Africa were both started by Catharina Scheepers-Meyer to provide a means of artistic livelihood for displaced Nharo San, !Xu and Khwe-speaking people living on the edges of the cash economy. The Kuru Development Trust, founded in 1986, grew out of the consolidation of several grass roots development projects started by churches in Botswana (Kuru is a Nharo word meaning 'do it'). The Art and Cultural Project, which combines elements of both a non-directive art workshop and a community self-help project, began in 1990 with a textile workshop for San women. The project has now been subdivided into a leather workshop, 'crafts' such as woodcarving and beadwork, a silkscreen fabric-printing

60

workshop, and the painting and printmaking group. Since then, their extraordinary creativity as artists, coupled with the machinery of a well-run development project, has propelled them into the museum world where they have exhibited in Poland, Finland, England, Germany (at Ulli Beier's Bayreuth gallery Iwalewa Haus) and the USA as well as in Botswana and South Africa.

The work of some artists in the group is strongly reminiscent of rock painting, a traditional San artistic practice, although not in subject matter or even style, but in the way the separate pictorial elements resemble objects floating randomly on an undefined surface. There is often no imaginary 'picture space' other than this surface, and the choice of images resists any easy analysis. One picture by Quaqhoo Xhare depicts skin bags and a tiger fish, not in any apparent relationship to one another. Another by Thamae Setshogo shows a dead tree and zebras. This randomness is also found in the !Xu and Khwe work such as Fulai Shipipa's *Two Rosaries and an Eel* (c. 1994). While outsiders attempt to unravel these images as symbols or to create a narrative content for them, they may be closer to a formal inventory of what is visible or imaginable to the artist.

45. **Fulai Shipipa**, *Two Rosaries and an Eel*, c. 1994

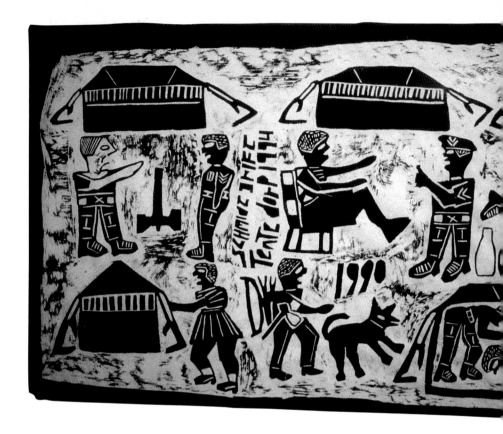

While at Rorke's Drift and other rural workshop schemes, the more traditional artisanal practices such as leatherworking have continued to be gender-specific, at Kuru, the new painting and printmaking group consists of both women and men. Despite the similarities in the art itself, the !Xu and Khwe Cultural Project serves a rather different Bushman population – families of ex-soldiers and trackers who were resettled at Schmidtsdrift, a South African army camp in the Northern Cape, in 1990. These people lived in Namibia (and many in Angola before that), caught between the SWAPO guerrillas and the South African Defense Forces (SADF), and were later hired by the SADF as expert trackers. With the war over, they now live in a post-apartheid army camp where artmaking is a kind of therapy to counteract alcoholism and hopelessness, as well as a community development strategy. Army-camp life as depicted in Thaulu Bernardo Rumao's *Tent Town* (c. 1994) is rarely a subject of these pictures. But in some

compositions the forms are drawn from the Namibian war experience as well as from nature, creating startling juxtapositions such as *Nests, Landmines and Plants* (1995) by Julieta Calimbwe and Zurietta Dala.

Partly because of the extreme poverty of the community and their lack of experience in artworld dealings, the organizers have taken a protective stance towards the workshops and have played a supervisory role in presenting both the artists and their production to the public. While the purpose of this is ostensibly to prevent the exploitation of the artists by unscrupulous outsiders, it also means that the white organizers have found themselves constructing and authenticating a Bushman culture for the benefit of the rest of the world. It is advantageous to link the workshop artists with a Bushman hunting and gathering past, even though none of the artists or their families have ever lived that way, because this gives their art a pedigree which spectators will recognize as authentic. A successful model for this already exists in Southern African tourism, in which the Bushman is represented as living in close harmony with nature, although the reality is that they are hired workers on white farms or demobilized hired mercenaries. The workshops therefore engage not only in art production, but also in the production of 'Bushman culture'. The power of the organizers to frame both the art and its makers for global consumption and the problems this generates are considered in Chapter four.

46. (above) **Thaulu Bernardo Rumao**, *Tent Town*, *c.* 1994. Using a kind of x-ray visual device also found in certain Australian aboriginal paintings, the artist depicts (right centre) the bushman's arrow penetrating the innards of the fleeing white man and below it another attacker knifing a sleeping figure inside a tent.

47. (right) **Julieta Calimbwe** and **Zurietta Dala**, *Nests, Landmines and Plants*, 1995. Landmines, despite their sinister real-life meaning, are part of the visual repertory of the army camp and are employed here as round shapes to anchor the four corners of the composition.

# Chapter 3    Patrons and Mediators

*Foreign patrons and the new artistic geography*

The most striking differences between pre- and postcolonial African arts result firstly because of the different audiences for whom they are made, and secondly because of the greatly expanded geography in which first colonial, and now postcolonial, art circulates and ultimately resides. Precolonial (and more specifically, premercantile) patronage was enmeshed in the same expressive culture as the artist or at most a neighbouring one, but since 1900, if not before (and in the mercantile centres along the African coasts, centuries earlier), both old and new forms have increasingly been produced for patrons and audiences far removed from the originating culture. This shift has happened because of the major political ruptures of the nineteenth and twentieth centuries, and in their wake urbanization, schooling and literacy, the cash economy and links to the colonial metropole.

Just as these changes have produced new artists, genres and patrons throughout the continent, successful Christian and Muslim proselytizing and the advent of the modern state have in equal measure undercut the old art forms and patronage system. Some genres simply disappear once the old patronage fades away (e.g., women's masks in the Senegambia region), while others incorporate new meanings which allow them to continue to exist in a situation of shifting patronage. Thus there are colonial period masks depicting Jesus along with Mami Wata, or chiefs' stools in the shape of early motor vehicles. Undoubtedly, the patrons who commissioned these pieces were in different ways trying to come to terms with the changing meaning of power and authority. But once such objects are no longer in their intended context, they become open to various interpretations. What was seen as an aggrandizing of powerful symbols of modernity to an African artist and audience is frequently reframed by the Western spectator as parody, or quaint naiveté. In such a situation, meanings are no longer fixed and the role of the go-between or broker is called into play to frame and explain them for the new audience. Whether the go-between is an itinerant trader on a motorbike, a wealthy European collector, or a museum educator, meaning that was once local and predictable is now distant and constantly renegotiable.

These altered realities have sociological, economic and political, as well as aesthetic, dimensions. The frequent lack of a viable indigenous art market and the resulting constant flow of 'cultural capital' to foreign patrons are not only part of a deeply seated postcolonial economic dependency. More crucially, economic incentives have begun to shape the work produced – Lega carvers from eastern Congo working in Uganda know that expatriates prefer either miniature figurines of ivory (or nowadays, bone) or elaborate hardwood chests and chairs with animal figures carved in relief. The former are part of the traditional Lega repertory, but the latter are strictly a colonially derived export genre. If Gallery Watatu in Nairobi encourages Jak Katarikawe to make more 'naive' paintings of people and animals kissing – for which he has become well known – rather than something more experimental, he is likely to do so. The expatriates and the Nairobi gallery are engaging in acts of important cultural brokerage, determining what will be made and how it will be interpreted by potential buyers – in one case as 'souvenirs of Africa', and in the other as 'authentically naive' painting. To illustrate this more fully several case studies in which patronage also acted as cultural mediation between artists, their production and their audience, or in the case of the Triangle Workshop model, among artists of different backgrounds, are described in this chapter.

A 'patron' can be anyone from a favourite saint to a regular customer, or according to one dictionary, anyone who 'countenances, protects or gives influential support'. Brokerage or mediation on the other hand implies a specific kind of agency: one who actively intervenes as a go-between, in this context between artist and public, or artist and institutionalized art world. All patrons are not brokers, nor are all brokers patrons. Clearly some of the most famous patrons in art history have been content to add lustre to their names as protectors and supporters of artists, while others have been more actively engaged as brokers in the promotion and even sale of particular artists' work. The emergence of new African art onto the world stage, beginning in the 1950s and 1960s, seems in retrospect to have been a major act of cultural brokerage by a small number of mainly European supporters. Some have been charismatic or merely driven, others paternalistic or romantic. In several instances, it has been African intellectuals rather than white foreigners who have created the conditions for this new art to flourish, and in the case of Oshogbo (see Chapter two) it was both. In these cases, a different set of premises were at work, connected to an emergent cultural nationalism (see Chapter six).

49
50

51

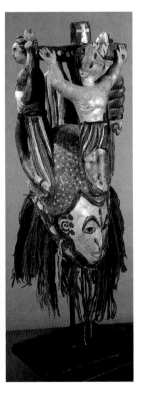

48. Igbo face mask depicting the Crucifixion and Mami Wata, Nigeria.

Many of these patrons and brokers are not known outside the countries in which they were active. Instead, we are limited to a handful of well-publicized cases dating from late colonialism through the early years of independent statehood, roughly a twenty-five-year period from the mid-1950s to late 1970s. They include Ulli and Georgina Beier as well as Susanne Wenger in Nigeria, Frank McEwen and Tom Blomefield in Rhodesia (now Zimbabwe), Pierre Romain-Defossés and Pierre Lods in the Belgian and French Congo and Pancho Guedes in Mozambique. Cecil Skotnes and later Bill Ainslie in South Africa could also be included, and besides this small core of independent agents, missionary-sponsored projects also developed important artists during the same period. The most written about have been Father Kevin Carroll in Nigeria, Canon Paterson and Father Groeber in

49. (top) A Lega artist from the eastern Congo carving a type of small ivory or bone figure formerly used in Bwami initiation and now produced for export by this small workshop which has flourished in the Kibuli section of Kampala, Uganda, since the end of the Civil War in the late 1980s.

50. (above) Mushaba Isa, a Lega artist who first came to Uganda in 1962, specializes in carving chairs for the export market.

Rhodesia, and Ulla and Peder Gowenius in South Africa. There were also influential expatriate art teachers in colonial schools and universities everywhere, including Kenneth Murray, Dennis Duerden and David Heathcote in Nigeria, Margaret Trowell in Uganda and dozens of others. Finally there were foreign philanthropies interested in promoting new African art – the Harmon, Farfield and Gulbenkian Foundations as well as the more controversial Congress for Cultural Freedom. While these usually did not interact with artists directly, they underwrote publications as well as bricks-and-mortar projects. In the same vein, certain large corporations such as Esso, BAT and BMW sponsored annual countrywide art competitions which uncovered artistic potential in unexpected places. Each functioned in crucial patronage roles.

51. (below) **Jak Katarikawe**, *People Happy at Christmas*, *c.* 1986. Katarikawe, a Ugandan practising in Kenya, has been the most successful of the unschooled artists in East Africa in the past decade. He was a taxi driver in Kampala, Uganda, and was encouraged by Makerere Professor David Cook who provided him with paper and coloured pencils, and later paints.

*Frank McEwen and Zimbabwe stone sculpture*

The most written about of these early patrons has surely been
Frank McEwen, universally lionized in the 1960s and 1970s, but
more recently held up to the cold scrutiny of postmodern criticism
and judged as excessively purist and an icon of high modernism.
McEwen, born in Mexico in 1907 to a French mother and British
art-dealer father, was brought up in England but made his way to
Paris as an aspiring artist in 1925. There he studied painting and
restoration, attended Henri Focillon's lectures in art history at the
Sorbonne, and came to know many of the artists active in the
1930s avant-garde as well as their patrons, both of whom were fre-
quently collectors of African art. These included Picasso, Matisse,
Braque, Léger, Daniel Henry Kahnweiler, Tristan Tzara and
Michel Leiris. He was particularly drawn to the unconventional
theories of Matisse's teacher Gustave Moreau which forbade
direct instruction or copying and stressed the necessity for artists
to reach inside themselves for the source of their creativity. These
ideas were the focus of a workshop he organized in 1938 in Toulon,
and again when he went to Africa in 1956 to become the first
Director of the new National Gallery in what was then Salisbury,
Southern Rhodesia (and since 1980, Harare, Zimbabwe). Between
1938 and 1956 he had established himself as an art reviewer and
curator in Paris and in 1945 had brought the first Picasso and
Matisse show to London. McEwen, like others in his circle, was
influenced by Focillon's notions of the archaic and the primitive in
art, as well as by Carl Jung's theories of the collective unconscious,
all of which were critical in forming his views of what the sources
of creativity in African art ought to be. But what he found on his
arrival in Salisbury was little more than modest souvenir produc-
tion, in a conservative white-settler dominated society which had
no use for either avant-garde modernism or the African collective
unconscious. Despite this, in only a few years he was able to bring
forth a thriving group of stone sculptors, and beyond that, to blur
the boundaries of ethnography and patronage by establishing an
intellectual framework for this sculpture to be interpreted within.

The 'experiment', as it was usually called, began with his giving
painting materials to Thomas Mukarobgwa (1924–99) and Paul
Gwichiri whom he had hired as young museum attendants.
McEwen frequently referred to their early paintings as a type of
'adult child art'. A few years later, when the emphasis in the work-
shop had shifted to sculpture in stone, he referred to a 'Pre-
columbian' phase which followed a stage of 'heavy primitivism'
before 'achieving personal sophistication'. Even without Focillon

and Jung looking over his shoulder, McEwen's easy familiarity with the stone sculpture of Henry Moore and the work of Picasso and Matisse would have been sufficient for him to frame the workshop sculpture in this kind of discourse. In news releases and interviews he attributed the early workshop paintings to an 'innate African aesthetic' from which the German expressionists drew their inspiration. This aesthetic, since it had no obvious local precursors in the immediate past, was endowed with a mysticism 'at which we do not cease to wonder but for which there are no obvious explanations'.

As the workshop became known, many of the artists came to speak in similar mystical terms about their work, but initially they viewed it pragmatically – it provided a chance for economic security in a settler society with few avenues of advancement for Africans. For Mukarobgwa, it allowed him to give up his bicycle-messenger's job for a much more promising one as an attendant and fledgling painter at the new National Gallery. In an interview in 1996 he recalled how he had been hired after a chance encounter with McEwen at the gallery's construction site:

52. Henry Moore, *Divided Head*, 1963

*TM: From [July 1957] I was working and he gives us…watercolor paint for us to go and try because I didn't even know how to use the paint…and then we go work at our Township, in the African Township…then we show to him. He was pleased with mine…then he bought it…. As I carried on, he decided that I should go out and talk to other people…so then we can open the workshop here in the National Gallery…. All these artists – [Nicholas] Mukomberanwa, Sylvester Mubayi, Joseph Andika – all these who are expanding…. They all come from the idea of Frank McEwen.*

*SLK [Sidney Littlefield Kasfir]: Why did he switch over from watercolors to sculpture?*

*TM: Why he has done that is that he knew there are some other things which you cannot put into painting which you can put into the sculptures. So they can give more movement in the sculptures than in the painting. [But] there are people born as a painter, he knew that because he had been with Picasso…. Picasso had never been into Africa but he had influence.*

McEwen's all-embracing presence appears in his role as teacher. Important lessons about originality were demonstrated to the workshop artists by travelling exhibitions of Picasso and Moore which he brought to the gallery. In Moore's case, his monumental figures must have also provided an explicit model of how to exploit stone as a sculptural medium.

52

53. **Thomas Mukarobgwa**, *Suggest Paintings: Adam and Eve*,
1963. Mukarobgwa was the only one of the original Salisbury
Workshop artists to become internationally successful as a
painter, with works in the Museum of Modern Art, New York,
and elsewhere. He was also an accomplished stone sculptor.
Frank McEwen referred to his thickly applied paint surface and
use of saturated colours as 'Afro-German Expressionism'.

SLK: So he [McEwen] brought an exhibition of Picasso's work here to this gallery...and did he go through the exhibition with you and talk about these things?

TM: That's what he used to do. He used to take the whole group. Everyone would have to join in order to hear what he was explaining about. Because he used to explain nicely and he used to know every color, why it was put there. He was such a wonderful genius. You know, he used to know quite a number of things.

SLK: Was he a painter himself?

TM: No, actually. Just because he had grown into art for all of his life. He was the person who loves art.

The shift in emphasis from the promotion of painting to stone carving in the early to mid-1960s was a complicated leap of faith on McEwen's part. It was a direction in which the hoped-for Jungian mythic connection to the past could be developed, perhaps around the controversial stone ruins of Great Zimbabwe which the archaeologist Gertrude Caton-Thompson had concluded were of local Shona origin. Local sculpture was also being produced, though not the kind he wanted – souvenir soapstone and woodcarvings and more importantly, sculpture produced in the service of the Church at the Cyrene and Serima missions, the former training Samuel 54, 55 Songo in the early 1950s and the latter Nicholas Mukomberanwa a 56 decade later. Joram Mariga, who became a central creative force in 57, 61 the stone sculpture movement, had begun a steatite (soapstone) and wood carving workshop in Nyanga in the mountainous eastern highlands in the late 1950s. McEwen was not aware of its existence until 1961, but soon afterwards he was exhibiting the work of Mariga and his nephew John Takawira in the National Gallery.

As various sculptors were assimilated into McEwen's project, they abandoned their early representational pieces and heeded his advice to look deep within themselves to a collective Shona mythology and to avoid anything that bore the taint of 'airport art' – a term he coined – including both realist representations of all kinds and common carving materials such as wood and soapstone. These were replaced by serpentine – a metamorphic rock, which can be soft or hard and capable of a high polish – and other harder stones. The sharp distinction which McEwen drew between pure, original artistic expression and a practice aimed at the craft and souvenir market was deeply impressed upon the early workshop sculptors. Mukarobgwa still spoke of it eloquently forty years later:

54 and 55. **Samuel Songo**, chapel doors depicting Biblical scenes with Mediterranean – and Egyptian – African connections, Cyrene Mission near Bulawayo, Zimbabwe (then Rhodesia), early 1950s. Unlike Father Kevin Carroll at the workshop at Oye Ekiti, Nigeria, Canon Ned Patterson himself taught the artists at the Cyrene Mission. Songo, although severely disabled, displayed prodigious talents as both a sculptor and as a painter and became Cyrene's most widely known artist.

*TM: We want to do something absent which you can bring from your mind into your eye and you talk with it until the last of your work and you can say, 'Yes I've finished'. And that work which you finish can also say 'yes' to you when you have finished it in the way you feel because it has been created by your spirit…when you're trying to do work on behalf of someone…that's not yours. He [McEwen] was trying to explain that. He was trying to give an example of when you have a child, that child is not going to look like [another] man. Because if it is created definitely by your blood, you have created…a very original one. So that's what he used to explain.*

*SLK: So your sculptures are like your children in that way.*

*TM: Yes. Sometimes you can do your features on your sculptures or even your painting figures.*

Mukarobgwa frequently returned to the contrast between this inward-directed artistic process and the work being done now by younger Zimbabweans based on either international models or emulation of the stone sculpture of his generation. He acknowledged that a certain amount of copying must occur during the early stages of the learning process for any artist, but it should be temporary:

*TM: Now you should find your own way, how to do things in order to develop. But if you stand still as the way you have been taught, you are nothing. You are not trying to make other people think how things should be done.*

*SLK:... once they get past the stage of being a student who's learning, and can work on their own, you're saying that they need to develop their own way of working. But what of all the things they've seen?*

*TM: They can combine, but not very much. They must show their tribes.*

In this philosophy, which is Mukarobgwa's personal reinterpretation of McEwen's ideas (devolved in turn from Moreau, Jung and Focillon), originality is foremost and has two elements: a deeply individual consciousness unique to each artist, and a collective one drawn unconsciously from shared historical experience ('their tribes'). But it disapproves of that element in art which intentionally plays with, comments upon or borrows from other art beyond 'the tribe'.

Unbidden, the political independence movement intervened in the direction the workshop was to take. With the announcement of UDI (the Unilateral Declaration of Independence) Ian Smith's white minority government broke all ties with Britain in 1965 and in retaliation the British government imposed an economic boycott which was to affect deeply the development of new art. Imports such as paint supplies disappeared almost overnight, making sculpture not just a workshop choice but a necessity. Smith's government blacklisted McEwen, who fraternized with the workshop artists and violated white separatist principles. In 1969 Joram Mariga helped McEwen to move the workshop out of the National Gallery to Vukutu in the Nyanga mountains, to lessen government surveillance and remove the artists from market pressures to sell,

56. (below, left) **Nicholas Mukomberanwa**, *Man*, 1969

57. (below, right) **Joram Mariga**, *Anteater*, 1990

but also to create a residential community for those artists already trained by Mariga at Nyanga. This new location inspired McEwen to reframe the workshop as a 'bush school' and to look to Shona ethnography and history for an explanation of the sculpture. The stories told to him by sculptors Joseph Ndandarika ('previously apprenticed to a famous wizard') and Thomas Mukarobgwa ('a master of folk knowledge and ancient myth') provided McEwen with the evidence he wanted. At Vukutu, his new American wife Mary McEwen encouraged sculptors to develop themes out of Shona tradition and a monthly prize was awarded for the best example. In an illustrated pamphlet on the Workshop School McEwen alluded to the 'mystic secret' of 'sacred caves concealing numerous and varied ancestor figures carved in stone', as well as the handful of documented steatite bird sculptures taken from the Great Zimbabwe ruins. Photographs of a Nyau society masquerade performance link the artists in the workshop to an unspoiled traditional Africa, while their sculpture is said to be 'born directly, locally, from natural elements in the virgin ground'. Two historical issues are skirted here, however. Firstly, some of the artists who joined the workshop had learned to carve at the Cyrene and Serima missions, and themes such as the Mother and Child were also biblical, not simply indigenous. Secondly, others (particularly those belonging to the Chewa Nyau society) were not Shona, undercutting the idea of an ancient Shona tradition of ancestor figures concealed in caves, or stone birds from Shona architectural ruins (*zimbabwes*) informing their work. These attempts to frame creativity as a response to a collective mythic past have ironically become the rhetoric upon which a 'Spirits in Stone' carving industry has been founded by the very entrepreneurs whom McEwen tried to keep at bay.

Nonetheless, the combination of the unquestionable power of much of the early workshop sculpture with McEwen's interpretive strategies and unsurpassed art-world connections propelled this work onto the international stage of modern art. In 1962 he arranged the First International Congress of African Culture in which art from all over the continent was exhibited in Salisbury, but more importantly its international participants (including the renowned African art scholar William Fagg and Alfred Barr, the former Director of the Museum of Modern Art, New York) were introduced to early workshop painting and sculpture. This was followed by an exhibition in London at the Commonwealth Institute in 1963 and after the expansion of the workshop to Nyanga, the Museum of Modern Art in New York organized a show of forty-six

58. (above, left) **Josia Manzi**, *Baboon Stealing the Crop Guard's Child*, n.d.

59. (above, right) **Amali Mailolo**, *Man and Crocodile*, n.d.

works which toured the United States during 1968 and 1969 under the title *New African Art from the Central African Workshop School*.

But after the imposition of the 1965 economic boycott, McEwen no longer exercised complete control over the promotion of stone sculpture in Rhodesia, and other styles of cultural brokerage and of sculpture itself, emerged. The central figure in this was Tom Blomefield, a tobacco farmer from Tengenenge, 150 km north of the capital in the mountains of the Great Dyke. Blomefield had been hard hit by the British ban on the importation of Rhodesian tobacco. Discovering a large deposit of serpentine on his farm property, he enlisted the help of Lemon Moses, a sculptor from Malawi, to help set up a carving group among his migrant farm workers, most of whom were Chewa and Yao from Malawi or Mozambique and Mbunda from Angola. Between 1966 and 1969, these stone carvers (including the Shona sculptors Henry Munyaradzi and Bernard Matemera, the Yao artists Josia Manzi and Amali Mailolo and several others) exhibited under McEwen's patronage at the National Gallery in Salisbury. However, Blomefield's

58

59

approach differed radically from McEwen's in the degree of control which he thought it was crucial to exert. Works that McEwen rejected were sent later by Blomefield to be exhibited and sold in South Africa – on the principle that the artists must be able to preserve their own independence, both aesthetically and economically. Blomefield's personal style was different from McEwen's: he spoke fluent Chewa instead of French, was an artist himself (trained by Mariga's student Crispen Chakanyoka), and was able to operate in an environment of relaxed mutual respect which allowed talent to develop without being subjected to museum-style critique. Inevitably, his methods and McEwen's could not coexist peacefully, because McEwen thought the workshop's reputation would be undermined by the promotion of work which fell beneath his own standards. After 1969 the Tengenenge artists were not invited to exhibit at the National Gallery until McEwen left in 1973.

During the troubled years of the Chimurenga (war for independence), the greatest support for the sculptors came from Blomefield, who purchased houses for several of them in Salisbury, and from Roy Guthrie, who from 1973 was the director of Gallery Shona Sculpture, a private gallery in a complex on the outskirts of the city now known as Chapungu Sculpture Park. McEwen, by then in his seventies, never returned to Rhodesia, living out his years in France. He hoped to write a book about the Workshop School, but the economic boycott prevented the National Gallery from providing him with any funds.

*Trade-offs between patrons and artists*
Despite its crucial role, patronage alone cannot bring art into being and Zimbabwe stone sculpture was not the creation of its patron-brokers. Significantly, the range of specific thematic content had little or nothing to do with either McEwen or Blomefield. Furthermore, Mariga had already begun a workshop 57, 6 before either of them, and so if anyone is the 'father' of the

60. **Damien Manuhwa,**
*Creation of a Woman,* n.d.

movement, he is. Nor is there a single style or attitude towards the stone itself, but a wide range from the smooth-fleshed descriptive fantasies of Amali Mailolo to the rough and unfinished semi-abstraction of Damien Manuhwa. Perhaps the one thing they all have in common today is an army of imitators, from street sellers to artists whose work is sold along with theirs in galleries and abroad by (mostly white) Zimbabwean dealers and promoters. 60

The elaborate and conflicting discourse that has resulted from this veritable industry has helped sell Zimbabwe stone sculpture, but has hurt it critically. While *Newsweek* proclaimed in 1987 that Shona sculpture was the most important art form to emerge from Africa in the twentieth century, it was not included in major exhibitions such as *Africa Explores* in 1991 (supposedly because the artists were well established) or *Seven Stories about Modern Art in Africa* in 1995 (perhaps because their 'story' had been heard too many times). The other, unspoken reason in both cases may be that the artists have been too obviously successful, invoking curatorial suspicions of a descent into formulaic repetition. Furthermore, the high visibility of certain patron-brokers has, in the eyes of critics and scholars, cast the artists' own agency into doubt. This has happened in many workshop situations – not only in Zimbabwe. Hierarchies of value were created in the early 1960s by the monthly prize at Vukutu for the 'best traditional theme', and in Oshogbo, Nigeria, when Georgina and Ulli Beier selected the best workshop pictures each day and hung them for everyone to see.

61. **Joram Mariga,**
*Chief Chirorodziwa*, n.d.

These hierarchies of value mattered at that moment, but are progressively diluted over time as artists gain experience and develop a greater awareness of what they are doing.

Oshogbo, the workshop movement whose issues run like a thread through this book, did differ in two important ways from Salisbury – Georgina Beier, as a painter herself, provided a strong experiential model, beginning with her stage sets for Duro Ladipo's theatre productions put together by the same individuals who later participated in the 1964 workshop. Other Oshogbo workshops in the early 1960s and 1970s were also run by practising artists, from the Guyanan painter Denis Williams to Dutch printmaker Ru Van Rossem and Nigerian printmaker Bruce Onobrakpeya. At Salisbury, McEwen stage managed, but did not play the artist role himself or put an artist in charge. However, his workshop project lasted more than a decade, and hundreds of artists passed through it. By contrast, workshops at Oshogbo were extremely brief, the 1964 session only lasting a week. It is difficult to quantify influences, which ultimately depend as much on receptivity and chance encounters as on their duration or structure.

*A generation later: patrons and brokers in the 1990s*
In the 1960s it was confidently assumed that Africa would develop indigenous patronage for new art forms as it emerged from the socio-economic climate of colonialism, but contemporary art patronage is still dominated by European, American and white Southern African dealers, promoters and collectors, leaving the curios and dubious 'antiquities' to mainly African and Indian traders. Ruth Schaffner, the owner of Gallery Watatu in Nairobi, Kenya, from 1984 until her death in 1996 at the age of eighty-two, was a member of the same European generation as McEwen. Like him and her younger countryman Ulli Beier, she believed that academic instruction spoiled the innate creativity of African artists. The daughter of intellectual emigrés from Hitler's Germany, she studied economics at the New School in New York and then began a career as a photographer. She travelled to Côte d'Ivoire in 1948 with her first husband, filmmaker Hassoldt Davis, but did not return to Africa until 1984, having spent more than a decade running galleries devoted to contemporary art in Los Angeles and Santa Barbara.

At Watatu, Nairobi's leading gallery, eighty per cent or more of the artists are 'self-taught' and Schaffner's relationship with them was complex and familial despite her reputation as an astute businesswoman. She lent them money for painting materials, paid

their children's school fees and gave cash advances against hoped-for sales. In return she expected total loyalty, exclusive representation, and from the early 1990s took a fifty per cent commission on their sales. Her justification for this unusually high rate for an African gallery was that she could command much higher prices for their work than lesser-known galleries and could therefore make more money for them in the end, a point disputed by some of the artists.

Like McEwen, she had strong opinions and her judgments were final. Once a month Watatu Foundation held an 'artists' day' when new and would-be artists were encouraged to bring their work for appraisal and feedback. In her last years, Schaffner was too overburdened to perform this task herself and increasingly delegated it to her staff, but while she was alive it remained the litmus test of whether an artist's work held possibilities and would fit within the range of cultural production that Watatu actively cultivates. This is not to say that all Watatu artists' work bears a generic stamp of likeness – it clearly does not – but it does encompass certain possibilities and exclude others. Just as McEwen forbade descriptive realism, so Schaffner usually avoided pictorial styles which reflected academic training or European-derived

62. Ruth Schaffner on location in Côte d'Ivoire while filming *Sorcerer's Village*, early 1950s. The photograph appears in Hassoldt Davis's eponymous book and shows Schaffner explaining the workings of the camera to a young Lobi woman. Subjects posed in this way were part of a popular *National Geographic*-type practice of exoticizing non-Western people by emphasizing the contrast between tropical semi-nudity and the fully clothed Western visitor, as well as the 'magic' of the camera.

63. **Kivuthi Mbuno**, *Mutinda*, 1992. Mbuno is one of the most original of the Watatu artists. His personifications of monkeys as quasi-people and people as quasi-animals in a sparse landscape, as well as his gigantic female lions lurking on the horizon, are not characters from folktales, but products of a rich artistic imagination.

preoccupations with abstraction. Scenes of urban and rural life, or expressing fantasy (such as Kivuthi Mbuno), were encouraged both because they encapsulate the 'primitivism' which buyers prefer and because they fit the intellectual assumptions upon which Schaffner herself guided the gallery's patronage.

Sane (Mbugua) Wadu is an artist in point – he was an ex-primary school teacher who left the classroom to become a successful painter under Schaffner's patronage. *Seven Stories about Modern Art in Africa* curator Wanjiku Nyachae has described how Wadu arrived at Gallery Watatu wearing an improbable canvas suit he had painted himself and carrying shopping bags containing rolled-up pictures. In his community people had begun to call him 'Insane' Wadu. Schaffner gave him materials and four months later he had his first show at Watatu. He subsequently began to call himself 'Sane' and others followed. His thematic repertory, like that of the Kinshasa flour-sack painters or the Weya women (see Chapter four), is full of narrative detail taken from the everyday life of ordinary people: bus passengers, a crowd listening to an evangelist in a Nairobi park, someone on a bicycle. But the crowded pictorial compositions, frontal stares of their subjects and swirling impasto brushstrokes give his work a wild energy not seen in that of most of the Watatu artists' work.

One outcome of Schaffner's artists' successes has been their emulation, usually by members of their family or community. As elsewhere among unschooled artists, imitating a successful model has been seen as both pragmatic and commendable, creating a problem for Schaffner and for Watatu, where originality is assumed to issue forth naturally from untrammelled artistic expression. People in Ngecha, Wadu's hometown near Nairobi, soon began to see the benefits of becoming a painter and in the early 1990s started bringing samples of their work to the monthly artists' days at Watatu.

In 1995 the artists (including Wadu's talented sister Lucy Njeri) formed the Ngecha Artists' Association and workspace. Occasional canvases are jointly produced mixtures of individual styles within group compositional frameworks. Not wishing to lose them, Schaffner responded by helping with fundraising and held informal artist workshops at the Ngecha YMCA. What Schaffner's patronage demonstrates is the fine line that exists between encouraging a whole community to become artists and the new direction, no longer within gallery control, which often

65
66

64. **Sane Wadu's**, *Waiting*, 1991–92, was painted on the eve of the Kenyan elections when the country experienced violent clashes between the state's paramilitary forces and citizens protesting for a multiparty form of government. Wadu has included a representation of himself – the bearded figure at the bottom among the protesters.

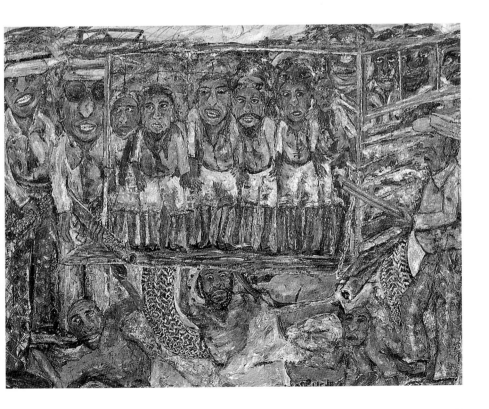

65. (left) **Lucy Njeri**, *Can the Landers Invert?*, 1998. Njeri's paintings often address the position of women in Kenyan society. Here, she has inverted the status quo with women on top supported by male productive labour below.

66. (below, left) **Ngecha artists**, untitled village scene, 1995. One of five canvases painted collectively by the founding members (Chain Muhandi, Eunice Wairimu Wadu, Sebastian Kiarie, Sane Wadu, King Dodge and Wanyu Brush) of the Ngecha Artists' Association for

their inaugural exhibition in 1995 at Gallery Watatu, Nairobi.

67. (below) **Cartoon Joseph**, untitled village scene, 1998. Figures of different scales occupy the foreground of this crowded picture depicting life in an upcountry Kikuyu town with its church, bar and political headquarters amidst sprawling domesticity. The cross on top of the church is repeated as telephone poles in the distance, each with its own messages about modernity.

results when the group organizes itself. The premise that 'art comes from art' (see Chapter five) has two sides – it is the primary reason for the emergence of 'movements' or 'schools' or group styles, but it is also the guiding principle of emulation and of commodification. This is not to say that a scaled-down artworld version of mass production is necessarily the outcome of such projects – highly personal styles of artmaking may also emerge.

At Banana Hill, another rural community near Nairobi where there is an artists' association, 'Shine Tani' (*Shetani* or 'Devil', aka Simon Njenga Mwangi) and Cartoon Joseph (aka Joseph Njuguna Kamau) are both painters whose work is far from emulative and possesses an exuberance which is extremely difficult for formally

68
67

68. 'Shine Tani', *Homestead Acrobats*, 1997. 'Shine Tani' himself used to perform as an acrobat with a troupe from his hometown. He describes his experience as a survival tactic that kept him from 'living on the streets'. The visual expression of acrobats here parodies the convergence of 'tradition' with modernity, linking both to a kind of frantic activity of survival.

trained artists to achieve, partly because it ignores most of the rules of composition and partly because its subjects are taken from the street and not the studio. But resounding artistic success also breeds imitation, whether in New York or Nairobi.

### Triangulation, or where I went last year

Not all workshop patronage has followed the McEwen-Schaffner model of a well-connected art professional from abroad organizing a group of previously untutored African artists on their own home ground. Beginning in the mid-1980s, a more egalitarian (though no less brokered) series of international workshops have taken place which presume that the key to creativity lies elsewhere, in encounters with unfamiliar cultural models and artistic

practice. These have developed out of the Triangle Workshop model and in one sense have no 'patron' since they are organized by the artists themselves, though financial backers are necessary and in the African versions have been primarily corporate, cultural or development organizations such as the British Council or NORAD. The original workshop was organized in New York in 1982 by the British collector Robert Loder and the artist Anthony Caro, and involved participants from the 'triangle' of the USA, Canada and the UK.

Because the ANC-imposed Cultural Boycott was still in effect, there were few opportunities then for South African artists to break out of their isolation. However, in 1984, South African artists Bill Ainslie and David Koloane joined those participating in the Triangle workshop in New York and in the following year organized the first Thupelo workshop in Johannesburg. Triangle participants were encouraged to return to their home countries and organize annual workshops there in subsequent years. The basic principles are simple enough – several of the artists should come from outside the host country, the workshops should be brief (two weeks long), the encounter is meant to be intense, and to

69. **Dumisani Mabaso**, *Untitled*, 1988

69

make that happen, the location has to be an out-of-the-way place where the artists will not be distracted. It is based on a kind of 'combustion' theory of creativity – not only does art come from art, but the more heterogeneous the mix and the further from a familiar environment, the more it is likely to catch on fire.

The initial excitement that a workshop generates may linger for a while and die out, or may metastasize into several others. In South Africa, when Thupelo in Johannesburg had run out of

70. **Bill Ainslie,** *Pachipamwe No. 3,* 1989

energy, new workshops were started in Cape Town and Durban, while several artists from Thupelo became involved in the Bag Factory project in Johannesburg. But, as in the institutionalized artworld of biennales and other group shows, there can also be a powerful cultural politics of inclusion which develops around the workshops once they have been established and become regular events. A core group of workshop veterans decide which artists should be invited and their choices may be even handed, exclusionary or simply idiosyncratic, but never neutral.

Pachipamwe, the first of these workshops set up outside South Africa, was organized in 1988 by the sculptor Tapfuma Gutsa in Murewa, Zimbabwe. It brought together some of the most established stone sculptors (Joram Mariga, Bernard Matemera and Brighton Sango) with younger artists who hoped to move Zimbabwean art in new directions. The following year the second Pachipamwe workshop took place at the Cyrene mission and included several artists from abroad – from the UK, Angola, Botswana and South Africa. From this and subsequent workshops, new ones were spawned in Botswana (Thapong, 1989), Mozambique (Ujamaa, 1991), the UK (Shave Farm, 1991), Zambia (Mbile, 1993), Jamaica (Xayamaca, 1993), Namibia (Thulipamwe, 1994) and Senegal (Tenq, 1994).

Namubiru Rose Kirumira, a young Ugandan sculptor trained by Francis Nnaggenda and now teaching at Makerere, is a typical Triangle participant. She attended the 1995 Mbile workshop in Zambia and the Thapong workshop in Botswana during the same year. Ugandan artists were drawn into the workshop network after Robert Loder had visited Makerere in 1994 during the planning stages for the *Africa 95* events in London. Kirumira and the painter Richard Kabito were selected for the Mbile workshop and Francis Nnaggenda for a sculpture workshop in Yorkshire in August 1995. After participating in both Mbile and Thapong, she organized Namasagali in 1996 to bring together artists from the four major regions of Uganda in a national workshop. Her next project is an international workshop in Uganda similar to the ones she has attended in Zambia, Botswana and Denmark.

Artists certainly do not participate to make money. The sponsoring institution typically expects to be reimbursed with between 30 and 40% of the proceeds of works sold at the exhibition held at the end of the workshop, or by the donation of a work which can then be sold, or both. Despite this, the advantages of professional networking are obvious to many African artists, marginalized as they usually are within a global but Western-dominated system of

exhibiting and collecting. Participating is one way to receive invitations to take part in future workshops, to be nominated for travelling fellowships and residencies in foreign countries, and most important of all, to become known on the international gallery circuit.

These advantages may even outweigh the chances for creative encounters, which are not as straightforward as they might seem: as a sculptor in wood and metal, Kirumira found it difficult to interact with other artists and also complete two pieces (the suggested output) in such a short time when she attended the Mbile and Thapong workshops. The two-week duration favours painting over sculpture and installation work, acrylic (because it dries fast) over oil paint and abstraction over figuration.

The workshops with the exception of Tenq in 1994 have been firmly embedded in the English-speaking world, which means that they tap into a particular subset of African countries, which prior to 1996 were mainly in southern Africa. This was not just an accident of the Triangle workshops beginning in New York instead of Paris, but reflects the real differences in anglophone and francophone attitudes towards patronage and perceptions of authenticity in contemporary African art. If one adopts the premise popular among French-speaking European intellectuals that only the untutored artist is likely to exhibit a truly African artistic sensibility, why would one want to create a network of international workshops to dilute it?

While many established artists do participate, a large number are younger artists, African or otherwise, who have had some professional training, but are eager to be able to interact with a larger artworld, on the assumption that their work will improve as a result. Those not likely to be involved, on the other hand, are either artist-intellectuals who value introspection over collaboration, or (much more numerous) all those African artists who have neither gallery or patron connections nor the resources to acquire a passport and air ticket even if they somehow received an invitation. But overriding these tendencies are the real differences among African countries where the workshops have been established, which produce contrasting workshop scenarios.

In Botswana, for example, its population is sparse and there are comparatively few artists, so the National Museum has been an important sponsor for the Thapong workshops, thereby conferring on them a quasi-official status. Internationally, the best-known Botswana artists are the Nharo San of Ghanzi district who have no formal schooling or regular contact with artworld culture

71

69, 70

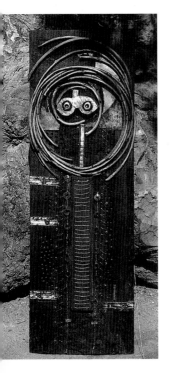

71. Namubiru Rose Kirumira, *Untitled*, 1996. Part of a series of faces, combining hardwoods and metal recyclia.

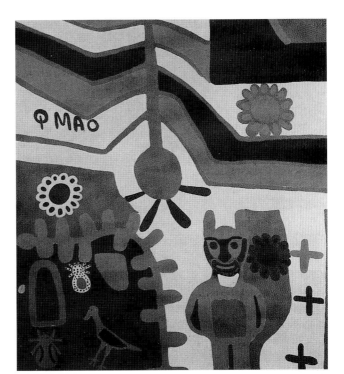

72. (above, left) The San painter Qmao Nxuku, from the Thapong workshop catalogue, 1992

73. (above, right) **Qmao Nxuku**, *!Xrii*, 1992

(see Chapter two). To leave them out of the Thapong project would be problematic from the perspective of national cultural politics, but to include them has created its own problems, since they work under the protective umbrella of the Kuru Trust and Cultural Centre. Kuru has attempted to preserve their artistic identities in relation to a remote rock-painting hunter-gatherer past, a strategy which works well in helping to explain and market their work abroad, but which conflicts with the idea of creative exchange at the heart of the Triangle workshop format.

The 1992 Thapong Workshop included San painters Qmao Nxuku and Xwexae Dada Qgam, whose participation was an important test of the workshops' cultural encounter thesis. However, *!Xrii* (1992), a painting Qmao did at the workshop, and *The Old People*, a lithograph he did in the same year at Kuru, reflect the same style and thematics – conceptually related but spatially unconnected objects and figures typical of Kuru, but not resembling anything else from the Thapong inventory of work produced that year.

Each of these accounts of brokerage has been centred upon a workshop or gallery, but just as common everywhere are one-to-

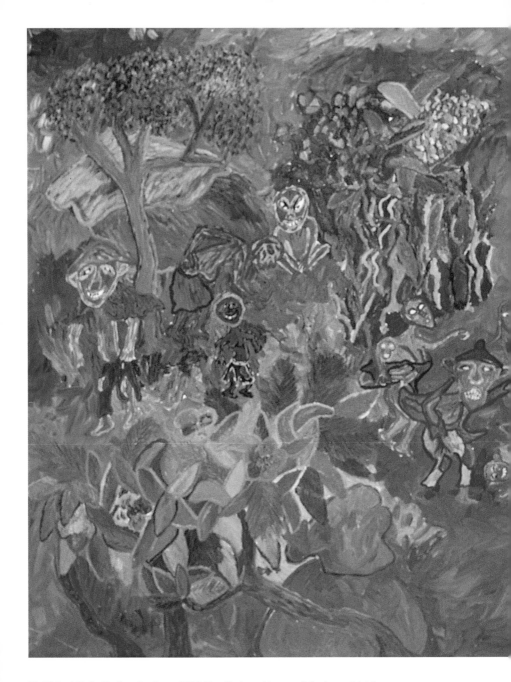

74. **Misheck Gudo**, *The Squatter Camp*, 1996. Here Gudo combines carefully observed detail with deeply saturated colours and a sophisticated use of compositional space. He began his art practice as a wood carver, but turned to painting after he was advised by a Harare gallery owner that Zimbabwe was full of sculptors, but had few painters.

one relationships between artists and individuals who create opportunities for them. Often these are collectors, but sometimes they are artists themselves. Pip Curling, a Zimbabwean painter, first encountered the work of Givas Mashiri on a street-corner kiosk. Mashiri, a self-fashioned sculptor in Harare who makes figures out of papier maché, was dependent on the street for displaying and selling his work. But as a painter and active board member of the National Gallery, Curling was better placed to raise Mashiri's level of exposure by introducing his work to other artists, patrons and gallery owners. Curling has also helped the painter Misheck Gudo by turning her garage into a studio for him, and teaching him to mix pigments and arranging a small show of his work in the National Gallery foyer.

In a very different kind of place, the resort town of Malindi on the Kenya coast, Richard Onyango was helped to get started by a local businessman Feisal Osman and the patronage contacts provided by the resident Italian community. Onyango, like many 'self-taught' artists, has paid meticulous attention to buses, cars and other symbols of modernity, but his signature paintings are a

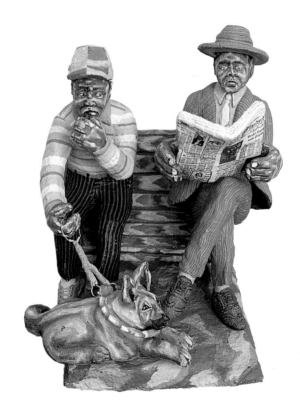

75. (right) **Givas Mashiri**, *Reading the Standard*, 1997. This sculpture was commissioned by a new local Sunday paper.

series about a white woman called Drosie, and his brief involvement with her, her possessions and pastimes. In *Day of Permission* (1990), she is lying on a sofa with a box of chocolates, surrounded by a TV, a stereo and souvenir wall plaques with slogans like No War, and No Soliciting, while the artist stands tentatively in the background. Unlike the satirical depictions of South Africans by Tommy Motswai, these minutely observed paintings are not meant to be humorous or ironic. However, the depiction of such subjects is only possible because patronage has exposed the artist to new experiences. These interventions can be crucial to an artist's repertory and ultimately, career.

76. **Richard Onyango**, *Day of Permission*, 1990

### South Africa's inside brokerage

While the political history of South Africa has been different from that of most African countries, achieving majority rule only in 1994 compared with thirty years earlier, the late-colonial relations between black artists and white patrons has been the same. But what has been distinctive is the presence of a resident white intelligentsia large enough to produce its own artists and writers, who during the apartheid era (roughly 1950 to 1994) became brokers for, and sometimes collaborators with, their black counterparts. The same intelligentsia also produced the core of critics, gallery owners, curators and collectors. Today there is much more of an organized 'artworld' in South Africa than in any other African country, which positions black artists there in ways that are reminiscent of African American, Native American and Hispanic artists in the United States – enclaved groups defined primarily by race or ethnicity in relation to artworld institutions which are still overwhelmingly white. But unlike in the United States or the UK, in South Africa minorities and the majority are racially reversed, so that white artists and critics have emerged out of a small progressive element of the minority population and have been drawn ineluctably into the South African preoccupation with racial and identity politics. And again unlike their counterparts in New York or London, they cannot choose to ignore the conditions of their privilege.

Two kinds of issues have emerged out of this historical situation – that of the relation of black artists and the black subject to the white South African intelligentsia, and from the mid-1970s to the transition to democracy in 1994, the ANC's rhetorical position of the artist as a 'cultural worker' in the political struggle to overthrow apartheid. A third issue has to do with the differences in consciousness reflected not only by white artists' racial and economic privilege, but also by their pedagogical grounding in the Western-style art academy. The latter are essentially the differences between formally and informally trained or untrained artists (see Chapter five), since nearly all white artists fall into the former category and nonwhite artists in the latter.

The most critical role played by the white liberal intelligentsia, other than that of willing consumer and audience, was as providers of informal training, usually in community centres for the African townships. The custodianship of these artist-mentors allowed a cadre of modern black artists beyond the inevitable makers of wire airplanes and souvenirs, or the producers of older genres of 'tribal' objects to be possible. Prominent among this initial group of artists

77. **Ephraim Ngatane**,
*Washerwomen, c.* 1970.
Ngatane studied first with Cecil
Skotnes at the Polly Street Centre
from 1952 to 1954 and then
with Durant Sihlali. Curator
Steven Sack divides township
paintings of the 1950s and
1960s into documentary works
of particular places and more
generalized genre paintings
which lent themselves to the
development of stereotyped works
for easy sale. *Washerwomen* falls
in the latter group, though it is a
'prime work' and not one of the
later replicas – an atmospheric
representation of women working
against a background of small,
brick, metal-roofed houses which,
through the suppression of detail,
renders the subject as outside
time and sociological reckoning.

78. **Cecil Skotnes**, *Procession*, 1963. Near the end of his Polly Street period, Skotnes joined four other artists in 1963 to form a group called Amadlozi (Zulu for 'the spirit of the ancestors') which took their work on tour to several European capitals before it disbanded. His painting style at the time has the look of woodcut with its incised lines resembling the texture of the block. This is coupled with massive figures in muted, almost monochromatic tones occupying a shallow space and connected by threadlike, interweaving lines.

were Durant Sihlali, Ephraim Ngatane and Sydney Kumalo, all emerging at the Polly Street Centre in the mid-1950s in Johannesburg under Cecil Skotnes' tutelage. But however well intentioned and successful (and it was clearly both), this combination of white instruction and patronage was to determine both the direction and the limits of modernism for the black artists who came of age in the 1950s and 1960s. At first glance, this does not set them apart from African artists elsewhere on the continent during those decades, but the difference was that in South Africa this occurred within the all-encompassing official ideology of racial separateness (apartheid), in which white artists as well as black were enmeshed.

Critics David Koloane (himself a non-figurative painter) and Ivor Powell have protested the tendency of white reviewers and gallery owners to encourage the development of 'township art' based in social realism and to discourage more experimental directions. While abstraction became the dominant international style in the 1950s, many South African promoters believed this was an unauthentic direction for black artists, who ought to be depicting the life that surrounded them instead of aspiring to membership in an artworld whose centres were far away and

putatively 'white'. The typical advice to a new artist or writer – begin with what you know most intimately – is normally viewed as benign, but in this racially charged context can also be read as a way of setting limits for black artists alone. However, it needs to be seen as one fragment of a larger picture in which all South African art in the 1950s existed on the far periphery of a late-colonial Europe where even white South African artists were largely pre-occupied with conventional genres such as landscape, still-life and the figure. In such an atmosphere one would expect abstraction to be regarded as suspect. By the late 1970s, for many black artists, and certainly for the freedom movement led by the African National Congress, the human subject was the only subject worthy of exploitation. Therefore, despite being poles apart ideologically, both official white-run institutions and the African National Congress supported the idea that the proper subject for black artists was some variety of narrative realism.

Even more revealing than the encouragement of township subject matter was the bureaucratic pairing of art lessons with games and sports under the general rubric of 'recreation'. This made administrative sense because the township community centres were multi-purpose – the venues for weddings, funerals and indoor sports as well as art lessons – but it also made it clear that art instruction was not really 'about' becoming a practising artist, but 'about' creating a law-abiding urban-worker class interested in self-improvement. Thus Cecil Skotnes was hired initially in 1952 as a 'cultural recreation officer' by the Non-European Affairs Department of the Johannesburg City Council. This very limited notion of African creative potential contrasted starkly with that of McEwen in neighbouring Rhodesia during the same period, believing he had tapped an ancestral wellspring of limitless possibilities with the Salisbury Workshop School.

The other question debated then, whether township artists should receive direct academic instruction at these community centres or should be given minimal technical advice and then left to work in their own way, has remained the most intractable issue in the construction of African modernism from the 1950s up to the present (see Chapter two). As we have seen, most Western intermediaries have come down on the side of advice rather than direct training, on the assumption that Africans have innate (and by implication, unique) artistic abilities which need only to be uncovered in practice. In Oshogbo or Poto-Poto, this may have seemed merely romantic, but in South Africa it was inevitably open to a racial interpretation – that blacks were 'natural' rather

79. (above) **Louis Maqhubela**, *Master*, late 1960s/early 1970s

80. (opposite) **Durant Sihlali**, *Graffiti Signatures*, 1997. In the words of the artist, 'From markings on rocks, impressions on walls and caves, to engravings on wood or metal... inscriptions bear witness to the existence of those who lived during a specific period in history. It has been my study for many years to microscopically scrutinise these... signatures of the past and present. I then reconstruct these on paper or canvas.'

than 'created' artists so (unlike whites) did not need any formal instruction. Carried a step further, such artists would be 'contaminated' by the exposure to many European-derived ideas. It became a point of contention for some of the Polly Street artists, such as Louis Maqhubela, who wanted a more complete education in formal technique. After winning a trip to Europe in a major art competition in 1966 he met Douglas Portway, an expatriate South African artist in Cornwall, and began to produce more abstract compositions combining fine linear figuration with diaphanous areas of colour, a development which David Koloane attributes to this post-Polly Street experience.

Durant Sihlali, another major artist who studied with Skotnes between 1953 and 1958, has also moved from a documentary

approach early in his career towards a more abstract and experimental one, making his own deeply textured paper which becomes a crucial part of the finished composition. But this has been a far from simple progression, since he is also a highly skilled wood and metal sculptor and is at home with several media.

Skotnes himself, a gentle and self-effacing man despite his status as a major icon in South African art history, remembers the Polly Street years somewhat differently than his students. As someone suspicious of manifestoes, artistic or political, he says he was reluctant to pursue a single set of recommendations for everybody under his tutelage. Classes at Polly Street were only held twice a week, but several of the artists supplemented this with visits to Skotnes' own studio to work on specific technical issues.

82. **Sydney Kumalo**, *Horse*, c. 1963–65. Kumalo's bronze castings ranged in style from fluid and elegant semi-abstraction to the more massive quasi-descriptive realism depicted here. He was a member of both the Polly Street Centre and the Amadlozi group along with Cecil Skotnes.

83. **Ezrom Legae**, *The Assassinator*, 1996. Legae was also an accomplished sculptor who had worked with Sydney Kumalo and Cecil Skotnes at the Polly Street Centre, but he is best known outside South Africa for his very fine draughtsmanship. Here, he plays on the idea of transformation from humanity to animality: the assassin on the right is in the process of taking on a dog's features while the one on the left is still indeterminate.

Aside from this, the artists, who came from different townships, did not spend much time together, which precluded the development of a Polly Street 'school' of painting. Skotnes' tutelage was much less aggressive than that of many teachers and sponsors during the 1950s and early 1960s, neither insisting like Margaret Trowell, Kevin Carroll and Kenneth Murray (see Chapter five) that students draw upon tradition nor like Frank McEwen that they conjure it, genie-like, out of a forgotten past.

Just as the idea of a clearcut European hegemony over the early workshops in Oshogbo (Nigeria) and Salisbury (Rhodesia) begins to dissolve on closer inspection, so it does too at Polly Street. In 1966, Skotnes left to pursue his own work fulltime and was replaced by Sydney Kumalo, who had already passed through his classes and was employed as a sports organizer at the centre. Kumalo, the first sculptor to train at Polly Street, was succeeded by Ezrom Legae, another ex-student, in 1968. Technically the centre was no longer 'Polly Street', having moved to new premises, but in actuality it was being perpetuated in a time-honoured African way, through the apprenticeship system in which pupil eventually becomes master. This was a kind of 'inside brokerage', no longer fixed in the old white tutor–black learner mould. The fact that the Triangle Workshop model could later succeed when transformed into the Thupelo Project by David Koloane and Bill Ainslie (like Skotnes a white artist who taught by example) was due not only to its intrinsic usefulness, but also because its *modus operandi* was already a familiar and accepted one in South Africa.

# Chapter 4    Art and Commodity

Anthropologist Bruce Lincoln argues that one problem with conventional high-art discourse is that it creates a major distinction between 'the privileged sphere of Art' and all other goods. As the case of McEwen and Zimbabwe stone sculpture demonstrates, one of the central tenets of this discourse maintained by museums, patrons and collectors is the difference between aesthetic objects made in response to an urge to create and those produced unabashedly to be sold. High or fine art, it is held, must be free of commercial motive because this reduces artworks to the status of household furniture. Historically, there have been two kinds of distinctions entangled in this belief, that between art (supposedly non-utilitarian) and craft (utilitarian) and a second between art (supposedly non-commercial) and commodity (commercial). Neither of these methods of categorization, which derive from European aesthetics and artisanal traditions, are, however, an accurate reflection of African cultural realities.

Before the intervention of European patronage in the nineteenth century, African art outside the major coastal trading networks was, as we have already seen in Chapter three, typically a local phenomenon. Masks, ritual sculpture and other highly valued objects were similar to what the anthropologist Arjun Appadurai calls 'enclaved commodities', circulated mainly through local patronage by traditional élites and members of various religious associations and performance groups. But to assume that no other exchanges ever occurred is to ignore the obvious routes opened up by war, trade and diplomacy, often before the advent of European colonization. It is therefore quite wrong to assume that the movement of art objects only began in the colonial period with the entry of African art into a global market. What is, however, undeniably true is that the global market is different from the local and regional one.

In the twentieth century, war, trade and diplomacy have gradually overshadowed a once-dominant local patronage as the means by which African art circulates. In the Nigerian Civil War of 1967–70 an unprecedented number of artworks were smuggled

84. Contemporary Benin head presented to the ex-American President Jimmy Carter by the Nigerian Government, 1997. This modern version of the well-known sixteenth-century copper-alloy casting of the Iya Oba or Queen Mother of Benin is a detailed, but smaller-scale replica of the original. Charles Gore has described the contemporary patronage of the Benin brasscasters' guild, Igun ne Eronmwon, which includes castings for presentation by the Oba of Benin to visiting dignitaries.

out of Nigeria and onto the world market. In a similar fashion the channels of diplomacy continue to be conduits for exchange. While the Africa Reparations Movement is attempting to convince British museums to return the Benin bronzes seized during the British Punitive Expedition of 1897 to Nigeria, the Nigerian government is giving away contemporary versions of the same bronzes as official gifts to various heads of state and institutions around the world. But it is trade – the global market – that has absorbed most postcolonial art production. For every piece of sculpture produced by the typical kin-based workshop for a local clientele, several more are made for export. Yet this is not a simple shift in practice but a very complex one, because it engages both the art–craft and art–commodity distinctions made by Western aesthetics.

84

In reality, every artwork, whatever the original motivation of the maker or its purpose, takes on the status of a commodity once it moves into a system of exchange. But artworld institutions, as the keepers of high culture, must maintain that artworks and commodities are two different kinds of thing. It has also led to the imposition of their own criteria for differentiating genuine artworks from commodities. One well-known African art museum declined to collect sculpture which had been carved with imported knives or chisels, since this apparently indicated a commercial tendency – a principle which would disqualify most Zimbabwe stone sculpture, since modern power tools are used to cut and polish the stone. On the other hand, Kamba sculptors in Kenya who are organized into large cooperatives to market their work still use adze handles faced with rhino hide.

In Africa, the issue is further complicated by the fact that the masks, figures and other objects identified as 'art' by Western collectors did not occupy this 'privileged sphere' in relation to other valued artefacts in the minds of the people who made them. To their African makers and owners, valuable objects were ones that possessed visual power and ritual efficacy. Furthermore, the value attached to both ritual objects and utilitarian ones depended on how successfully they performed their intended function. In that sense a shrine figure and a water pot were both 'functional' and therefore valuable.

In Africa, emulation of one artist by another was an integral part of the workshop system and an important part of apprenticeship. Also, precolonial workshops (as well as individual artists outside the workshop system) turned out an established repertory of forms which their patrons required. The upshot is that African artists who have not been exposed to Western high-art categories do not make the same judgments about either utilitarian and nonutilitarian forms or the continued replication of a known prototype which are crucial to Western assumptions about either art versus craft or artworks versus commodities.

As the social anthropologists Jean and John Comaroff argue, a commodity is 'not only a product but also the embodiment of an order of meaning and relations'. In an African workshop or cooperative the 'order of meaning' assigned to artisanal practice, and to the relations between producer-artists and consumer-patrons, is often very different from the image of African practice imagined by far-away collectors. Just as precolonial African art production has been idealized as part of the romantic image of a pristine traditional society, postcolonial workshop art has been dismissed by

the same collectors as commercial and derivative, and the differences between the two exaggerated.

The greatest difference between African and non-African assumptions about art and commodity can be seen where they are actually produced – in the workshop, the cooperative or the individual workplace. By contrast, it is where they are sold, be it a gallery, kiosk, street corner or illustrated catalogue, that an accommodation is attempted between producer and consumer, African artist and foreign collector. The dealer or trader is charged with bridging this divide and, once again, cultural mediation comes into play. All sellers have a strong interest in making their inventory desirable, which can either be done by appealing to various beliefs held by the buyer – that authentic art must be old, for example – or through the introduction of new 'stories' which the buyer may not have heard. This chapter considers the commodity question both at the site of production and as a problem of reception, but these are not easily separable, since one influences the other. The other important starting-point is that artistic production of all kinds needs to be viewed through the lens of the culture producing it, and not merely through Western assertions of what constitutes 'traditional' art and what are merely goods.

*Old commodities and new*
Since the late-colonial period there have been three main kinds of artists' groups which produce for global as well as local markets – old-fashioned kin-based workshops, cooperatives (which may be either outsider-founded or within the community) and experimental, non-traditional workshops (usually supported by external patronage) such as Oshogbo, Nigeria (see Chapter two), Tengenenge, Zimbabwe, or the more recent Triangle-inspired workshops (see Chapter three). What they produce varies from souvenirs to versions of established traditional genres to new media destined for the gallery circuit, but most are organized in ways which reflect local patterns of authority and artisanship. The distinction between workshops and cooperatives is sometimes blurred: some contemporary cooperatives are just overgrown local workshops with someone who keeps written records of financial transactions. But despite their genealogical link, they differ from their smaller and more traditional counterparts in the degree to which they are removed from their clientele and the change in the 'order of meaning' which structures their relationship to clients. In a typical cooperative, most transactions are with middle-men traders and distant, foreign consumers, while relatively few

85. Christopher Steiner photographed this Kulebele (Senufo) artist carving a Dan-Ngere style mask in Quartier Koko of Korhogo, Côte d'Ivoire, in 1988. Carvers usually see their ability to copy anything, including a non-local style, as a proof of their professional competence, whether it is for a global market or for patrons in their own village. Steiner's research demonstrates vividly the connections between market demand and the creation of multiple ethnic styles and hybrid artistic identities.

involve the artists in an ongoing commitment to supply ritual objects or prestige goods to the community or its leaders.

Nonetheless, some workshops and indigenous cooperatives manage to do both. Yoruba family-run workshops in Nigeria are known for their resilient traditional practices, but as the demand for shrine sculpture and other accoutrements of *orisha* worship has declined, they have increasingly sought new sources of patronage. In the early 1990s, workshop sculptors from Oyo State in Yorubaland gathered together to form a professional association and rented an exhibition space in Ibadan. The hope was that potential clients would come to see their work and then contact the artists whose names and addresses were attached. This was clearly an attempt to reach beyond the limited local patronage and a pragmatic recognition that art, once it is exhibited for sale, takes on a commodity status, with a changed 'order of meaning' between artist and client.

In Korhogo, Côte d'Ivoire, the postcolonial production of Senufo sculpture by Kulebele, a hereditary sub-group of specialist carvers, has evolved similarly into different art-market niches, but much more systematically than in family-run Yoruba workshops. Although in the past, patronage of Kulebele sculptors was dominated by the Senufo men's society, known as Poro, since the late-colonial period Hausa middlemen have succeeded in creating a successful bridge to the European art market as well as to tourists in Abidjan, the capital. As a result, there is a status hierarchy among carving groups based on different types of patronage, which in turn depends upon the level of carving skills.

When Dolores Richter studied the Kulebele carvers in and near Korhogo from 1973 until 1975 she found three types. First there were the barely competent 'hack' carvers and teenagers who would not have been carvers at all had there not been a tourist market. Their masks, which most could produce at the rate of one a day, would be unacceptable to local Poro society patrons as well as to knowledgeable foreign collectors and were suitable only for sale to the most undiscriminating tourists. At the middle level were carvers who were technically competent, but had a narrow repertory and unremarkable personal style, and produced the bulk of their work for the tourist and overseas market and a few traditional commissions. But the most interesting are the most accomplished carvers whose work was admired and discussed. They produced the carvings needed in Poro rituals as well as major pieces commissioned by Hausa, Senegalese and French dealers. They were also the *tamofo* (masters) of the apprenticeship system. Richter has argued that in their case, the export art market, rather than detracting from the quality of their work, actually improved it since it allowed them the opportunity to carve full-time and thus increase their technical skills. In other words, while commodification has lowered the overall quality of Kulebele carving (since there are now many more mediocre carvers than in the past), it has had the opposite effect on the best artists.

The same argument can be made for workshops and cooperatives where there is no traditional patronage at all, such as Kamba carvers in Kenya. The best carvers pay their dues to support the cooperative but have nothing to do with the production of ordinary curios. Instead, they only work on commission for Nairobi galleries or private clients, producing complex pieces which can take several weeks to complete and sell for high prices. Sculptors who do this kind of work describe it as onerous, since it exists outside the established repertory of the cooperative and

27

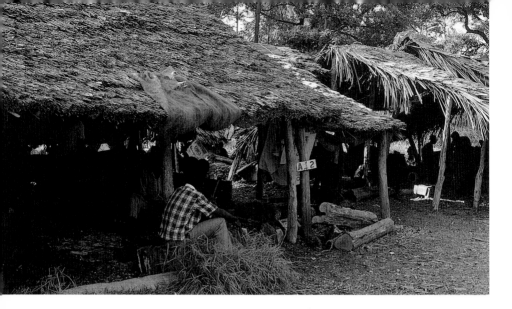

86. Kamba carvers at shed A-2 of the Changamwe cooperative outside Mombasa, Kenya, 1991

requires a good deal of mental as well as physical skill. In contrast, teenagers and the lowest-skilled cooperative members carve trinkets, salad spoons and napkin rings or polish finished carvings, but even though their remuneration is small, it is still much higher than the wage of a common labourer and the working conditions are much more congenial. There are, however, many carvers in between these two levels of competency.

Despite the fact that two of the three main cooperatives are located in the biggest urban centres of Nairobi and Mombasa, recruitment is typically based on kinship ties in Ukambani, the Kamba homeland. Even the very large Kamba cooperative at Changamwe outside Mombasa, which has well over a thousand resident carver-members, is organized into small sheds of less than a dozen men. These groups often stay together over many years and essentially replicate the conditions of the family workshop widely found among African cultures with a long woodcarving tradition, from the Yoruba in Nigeria and Benin to the Makonde in Tanzania and Mozambique. It functions as an informal apprenticeship system with the passing on of technical skills, as well as genre specialization, from the senior to the newer members.

What is unusual about the Kamba case is that these highly organized artisanal practices did not exist until the 1960s, although workshops had gradually developed following World War I. In the nineteenth century within Kamba culture there were at least two models of highly skilled artisanal practice – the blacksmith

and the ivory carver. The Kamba were known as both elephant hunters and ivory traders, out of which both their skill in ivory carving and their entrepreneurial awareness developed. And prior to the large-scale importation of beads through trade late in the nineteenth century, Kamba blacksmiths produced fine chains and other metal adornment which they exchanged in the Central Highlands and Rift Valley of what is now Kenya. Even during the Mau Mau revolt in Kenya in the early 1950s, Kamba who were held by the colonial government in detention camps spent their free time carving.

### The puzzle of Maconde sculpture

In contrast to Kamba artists in Kenya, who mainly produce highly naturalistic animal sculpture, the Maconde (also Makonde) sculptors of Mozambique and Tanzania raise awkward questions for Western museums regarding the entangled issue of commodification. Because Kamba work is marketed through cooperatives and is straightforwardly geared towards the curio market in Kenya and abroad, it sits mainly on the commercial side of the art/commodity divide in Western classification. But Maconde sculpture has a long history, with precolonial examples in many ethnology collections which predate its entry into the export market. It is produced by sculptors in small family groups, who regard themselves as having a deep cultural connection to their work, regardless of its intended audience. Since the 1930s, they have been economic and political migrants moving from northern Mozambique to Tanzania, but most of them have resisted commercial opportunities to produce curios according to specifications from patrons in the manner of Kamba carvers in Kenya or neighbouring Zaramo in Tanzania. They also held fast to Maconde marks of identity, continuing to file their teeth, wear the upper-lip plug and display elaborate facial scarifications long after these customs had disappeared regionally. Regardless of this apparent cultural conservatism, their contemporary sculpture is dominated by forms that are radical departures

87. (above) The Maconde sculptor Samaki in 1970

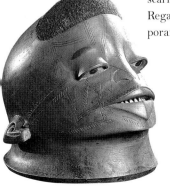

88. (left) Maconde *mapico* (*mapiko*) mask for initiation ceremonies. The same facial tatoos that appear as beeswax additions on *mapico* masks also appear on the face of Samaki (above, left), the best-known of the immigrant Maconde artists from Mozambique active in Tanzania during the 1960s and 1970s.

from their precolonial art. This new genre and style, called *nnan-denga* in the Kimakonde language, but better known by the Kiswahili terms *jini* (from the Arabic *djinn*) or *shetani* (satan), began to appear in Tanzania in 1959, beginning with the work of Samaki (Samaki Likonkoa). Unlike the angular realism that had characterized much precolonial Maconde figure sculpture and the earliest figures produced for Portuguese colonial administrators, the new sculpture was sinuous, anti-naturalistic and frequently employed erotic and social caricature.

Although seemingly a new sculpture genre and certainly a new style, the iconography of *nnandenga* was drawn directly from Maconde oral traditions concerning nature spirits and from a masquerade of the same name performed on the Maconde Plateau in Mozambique. Yet, despite traders' claims to the contrary, no Maconde person would purchase or use such a figure: they were made explicitly for non-Maconde patrons and therefore intended as art-market commodities. Even so, the Maconde played little or no entrepreneurial role in their sale – there were no Maconde traders hawking carvings to tourists on street corners or beaches. Their marketing success was made possible through the promotions of Mohammed Peera, a knowledgeable curio and gemstone dealer in Dar es Salaam who, like Tom Blomefield in Rhodesia a few years later, encouraged carvers to find their own direction.

The Maconde have bifurcated their art production unlike the West Africans (e.g., Yoruba and Senufo) whose precolonial mask and figure genres have been introduced as commodities into wider circles of exchange or the Kamba who did not make ritual sculpture and whose work is therefore for non-traditional patrons. Maconde *mapico* initiation masks continue to be made and used by Maconde themselves while the new genres (the bulk of their production) are made by the same group of artists for a completely different audience. This has caused a good deal of ambivalence in Western art circles since Maconde sculpture therefore does not fit easily into either an 'art' or a 'commodity' designation. Some European museums, especially in Germany and France, have admitted contemporary Maconde sculpture to 'the privileged sphere of art'. A Maconde sculptor, John Fundi, was included in the high-profile *Magiciens de la Terre* exhibition in 1989 in Paris, but in the equally important *Africa Explores* show in 1991 in New York, Maconde art was effectively divided into two irreconcilable entities – initiation masks from Western collections were featured as fine examples of 'traditional' art while contemporary Maconde genres were omitted from the exhibition, and only mentioned

dismissively in the catalogue as a 'fantastical[ly] misshapen...ersatz style' which 'responds to the Western buyer's admiration of uniqueness and authorship.' In this kind of summary judgment, Maconde sculpture is not treated as the work of individual artists, some of whom are master sculptors worthy of our attention and others more mediocre followers and imitators, but is rejected categorically because it is made for non-Maconde patrons. It is also wrongly assumed to have no connection with the culture from which it springs. Its commodity status casts it into a limbo from which it is difficult to escape.

To overcome this problem, enterprising dealers frequently try to authenticate Maconde sculpture by creating narratives around each piece which are sold as texts along with the sculpture. One Nairobi gallery owner believes that the hidden meaning of Maconde sculpture is revealed by allowing it to cast its own shadows. He therefore exhibits his sculptures using special lighting. The same dealer employs local Kenyan artisans to put a high polish on the ebony (African blackwood) which Maconde artists leave in its natural state. In myriad ways Maconde art has been subjected to continual reinvention by both its supporters and its detractors.

89. Maconde sculpture in the National Arts of Tanzania Gallery, Dar es Salaam, 1971. Curatorial reservations about non-figurative Maconde sculpture are based partly on its radical departure from early colonial examples found in ethnology museums. It makes no attempt to comment upon or emulate older Maconde forms. It also stands outside the stylistic range of pre- and early colonial African sculpture, running counter to established tastes among collectors of canonical African sculpture. Collectors of modern Maconde art are very rarely collectors of 'classical' genres.

*Crossing the art–craft boundary*

There are cooperatives of weavers, dyers, calabash or basket makers, but what is most relevant here are those cooperatives that produce artefacts that can cross the boundaries separating 'craft' from 'art' in terms of their reception by a Western audience. Roughly speaking, these are artefacts that qualify as representations – sculpture and pictorial media. In their facture, replication from one form to another is inexact and variation a natural occurrence. In addition, the artist's hand is more visible in the end product than in, say, weaving (though it is visible there also, to an experienced eye). For these reasons, sculpture and pictorial representations have the potential to be seen as art by a Western audience which views uniqueness as the *sine qua non* for an object to transcend craft status. Cooperatives with their very egalitarian nature and their emphasis on production seem to work against this goal.

Two of the previous examples (Kulebele and Maconde) have involved a partnership between kin-based carving workshops and local traders or dealers who market their work beyond the region. The Kamba cooperatives are organized specifically to produce and market their own carvings and earn income for their members so are more independent and entrepreneurial than the family workshops. Cooperatives of a different kind were set up with the assistance of outsiders, usually as a community development project. International aid organizations and volunteer services have made such cooperatives part of their income-generating strategies for both rural people and urban migrants and many of these focus on recruiting women artists.

The severe financial constraints under which so many unschooled artists must work is made even more complicated by the social position of most women as men's dependents, even if they are financially self-supporting through their own labour. They are often not free to attend workshops or join cooperatives without the consent of a male family head. And even with such permission, if a woman does not have her own source of income she may be unable to join because she is not able to pay the modest fees for materials or membership dues. Yet some women do persevere against these odds and become artists by joining training centres.

Cloth is easily commodified (in the past it was even used as a currency) and usually remains on the craft side of the art–craft distinction found in Western aesthetics. But it is also capable of being used as a one-of-a-kind pictorial or narrative medium, and can acquire the distinction of being 'art' according to the criteria used by museums and collectors. One of the best-documented

examples of this was a project started by a German art teacher, Ilse Noy, who went to Zimbabwe in 1984 with the German Volunteer Service to work in a weaving cooperative. Between 1987 and 1991 she worked at Weya, a Shona-speaking communal area (former 'native reserve'), 170 kilometres north-east of Harare, where she and Agnes Shapeta, a local dressmaking instructor at the Weya Community Training Centre, taught women to make narrative compositions using various techniques – to be story-tellers and 'artists', as well as seamstresses. The problems they encountered were formidable. An earlier dressmaking project had failed because women could not afford the necessary investment in a sewing machine, and the cost of cloth alone was frequently as much as a factory-produced dress. But in addition, their rural neighbours were too poor to buy the dresses they had made.

In retrospect, Weya turned into an art workshop once it had been decided in 1987 that the machine-sewing courses should be dropped and replaced with hand-sewing techniques which did not require any expensive equipment. Ilse Noy had originally wanted to develop a training course based on traditional pottery or basketry techniques, but women in the Weya area did not produce either. The crafts they knew, which reflected the European-derived artisanal skills women were encouraged to learn under the former colonial state of Southern Rhodesia, were knitting and crocheting. Noy realized that however skilful these goods might be, they did not look 'African' to an expatriate or foreign buyer and therefore had no chance of being marketed outside the local community.

What happened next is paradigmatic of a workshop situation led by a cultural outsider – the introduction of a borrowed idea from outside the repertory of knowledge available to the local participants. In this case it was African, but from a different part of the continent altogether – Noy read about the appliquéd textile compositions produced by Fon artists in Abomey in the far-off Republic of Benin. She reasoned that the handsewing skills of Weya women could be applied to the appliqué technique, which could be produced as wall hangings in the form of pictorial compositions.

At first the women who had come to learn practical hand-sewing resisted the new genre. Many dropped out and those who stayed were very sceptical, some because of its strangeness and others because they found it hard to believe that anyone would buy the wall hangings. The women had no previous experience of visual representation, and had to teach themselves how to shape figures and arrange them in meaningful compositions. But

90

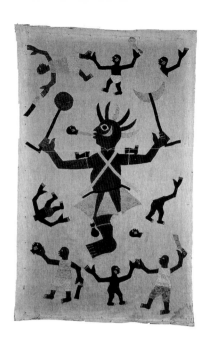

90. Fon appliqué cotton
textile, Republic of Benin,
1982

perhaps because it was clear from the start that the buyers for
these works were not going to be local people, the women adopted
a social documentary approach – depicting not only domestic
village scenes of people and animals, but also sex, prostitution,
witchcraft, drunkenness and anything else around which a pictor-
ial narrative could be constructed. Many of the subjects are openly
transgressive – topics women would never speak about in public
or in the presence of men. Here the role of the workshop coordina-
tor obviously came into play: the women were not admonished to
stay within accepted social codes for female behaviour, which
would have precluded their representation of tabooed subjects
such as male and female nudity, people urinating, etc., so with the
workshop's encouragement they came to focus on stories that
reflected some of their most powerful personal experiences.

In the Weya work there is less compositional sophistication,
and less realistic modelling of figures than in the work of untrained
urban artists such as the Kinshasa painters. This is partly due to
the technical limitations of cloth appliqué and partly due to the
less frequent exposure of rural people to the variety of pictorial
icons – in magazines, newspaper supplements, billboards – which
are ubiquitous in the city. This means that Weya art conforms
closely to Western notions of 'folk art', a category which the urban
paintings resist. Another difference is that the appliqué technique

does not lend itself to the use of text and so as a result the story itself is not inscribed into the picture. To explain the often very complex narratives to customers, the texts may be written down separately on a piece of school notebook paper and sold with the picture. In Noy's book on Weya, the texts are as important as the compositions themselves.

The themes in Weya art are as wide-ranging as those of urban popular paintings in Congo (Zaïre), but the major difference is that these artists are seeing the world through their experience as rural Zimbabwean women. Nerissa Mugadza depicts the problems of the unmarried woman, who is not only marginalized socially, but is also a source of danger to her family:

*If the person is not married (and has no child), maybe there is something else in this family causing her to be unmarried. When she dies maybe she will wake up as a ngozi (spirit), saying 'Why did you not sort out your problem, leaving me to die like that?'*

91. **Enesia**, *Drinking Beer*, 1989. In the words of the artists: 'People are drinking beer [top]...old men are in love with little girls because the old men are drunk [centre, left]. They are urinating outside the toilet [centre, right]. Now the men are fighting for a girlfriend [bottom, left]. They are going home and some are falling down [bottom, right].'

MUGADZA WEYA

92. (above) **Nerissa Mugadza**, *Life of an Unmarried Woman Who Has No Child*, c. 1987

93. (opposite) **Mary Chitiyo**, *Kuoma Rupandi and Committing Suicide*, c. 1989–92

In the top left of the picture a woman is carrying poles to build her house and in the next panel she is using grass to thatch it herself. Below, and presumably later, she is lying dead and others are sitting with her corpse. In the last panel she is carried to her grave to be buried with an empty maize cob because she is childless.

The stories range from prosaic descriptions of daily life to melodramas of good and evil. One source of conflict for these women is the love triangle – husband, wife and girlfriend (or husband, older wife and new wife). In Mary Chitiyo's sadza (maize-starch resist) painting, *Kuoma Rupandi and Committing Suicide* (c. 1989–92) eight narrative panels are read from left to right and top to bottom in a morality tale of greed, faithlessness, healing, retribution and death. In the first panel, husband and wife are cultivating the fields, in the second he transports the maize to the Grain Marketing Board by ox cart. The third panel shows him giving some of the grain cash to his girlfriend and receiving *mupfuhwira* (powerful medicine used to make or destroy a love relationship) from her. In the fourth panel the wife, the dog and the cat have been stricken and paralyzed by the *mupfuhwira* which the husband put in the stew. The fifth panel shows her being cured by a

*116*

n'anga (diviner) and then in the sixth she is learning to use a sewing machine so that she can become a dressmaker, while her estranged husband and his girlfriend, both now barefoot and without money, pass by. In the seventh panel the contrite husband returns home, only to be spurned by his wife and even the family dog. In the final panel, distraught, he hangs himself from a tree.

The punishment of greed and moral weakness in these pictures is a common theme in such diverse artistic expressions as Weya art from Zimbabwe, Mami Wata and other paintings from Congo and the Yoruba travelling theatre performances of the 1970s (see Chapter one). In all three cases the punishment is accomplished by superhuman intervention – for the Yoruba, it was the *orisha* (the gods) who appear in the finale of the play to seal the fate of wrongdoers; in Congo, the Christian gospel, and in Weya art it is the *n'anga* (a diviner-priest). But while the artist Cheri Samba depicts himself making a moral choice between good and evil, Chitiyo illustrates the inevitable outcome of moral weakness that causes so many men to make the wrong choice.

94. **Valente Malangatana**, *The Last Judgement*, 1961. Malangatana's apocalyptic, but constantly energized, view of life has not been reserved for his religious and moral subjects alone, but even extends to such topics as visits to the dentist. He is one of the very few artists who rose to fame in the early 1960s and are still actively turning over new ideas. While he has probably never met the Weya women, everything about him, from his views on art (he once taught children) to his political activism, suggests that there would be instant mutual understanding and affirmation.

95. **Filis**, *Village Life*, c. 1987. A 'Malangatana' painting in which the composition is richly dense with overlapping figures and buildings. Its main technical problem is that the artist has not yet grasped the convention for depicting faces realistically in profile, though she tries out several unconvincing solutions.

The earliest efforts were in cloth appliqué, but after its establishment as a viable artform, gradually Noy introduced other techniques into the training centre – painting on board, *sadza* (maize porridge) resist painting, drawing and pictorial embroidery. Embroidery was impractical because it was so labour intensive that artists could not realize a fair reward for their work. Painting, although totally foreign to all the participants, became popular very quickly because it was easy to execute. And although they did not employ the use of parallel text like the Congolese (Zaïrean) painters, they were able to introduce signage into the compositions. The painting group, once established, initially produced monotonously similar pictures of village life, which did not sell well in Harare – for one thing, they contained much empty compositional space, which the women filled in with dots and lines, not knowing what to do with the background. To inspire them to produce denser compositions, Noy showed them reproductions of paintings by Valente Malangatana, the well-known Mozambiquan painter, so they began to work in a new, richer compositional style which they dubbed 'Malangatana'. As with the Abomey appliqué cloths, it was Noy's intervention that provided the women with an outside model, one which was unquestionably African, but far

94
95

96. **Mary**, *Problems of Transport,*
*c.* 1989

removed from their visual experience. The models were not chosen
for either their historical or their ideological affinity with Weya art
– they were chosen to demonstrate what 'works' in artistic terms.

Not all successful paintings were crowded 'Malangatana'
compositions – some employed areas of empty picture space, but
minimized these by including several focal points of action. In
*Problems of Transport* (*c.* 1989) an exuberant artist called Mary
comments wryly on one of the difficulties that lie at the heart of
rural life and in doing so rivals the work of Moke, a Congolese
urban artist. Moke's rendition of an 'express taxi populaire' shows
a mastery of anatomy, modelling in light and shade, and certain
aspects of linear perspective while Mary's figures are like appliqué

cutouts, the perspective is vertical, and only the large bus, 'Suffer Continue', appears to be rendered in space. But the narrative, read from top left to bottom right, is as revealing of the African condition as Moke's – people wait for a bus, it breaks down, leaving one man to hire a wheelbarrow to transport his pregnant wife to the rural clinic fifteen kilometres away, while some of the other passengers trudge back to their village in the rain and others crowd into the back of a Mazda pickup truck.

While most of the compositions by Weya women deal with the dramas of domestic problems and rural life, many of the Weya artists experienced the Chimurenga, or war of liberation, against the white minority government of Ian Smith, and the social disintegration which accompanied it. But there are dangers associated with depicting politics as art, here as well as elsewhere. Certain topics have emerged as off-limits, although not within the workshop, but at the point where they are marketed in Harare. During the guerrilla war, accusations of selling out to the enemy, or of witchcraft directed against the struggle, were common and were punished summarily by freedom fighters ('comrades'), but narratives other than the official version of the war of liberation

98

97. **Moke**, *Street Scene*, 1990

are not accepted for exhibition in galleries, or for sale in marketing outlets. Weya was an area of heavy fighting, but the women have to keep these stories out of their art.

In summary, the Weya workshops between 1987 and 1991 resembled many earlier workshops throughout the continent in at least four ways – they recruited individuals with little or no formal art training; they were founded and coordinated by a cultural outsider; their pedagogy focused on instruction in basic technique in non-traditional genres; the workshop's products were not intended for local audiences, but were aimed at an élite market in an urban capital or abroad. However, in two important ways they were different – the artists were women and unlike most work-shops, Weya has been a long-term phenomenon, a community training centre whose set up more closely resembles a cooperative.

All of these realities have contributed to the level of commodi-fication of Weya art (which has appeared most recently in the form of hand-painted one-of-a-kind coffee mugs in Starbucks coffee shops in the United States). The conditions of cultural production deeply affect the way artists think about their work. The Weya women worry about what will sell in Harare, because they use this income to lift themselves out of poverty – to pay for food, clothing and their children's school fees. This uncertainty and lack of individual recognition heightens anxieties about success and failure. Although some of the Weya artists earn as much as secondary school teachers, they have no guaranteed income. This unpredictability, as well as their lack of educational qualifications, causes them to associate artmaking with the conditions of uncertainty and poverty and to hope that their own daughters will attend secondary school and become nurses or teachers rather than artists.

These psychological constraints also have a great deal to do with how artists view the creative process. It is difficult to prize originality when driven by the need to sell, and similarly hard to imagine the artist as a lone creator when involved in group production. Furthermore, success and failure are often linked in ordinary people's minds not only with diligence and hard work, but also with some form of superhuman intervention on the artist's behalf. Many studies assert that success in contemporary African terms is usually thought of as a 'zero-sum game'. Every win must be offset by someone else's loss, which can trigger jealousy and witchcraft accusations.

In small, kin-based groups such as the immigrant Maconde carvers in Tanzania or the old-style Yoruba carving workshops in

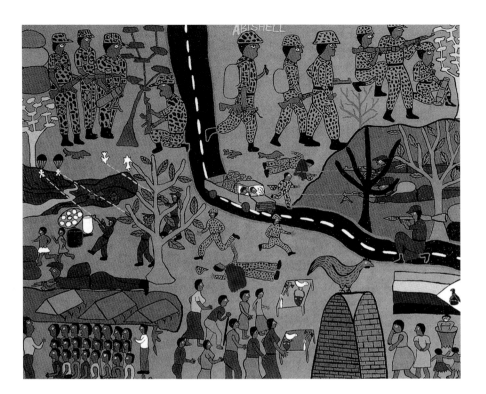

98. Abishell Risinamhodzi, *Chimurenga, c.* 1989. This idealized version of the War of Liberation depicts freedom fighters shooting down parachutes and aeroplanes as well as attacking a truckful of Rhodesian soldiers on the road. In a reversal of conventional pictorial perspective, the Rhodesian soldiers at the top are larger ('closer') than everyone else, while at the bottom small figures of men and women participate in the first free elections following the cease-fire agreement.

Nigeria, mutual ties of obligation are very strong. Personal animosities, when they arise, have to be contained. But in newly formed groups such as Weya, where artisanal workshops are not part of the community's experience and people may be working together for the first time, there are jealousies and anxieties both within and without. The women's earnings set them apart from other members of the rural community who have little or no access to money. Unmarried women artists become particular targets of village criticism – one young Weya artist told Noy that, 'If we live here some of the people can kill me because I am earning more money and I am so young.... The *n'anga* gives me the medicine to protect my body.' In 1990, the two painting groups which were dominated by young unmarried women decided to leave Weya and to work together in Harare, far from family obligations and village conflicts. These kinds of fissions and fusions are common in workshops and cooperatives and serve as a reminder that with or without commodification, all workshop artists work in complex creative environments which deeply affect what they produce.

# Chapter 5     The African Artist: Shifting Identities in the Postcolonial World

*Creativity as the child of facture*

The strikingly different attitudes towards facture – the actual process of making – among different types of contemporary artists across the continent reflect not only their modes of training, but also their experience of patronage and the degree to which they are familiar with art and artmaking beyond their own communities. There is no simple way to chart or explain all of these differences, but it is possible to make certain important connections. For example, it would be difficult for one of the Weya workshop artists (see Chapter four) to define herself as an 'intellectual', given the fact that in rural Zimbabwean life, intellectualism does not exist as a recognized social category. There even the designation 'artist' fits awkwardly with being young and female, although the success of the Weya women has begun to change that assumption locally. On the other hand, colonial education opened up radical new possibilities of self-definition by situating artistic practice in a new relationship to pedagogy. In African countries, as elsewhere, universities are the breeding-grounds for the intellectual class, and authoritarian governments fear them, which gives students a much greater sense of their potential and power to effect change than in Western democracies. Where the training of artists is part of the curriculum, they too are caught up in this euphoria of self-invention.

    This sense of potential invested in the young and well educated, which in most African states reached its peak in the 1960s immediately following independence – although it still exists in a more tempered form – has a double-edged significance. It is largely responsible for the vitality and adventurousness seen in the best work by academically trained artists, but because of its connection to a highly developed self-awareness, it also accounts for occasional pretentiousness and self-absorbed rhetoric. Any fair assessment of the role of African artist-intellectuals must take into account this same range of talent and creativity as found among untrained and informally trained artists.

A formal art-school education does two things in addition to the creation of this artistic consciousness: it offers a mastery of techniques which take time and practice, but also specialized materials and equipment, and confers some level of familiarity with world art history. These experiences distinguish the formally trained artist from their untrained or informally trained counterparts. Taken together, they inculcate both a sense that artmaking is a true profession in which one is qualified through a long and demanding course of study, and the Western-derived ideology that to be significant, artworks must place a high premium on originality and uniqueness (unlike either traditional African genres or commodified forms, both of which situate originality within the boundaries of a prototype).

Training, or the lack of it, deeply affects attitudes towards originality or its opposite, emulation. In an apprenticeship there is a pre-existing set of models which the aspiring practitioner must learn to emulate and it makes little difference whether it is a traditionally organized kin-based workshop or a much larger, modern cooperative. On the other hand, in a short-term workshop in which participants are more or less of equal status, everyone except the organizer is cast into the role of a learner, and replication is usually discouraged as a matter of principle. In art-school instruction, which is more highly structured, more comprehensive and longer term than the workshop, students receive a mixed

99. Makerere student finalist preparing for painting exhibition, Kampala, Uganda, 1996

message – do not slavishly copy, but, on the other hand, here, in the art-history lectures, is the significant art which has changed the course of history... learn from it. Students are encouraged to develop a knowledge base that situates their practice within a wider and longer art history than any workshop or untrained artist usually encounters. In the best schools, it includes African art history as well as European and Asian, which in turn creates its own pedagogic issues: the development of a more pan-African sensibility, but also the tendency to folklorize unfamiliar traditions. Finally, the relation between art-school students and teachers is firmly lodged in African notions of respect for authority which permeate all levels of schooling and which reach back into the much older pedagogy of apprenticeship.

As young intellectuals, these students also develop an awareness of the postcolonial condition. Some student artists become so mired in the implications of this that they substitute a politicized notion of 'origins' for the less certain outcomes of solitary experimentation. One such case was the Ecole de Dakar, discussed in Chapter six. Others engage in what David Hammond-Tooke, a South African curator, calls 'highly personal attempts at psychotherapy'. A few are able to break through this intensive self-consciousness and see beyond themselves, but they constitute quite a small vanguard, working for the most part in isolation, or in small experimental settings which resemble either the workshop or the apprenticeship model. Laboratoire AGIT-Art 10 in Senegal exemplifies an egalitarian worksite while Bruce Onobrakpeya's Ovuomaroro Art Studio in Nigeria, with its students and assistants, more closely approximates a master-apprentice model.

By contrast, non-academically trained artists are simply not encumbered in this way: their encounters with Picasso or with contemporary art in far-flung places is haphazard rather than academic. Those who are 'discovered' by critics and collectors are often sent abroad to participate in symposia or international exhibitions such as *Magiciens de la Terre* in Paris in 1989 and *Africa Explores* in New York in 1991. The scenario in that case is the hoped-for dialogue between authentically 'naive' artists and 'sophisticated' foreign critics and audience, which frequently, in fact, reveals the sophistication of the artists and naiveté of the critics and audience. Conversely, world art occasionally comes to them, either from books or travelling exhibitions. As we have already seen in Chapter three, Frank McEwen, the first director of the National Gallery of then-Rhodesia and well connected in the

100. Objects of Performance,
Laboratoire AGIT-Art, Dakar,
Senegal, 1992

art world from years spent in Paris, arranged for a travelling
Picasso show to come to Salisbury in the early 1960s. Thomas 101
Mukarobgwa remembered it well, although he saw Picasso not as
one of the great paradigm-shifts in Western art history (since he
did not have that kind of academic knowledge), but as a moral
exemplar, someone whose worth lies in the fact that he did not
copy other artists. Mukarobgwa's aversion to emulation came
from his long membership in the Workshop School, where
McEwen's primary injunction was 'never copy!' In a 1996 inter-
view he explained:

*Picasso, he was doing a straight thing from his mind. He didn't used to
look in the book anyway. People [artists in Zimbabwe] are now looking
at the work of Picasso and trying to do some of those things now. But
it won't work, you see what I mean?…there are quite a number of our
children who never grow out in the bush and who never see the natural
things in the bush. They've grown in the city, became older…without
seeing the bush very much…. You can see women even now trying to
stretch their hair and become white. You can't compare with someone
out in the bush. It's different. So those kinds of women, one from the
bush, one from here [Harare], they do different thing. I think this
[imitation of things foreign] is what spoiled the people when they
are doing their work.*

Picasso is an all-encompassing symbol in the minds of many African artists. The Sudanese painter Ibrahim El Salahi says that he applied the lesson of Picasso's Cubism to break apart and reconstitute Sudanese calligraphy. In Senegal in the 1960s, poet-President Léopold Senghor tried to convince artists at the Ecole des Beaux-Arts that Picasso was the best role model for them because he had helped invent modernism while retaining his Andalusian cultural identity. At Makerere Art School in Uganda this mediation has come most recently through the influence of artist-teachers such as Francis Nnaggenda who, trained in Europe, has continued to pose for himself some of the problems raised initially by Picasso and Braque with analytical Cubism. Those issues, now several times removed, have been picked up nearly a century later by Nnaggenda's students and appear in their own work. Given Picasso's well-publicized receptivity to African sculpture in his early visits to the the Musée Trocadéro in Paris, it is especially ironic that the ghostly presence of African forms in the work of a European artist from the early twentieth century should have filtered back into contemporary African art practice by this circular route, from colony to metropole and now back to the postcolony.

101. (below, left) **Thomas Mukarobgwa**, with work in progress, 1996. Mukarobgwa always followed the practice of 'doing the thing straight from his mind', and therefore admired and spoke of Picasso's independence, but did not treat his work as a specific source of ideas.

102. (below, right) **Kizito Kasule Maria**, studio painting in progress, 1997. This treatment of the Mother and Child theme by a young artist who has studied with Nnaggenda retains Picasso as a distant iconic authority though its more immediate sources are closer to home at the Makerere Art School, Uganda.

What this throws into sharp relief is not only the difference between academically trained artists who see themselves as part of an interconnected web of world art and those whose sense of artistic identity is very localized, but it also reveals an attitude towards the exemplary which is radically different from the Euro-American one. Far from regarding emulation as a mark of weakness, it was – especially in the formally structured apprenticeship – until very recently a sign of competence. And far from there being negative connotations to copying the work of a master, it was, and still is, a form of respect and therefore worthy. It was also pragmatic, a solution which was seen to work.

Western notions of originality sit uneasily in such a situation because they require the rejection of African cultural models of how teaching and learning take place. In this sense African practice is culturally much closer to Asian than to contemporary European models. While African art-school students do absorb notions of one-of-a-kind originality, these are deposited upon a foundation of early learning that stresses emulation as the proper and natural path towards competence. In an effort to banish such notions, not only art schools, but also workshops, run in the 1950s and 1960s by expatriates inculcated the importance of originality

103. (below, left) **Picasso**, *Seated Woman*, 1927

104. (below, right) **Francis Nnaggenda**, untitled studio sketch, 1997. It would never occur to Nnaggenda to emulate Picasso in any direct way, but he nonetheless continues to use the lessons of Cubism to work through certain technical issues in his work such as how to represent the interpenetration of the mother's gaze with that of the child on her lap.

and that it is wrong to 'copy'. Such cases were not just the sancti-monious imposition by expatriates of the tenets of modernism: they became part of a constellation of ideas which African intellec-tuals themselves promoted. In East Africa, the artist Elimu Njau's widely quoted dictum became, 'Copying puts God to Sleep'. But the fact that such declarations were required at all is proof of the problematic nature of emulation.

*Art for whom? Acceptance and denial of its commodity status*
The attitudes towards selling art further exacerbate the differ-ences in artistic self-consciousness between artists who have been academically trained and those who have not. Artists working in cooperatives have a clear goal when they make something – it is to be sold. Its commodity status is therefore unambiguous at all stages in the creation process, but art-school training is a good deal less candid on this point (as it is also in the West). The com-modity status of the artwork is clothed in, and even denied by, a rhetoric which says that art is created as an act of self-realization for the artist. What eventually happens to it once it is completed is treated as a secondary issue. At the same time, it is obvious to all students that one of the main measures of success for an artist is the recognition which comes from having his or her work collected, which is to say, purchased. So the work's commodity status is simultaneously affirmed and denied. The unsettling nature of this premise was expressed in a discussion between the author and a group of Ugandan artists in 1996. The economic realities of the art market are very difficult to ignore in Uganda, a small country where a large number of formally trained artists struggle to survive in the aftermath of twenty years of chaos, civil war and the disappearance of art patronage. Yet several of the artists disagreed very fundamentally over whether art had to be market-driven at all.

FIRST ARTIST (an unidentified middle-aged female printmaker):

*Today we have to live on art. We have to be able to play the tune. Given your [means of] expression, you have to know what is 'flying' on the market.... In the end, you are producing art which is channelled along certain lines.*

SECOND ARTIST (Kizito Kasule Maria, a young male painter and sculptor):

*Dealers are saying to us, please do work like this, I want it to be with this approach. If you are the type of person who is one hundred per cent*

*independent in art, you are going to be rejected, you are not going to be 'advancing' in art. About the art being produced in Uganda, I can classify it in two categories: there is real art, which you produce with all your heart, you put it in your studio, if someone comes, you negotiate, if he doesn't give you money [he shrugs], he leaves the work.... There's another category. You produce cheaper work: instead of spending [a long time], you complete it in three days and sell that work cheaply. But this kind of art...is destroying real art.*

Patronage also affects the artist's self-awareness through the channelling of work by different types of artists into correspondingly different venues for it to be exhibited and sold. According to one criterion, used by both local art establishments in African cities and the average foreigner, work sold in places that call themselves a 'gallery', 'museum' or 'cultural centre' are automatically accorded the status of art. Paintings, batiks, carvings and other media which are sold by hawkers on the street, or by small traders in places like the Blue Market in Nairobi (an entrepreneurial haven of kiosks, which until it was bulldozed by the city council in July 1998 overflowed from the City Market), have a much more uncertain status. Scoured by both the local cognoscenti and tourists looking for 'finds', such places operate with very low overheads, correspondingly low prices and no gallery aura. Even serious galleries such as Tuli Fanya and Nommo Gallery in Kampala include a crafts section to help cover costs.

A third kind of postcolonial art venue, the 'boutique' (Nigerian pidgin: *butik*), mediates the gap between gallery and souvenir or craft market. Some, like Cassava Republic in Kampala (Uganda), are artist-entrepreneurs aiming at a tourist market for hand-painted cards, posters and T-shirts. Others, such as African Heritage in Nairobi (Kenya) and Ndoro Traders in Harare (Zimbabwe), are well-capitalized businesses which stock hand-made goods ranging from paintings and sculpture to nomadic jewelry, wire toys, baskets and textiles. Nonetheless, they retain the cultural rules of the craft market in which the individual artist's identity is submerged by an ethnic, group or regional identity.

The work of a university-trained artist such as Kizito is clearly out of place in the boutique, the city market and, most of all, on the street. Everything such artists have been taught, especially the denial of the commodity status of their work, militates against it being presented to the public as merchandise. The other major obstacle is the anonymity of the artist that customarily accompanies the sale of art in the street or market. The corollary to the

conviction that the work of art ought to be original and one-of-a-kind is that its maker ought to be recognized as an individual, not just as a member of a group. Galleries reinforce these convictions and are therefore the only venues that give due respect to trained artists' own ideas of selfhood and singularity. But there are few galleries in African cities which are not boutiques in disguise. This places trained artists in a difficult position – they either accept the policies and conditions of the local gallery or they resign themselves to exhibiting their work in the houses of friends or, increasingly, in galleries abroad. Those fortunate enough to teach in universities or run their own workshop-studios (such as Bruce Onobrakpeya in Nigeria) develop small circles of disciples and admirers who create the profile needed for direct patronage. However, many trained artists are cut off from the public by the

105. **Adebisi Fabunmi**, *The Birth of Oshogbo*, 1977. Fabunmi emerged as a highly original printmaker in the 1964 Oshogbo workshop and began to experiment with yarn compositions in the late 1960s. Here, the yet-to-be town of Oshogbo is enclosed inside the womb of a monkey-like animal, its circular body repeated in egg-shaped forms arising from its head.

106. **Yinka Adeyemi**, *Baboon Hunter and Magical Antelope*, 1977. Yinka was not one of the participants in the Oshogbo workshops run by Georgina Beier, but was trained by Susanne Wenger in the art of batik which she practised herself. Like several other Oshogbo artists, he uses fantasy architecture as a setting for encounters with creatures from the spirit world, but also incorporates the human subject.

scarcity of acceptable exhibition spaces, which makes them a beleaguered, if privileged, minority.

Those who are workshop-trained, especially in Nigeria, have seemingly blurred the differences between themselves and academically trained artists by both their critical and their financial success on the international art circuit. But for many years the Nigerian cultural bureaucracy denied them that recognition. During the planning for FESTAC, the Second International Black and African Festival of Arts and Culture held in 1977 in Lagos and throughout the country, there was an attempt (later overruled) to exclude workshop artists altogether. The festival was supposed to highlight Nigeria's official commitment to the arts, but workshop artists found themselves left out of the bureaucratic vision of 'traditional' and 'modern' art exhibitions, the former consisting of the treasures of the National Museums in Jos and Lagos, and the latter of the work of art school-trained artists.

The apparent invisibility of artists such as Adebisi Fabunmi, Yinka Adeyemi and Jimoh Buraimoh, despite their by-then international recognition through the Oshogbo workshops a decade earlier, exposed the sharp cleavages between the official and unofficial versions of Nigerian art. In the government's vision of

105
106

*133*

art in the late 1970s, the minds of cultural bureaucrats were still comfortably focused on the seemingly sharp and irresolvable contrast between tradition and modernity, the dominant cultural paradigm of the early 1960s when they had been students themselves.

This 'two worlds' approach is echoed in numerous writings of the pre- and early independence period from Micheru Gatheru's *Child of Two Worlds* and Camara Laye's *L'Enfant Noir* to Chinua Achebe's great novels *Arrow of God* and *Things Fall Apart*. Because workshop artists of this period were not educated élites, and in the two-worlds model of African culture, 'modern' certainly meant educated, they did not seem to be essential players in this dialectic of progress. But in the 1980s and 1990s, ironically, it is precisely these artists who have come to seem most representative of contemporary artistic practice.

And in this reversal of fashion, a considerable number of French, German and Italian critics, galleries, museums and collectors who publish and exhibit contemporary African art are disposed to bypass the work of trained artists in favour of that by practitioners without diplomas and degrees. As early as 1968, Ulli Beier's seminal *Contemporary Art in Africa* devoted less than one-fifth of its text to formally trained artists and pointed out the derivative nature of much of their work and the inherent problem in introducing Western models. André Magnin and Jacques Soulillou's *Contemporary Art of Africa* published nearly thirty years later in 1996 selected artists to be discussed according to this same criterion. Of the sixty-odd artists included, nearly all were trained through apprenticeships, workshops, or by self-experimentation. A handful, such as the Vohou-Vohou painters of 10 Côte d'Ivoire or the well-known Senegalese artist-activist Issa Samb, are included as examples of artists in rebellion against their original academic training. The authors make their position on this point clear:

*Many artists formed in the schools of art, where they acquired a solid background in modern art of the West…produce work that all too often stays well within the realm of that tradition…. For them, the field of art basically remains confined to technical issues and begs the more fundamental question of the purpose of that technique…. Such recourse to these characteristic styles and techniques of Western modern art inevitably favors a hybridization…ceaselessly fueled by its sources. Unhappily, such a fuzzy aesthetic in which confusion reigns, which refuses to strike out in unknown territory, runs the risk of being fatal to art.*

107. **Theodore Koudougnon,**
*Beads,* 1988. As in Senegal,
rebellion by artist-intellectuals
against academic traditions in
Côte d'Ivoire has a distinctly
francophone flavour – the
Vohou-Vohou group to which
Koudougnon belongs issues
manifestoes which invoke
African identity claims while
simultaneously making fun of
manifesto writing.

The attack on hybridity seems somewhat misplaced in this context – it is the very fact of its hybridization and a 'fuzzy aesthetic' that gives much of the work of untrained artists its emergent quality and thus makes it interesting to critics such as Magnin and Soulillou.

*Inclusion and exclusion: the authority of collector and curator*

As the Cuban critic Gerardo Mosquera has noted, instead of colonizing the Third World, the West now sends curators as postcolonial explorers on voyages of discovery. To extend his metaphor, collectors are then a kind of advance-guard, scouting the territory and trading with the natives before any treaties are signed. The first major travelling exhibition of contemporary African art, *Kunst Aus Afrika* (1979), exhibited the private collection of Gunter Peus and featured (though not exclusively) the work of untrained artists from the young Cheri Samba to Middle Art (see Chapter one). The same was true of the major travelling show, *Africa Hoy!* (1991), which was based on the collection of Jean Pigozzi. This encyclopaedic and highly visible collection also provided all but a few of the artworks in Magnin and Soulillou's *Contemporary Art of Africa* and many of the examples for this book. At this stage when the

critical discourse on postcolonial African art is still emerging, the tastes and preferences of a handful of private collectors and the curators who work closely with them have had a great influence on the way in which contemporary African art is being defined for its various publics – 'autodidacts' are privileged over formally trained artists, women artists are nearly invisible, and with the exception of South Africa (which has its own corps of curators and critics), the anglophone countries are severely underrepresented relative to their artistic importance.

Two important exhibitions of contemporary African art that were shown as part of the Africa '95 festival in London illustrated both this set of preferences and a major attempt to challenge them. In the Serpentine Gallery's *Big City*, which was also based on the Pigozzi collection and curated by André Magnin, the dominant themes were enigma and fantasy, such as Kimbéville, the imagi- nary cardboard city and icon to modernity built by the Congolese artist Bodys Isek Kingelez. Five of the six artists then appeared in Magnin and Soulillou's survey. Taking a very different stance, the Whitechapel Art Gallery's much more inclusive project *Seven Stories about Modern Art in Africa* presented the work of academically trained, workshop and untrained artists, and gave anglophone Africa long overdue attention, as well as women artists and cura- tors a voice. Part of its ambitions stemmed from the organizer Clémentine Deliss's desire to have a group of African curators and contributors for the show who would also write and organize texts for the catalogue. Some contributors (Everlyn Nicodemus, El Hadji Sy, David Koloane and Chika Okeke) were also practising artists, others (Wanjiku Nyachae and Salah Hassan, as well as Clémentine Deliss herself) were closely involved with contempo- rary art, working as curators or critics. As the Whitechapel's director Catherine Lampert put it:

*Gradually, the romantic authenticity automatically associated with the 'untrained' artist has become an exhausted assumption, except in the media and among some collectors. Indeed the curators and galleries participating in this exhibition have chosen an approach that welcomes educated and intellectually rigorous thinking and acknowledges African art as being cosmopolitan while at the same time its content may abound in local and personal references.*

The overall effectiveness of *Seven Stories about Modern Art in Africa* (some of the 'stories' more compelling than others) restored both French- and English-speaking artist-intellectuals to the contem- porary art discourse.

108. (opposite) **Bodys Isek Kingelez**, detail from *Kimbembele Ihunga (Kimbéville)*, 1993–94

*'Art comes from art.' (Or does it?)*
This statement, made in an interview by the American poet laureate Robert Pinsky, expresses not only the observation that the work of every artist is in part conceived out of the work of other artists either past or current, but also the conviction that it ought to be that way. It is a powerful idea considered axiomatic by most art historians and critics. But what is perhaps overlooked by its otherwise compelling simplicity is the political force its meaning has in a colonial context. A palpable tension between identity and pedagogy developed along with the independence movement in many late-colonial states. One of the results of this tension has been the 'schizophrenia in the arts' described by another poet, Chinweizu, writing about intellectual life in the Nigeria of the 1970s. African artists and writers, composers and filmmakers have both wanted to break onto a world stage, to assert that Africa is a player and not simply a peripheral audience, and at the same time have wanted to express an identity which is not only 'not European' but is both African and anticolonial. This has led to a dilemma driven by both the uncertainties of postcolonial identity and an equally uncertain role played by colonial-style education. In its simplest form expressed in the 1960s it was the child-of-two-worlds argument about the conflict between tradition and modernity, Africa and the West. Since that time, these terms have been substantially criticized and redefined, and in the mind of a self-reflexive artist such as Ibrahim El Salahi of the Sudan, what is old or new, African or Islamic or modern, do not exist as free choices, but as partly intentional and partly predetermined. In a *Third Text* interview with Ulli Beier, he revealed that he often felt caught between two elements in his work – one over which he has no control that simply appears unbidden in his work and which he recognizes as the same images that used to appear to him as a child in Khartoum and the other which he consciously tries to impose as a trained artist with an arsenal of imagery and techniques at his disposal.

*UB: How then does the Sudanese element fuse with your Qatar or English experience?*

*IES: Well, the Sudanese experiences are in the images. As a child I had images of people. They appeared and I saw them physically. The things I draw are not imagined; they appear in front of my eyes.... Sometimes, like a fraction of a second, the horizon opens and I see them.... I work like a medium, so my imagery is not something I think about. I do not create them, they create themselves. When I came to*

*England, I learned two things: I learned about techniques, and I learned about the people. I was keen to acquire the tools of painting.... But I was also anxious to know about...the background of the Renaissance, about early Christian painting, the contemporary movements.... When I went to live in the Arab world my experience linked again with my early childhood. Arab culture is linked with the Arab language, with the Koran and calligraphy. And calligraphy is a most important subject for me, because it is abstracted form, with symbols which carry sound and meaning. First, I used to write calligraphy as it is: poetry or words of wisdom. But later on, I applied some of the techniques I had learned in Europe. I like what Picasso had done with Cubism, taking the visual form and breaking it into it original components, and then reconstructing it in a new form. I think I did the same thing with calligraphy.... I tried to go deeper and break [down] the actual shape of the symbol to its origin – to take it back to animal forms, or water.... And once I opened this door and went through it, it was like breaking glass! I had to walk carefully: sometimes you could cut yourself.... I was breaking and breaking...and figures appeared...the same figures or spirits that used to come to me as a child! They came to me when they were freed of the rigid form of the letter.*

UB:*...These images were strikingly African. You could almost have thought they had emerged from some culture in the Ivory Coast. There*

109. **Ibrahim El Salahi**, *Calligraphy*, n.d.

*was this extraordinary affinity: maybe there is some deep layer of consciousness that reaches out way beyond its narrow geographical location....*

IES: *That is quite true. At first I was just taken in by them. I couldn't even think about it, because they wanted to come out and I brought them out; and they kept coming and coming.... Later I used to think: here I am, thinking of myself as an Arab, but these do look like African masks! How come? I am trying to refine my calligraphy and these kinds of images emerge!.... This can cause a dilemma, this process of wedding what flows from within with what you have acquired from outside. How to weigh the two elements, which may be quite contradictory with each other, that is the nature of the work. Because ideas are ideas, not art. Art is what you make of the ideas.*

UB:*...Could you say that this image that appears, uncontrolled and unsolicited, is really some kind of archaic identity, and that the intellectual process then finds some common denominator between it and all the other acquired identities?*

IES: *Yes. Let us say that the work of art is the meeting point.*

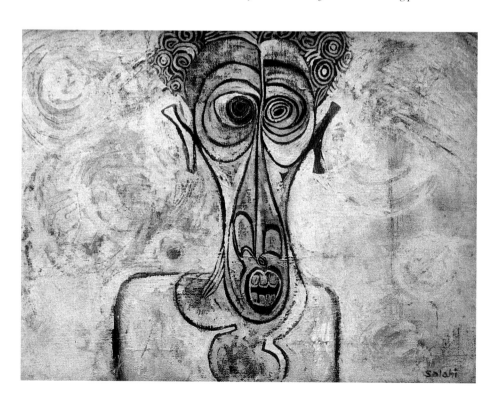

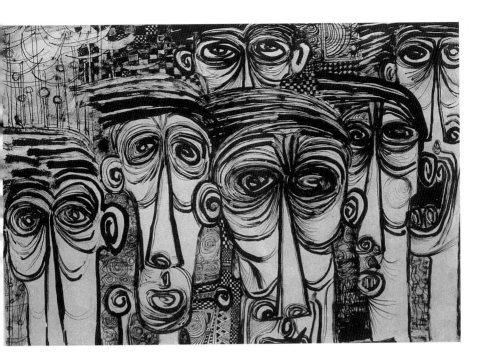

110 and 111. **Ibrahim El Salahi**, *Head* (opposite) and *Faces* (above) both early 1960s. While at first glance similar, *Faces* depicts six straight-nosed, straight-haired faces with the spaces between them filled with tiny intricate designs, while *Head* shows a solitary African face, perhaps a self-portrait, against a barely suggested background, giving it a tentative, unfinished quality – and the 'archaic identity' that Ulli Beier recognized.

Finally, what is most interesting here is that both El Salahi and Beier were intellectually 'formed' in the 1950s and 1960s, and that consequently both artist and critic see the unbidden element as a kind of African essence which refuses to be completely controlled by outside forces. It is part of a larger argument about the existence of primordial identities, which a younger generation would view with a certain scepticism.

*Uganda: traditionalist, modernist and nationalist pedagogy*

It is also possible to follow this dialectic of the inner and outer consciousness as it was played out in the education of those African artists who did not go to Europe to be trained. Nowhere can this rhetoric be traced more clearly than in the development of one of the continent's major art schools at Makerere University in pre- and post-independence Uganda. Margaret Trowell, its founder, represented a colonial pedagogy which grew out of British Colonial Office notions of native perfectibility and progress. As a governing strategy, Indirect Rule had adhered to the principle of least interference with existing tradition. In like manner, Trowell advised, 'We start from it, study it, and honour it.' Her instincts therefore were to build upon the artisanal practices which already

99

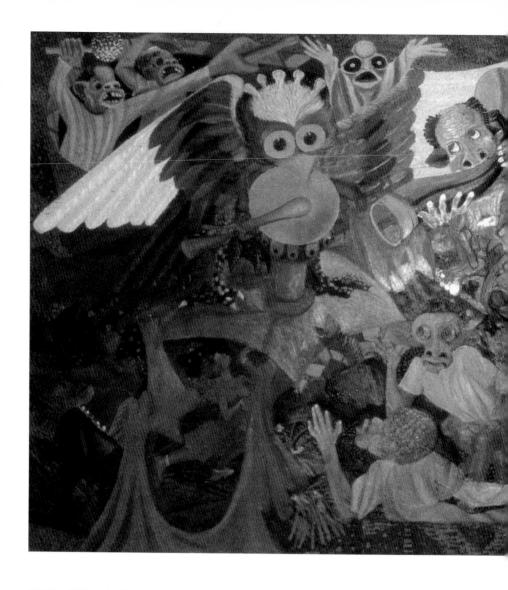

112. **Peter Mulindwa's**, *The Owl Drums Death (the Uganda Martyrs)*, 1982, is an example of a classic Makerere genre in which mythology carries both a pictorial and a narrative load. The Uganda Martyrs were early converts to Christianity who died at the order of a despotic *kabaka* (king) and so signify martyrdom under modern despots as well.

existed, but to introduce new technical knowledge as a pragmatic way to 'develop' the visual arts in a region of Africa where representational art was rare.

Trowell's teaching strategy was a conscious rejection of the model put forward by European modernism and set Makerere on a course which, while later redirected, earned it an early reputation among outsiders as an old-fashioned late-colonial institution. Uganda is not even mentioned in Ulli Beier's text of 1968, although Makerere was well established by that time as the major centre for

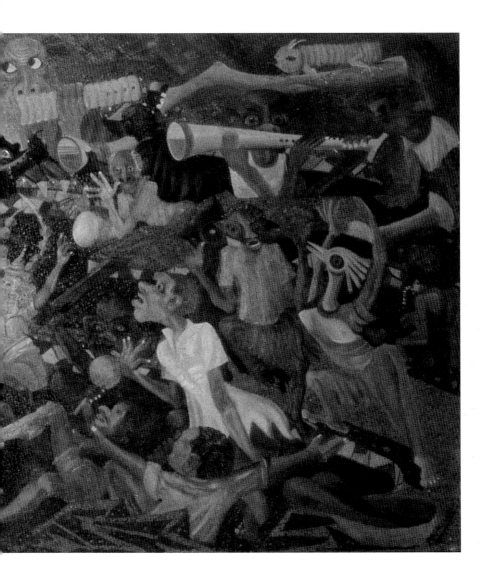

training artists from a wide region of eastern Africa, from the
Sudan to Rhodesia. Trained as an artist at the Slade, London, and
as an art teacher at the Institute of Education at the University of
London, Trowell introduced her students to Western techniques
such as easel painting and silkscreen printing. Within these picto-
rial genres she encouraged the use of narrative, which until then,
had resided mainly in oral tradition. The pictorial narrative, which
was rare prior to 1900 aside from prehistoric rock art, has become
a staple of representation in African art almost everywhere, from

the heroic exploits of the gods to the struggles of everyday life and
the chilling allegories of military rule.

Sculpture, while unable to carry the same complex narrative
load as painting, could thematize both mythic and genre subjects.
Trowell's most outstanding early student, the Kenyan Gregory
Maloba, developed a powerful monumental style using Ugandan
hardwoods and other materials, and assisted Trowell as an instruc-
tor at Makerere during the 1950s, later returning to Kenya to head
the Department of Design at the fledgling University of Nairobi.
In the early period, the first East African artist to be exhibited
abroad was the Tanzanian Sam Ntiro. His career as a painter and
Maloba's as a sculptor, both in many ways parallel to Ben
Enwonwu's in Nigeria, had been promoted initially by Trowell
just as Enwonwu's had been encouraged by the legendary
Kenneth Murray. Both Murray and Trowell as expatriate art
teachers had insisted on grounding their students in their own
local systems of knowledge and artistic practice – a deep interest
in preserving these traditions led Murray to become Nigeria's
first Director of Antiquities and to collect methodically both
objects and ethnographic documentation for the Lagos Museum.

Trowell was Director of the Uganda Museum (1939–45) when
she initiated art classes at Makerere and later wrote two influential
studies, *Classical African Sculpture* (1954) and *African Design* (1960).
Both Murray and Trowell arranged for their most promising
students' work to be shown in London – Trowell's students at the
Imperial Institute in 1939 and Murray's at the Zwemmer Gallery

113. (left) **Gregory Maloba**, *Death*, *c*. 1940

114. (opposite) **Shangodare**, *The
Triumphant Return of Shango from Battle*,
1977. Unlike *The Owl Drums Death* (see
plate 112), made in Uganda around the
same time, this narrative's intention is not
to draw explicit parallels with contemporary
political events in Nigeria, but to validate
Oyo Yoruba culture's mythic past. Shango,
the fourth king of Oyo, who was later
deified as the god of thunder and lightning,
returns on his horse from a successful
battle, accompanied by a line of chained
war captives. The artist is a disciple of
Shango and the godson and protégé of
Susanne Wenger (see plate 39).

in 1937. They sent the best students on to the Slade School of Fine Art or the Royal Academy of Arts in London for further training. But paradoxically this assured that these early students would take on larger-than-life reputations as archetypes of the 'modern African artist' in the minds of the British public as well as at home in the colonies. They were expected to epitomize the educated colonial élite, but also to represent an essential Africanity.

If Trowell represented a traditionalizing approach common to the projects of the 1950s, her South African successor Sweeney (Cecil) Todd was fully committed to an African modernism based on a knowledge of twentieth-century developments in Europe as well as canonical African art. Students were given a thorough training in world art history, scientific colour theory and life drawing. Like Trowell, Todd insisted on students achieving a high level of technical skill and making use of indigenous materials. As a white South African, he shared some of the same goals in training young African artists as his counterpart Cecil Skotnes had at the Polly Street Centre in Johannesburg a few years earlier. But whereas in South Africa the early Polly Street artists – Durant Sihlali, Lucas Sithole, among others – were not encouraged to learn about styles and movements elsewhere, Todd and his staff sought to make Makerere students conversant with a wide range of world art. Ironically, while Todd's position was considered a neocolonialist one in the 1960s, in the 1990s it was reinterpreted by many younger African artists as a form of enlightened 'internationalism'. If early South African attempts to avoid

115. Gregory Maloba teaching at the Makerere Art School, Uganda, in the 1950s. Students and teacher alike are in the British colonial school uniform of the time, modelling small-scale figures in clay.

116. Ben Enwonwu at work in his London studio, 1957. The *West African Review* published this photograph with the caption, 'Enwonwu the Bohemian', and the observation, 'Apart from the telephone at his elbow this could be a garret in 19th century Paris.' On the easel is an unfinished painting of Nigerian market women and on the left a sculpted male head.

'contaminating' artists with Western ideas now seems paternalistic and short-sighted, this shifting of values among the emerging generation of artists and critics is partly the result of their greater likelihood to exhibit, publish and even live abroad.

But the Makerere of the 1960s caught up in the intellectual euphoria of nationalism and anticolonialism was very different from either the late-colonial Makerere of Trowell or the postcolonial internationalism of today. Todd was unwilling to condone student radicalism that rejected British pedagogy, symbolized in the University (though not the Art School) through the official subordination of Makerere's degree-granting status to the University of London at that time. While the intellectual debate was usually couched in terms of African literature and the importance of teaching the work of African writers along with Shakespeare, it also spilled over into art and music.

Three young artists whose ideas Todd opposed were the Ugandan painter Eli Kyeyune and the Tanzanians Sam Ntiro and Elimo Njau. Njau, an outspoken and charismatic artist who had been trained by Trowell herself and graduated in the first diploma class, was not invited by Todd to teach in the Art School and Kyeyune, who later won an international artists' competition sponsored by the then-fledgling journal *African Arts*, left without finishing his degree to follow Njau to Nairobi. There Njau set up Paa ya Paa ('the antelope rises') Cultural Centre which, despite an inadequate staff and operating budget, managed to survive over the years with a changing clientele of visiting artists, tourists and

118

international student groups until it was tragically destroyed by a fire in December 1997, but partly reopened with the help of local and donor support only a year later.

Ntiro had been Trowell's protégé and after completing further training at the Slade in London, he returned to the Art School but was later dismissed by Todd. Ntiro went back to Tanzania and became a commissioner for culture in the socialist government of Julius Nyerere. Todd was also assisted by a teaching staff of extraordinary younger (and predictably more iconoclastic) artists including Ali Darwish (Zanzibar), Jonathan Kingdon (Tanzania) and Michael Adams (UK), all with burgeoning careers of their own. For all of these artists as well as their protégés among the students, the Nommo Gallery in Kampala provided the necessary access to patrons and audience. Adams and Kingdon were even responsible for teaching printmaking after hours to the Art School's custodian Richard Ndabagoye, who proved to be a more formidable talent than most of the students and held a one-man show at the Nommo Gallery, although he was imprisoned shortly after and his career cut short.

Todd's major project was the construction of a gallery at the School to house the permanent collection of works by staff and students, funded by the politically conservative Gulbenkian Foundation. This, too, drove a wedge between him and the group of radical East African intellectuals who were setting the terms of the first discussions about postcoloniality. Many of these debates took place in the pages of *Transition* magazine, the literary and

117. (opposite) **Michael Adams**, *View from Fazal Abdullah's Mother's House, Lamu, c.* 1966. Adams, a brilliant colourist, set a high standard for Makerere students in his painting classes. The contrast here is between the cool, dark interior of a Swahili house and the almost blinding sunlight reflected off the Indian Ocean and the coral stone walls of the house exteriors, which effectively washes out all detail.

118. (right) **Elimo Njau**, *Milking*, 1972

*149*

119. **Richard Ndabagoye**, *Mume na Mke (Husband and Wife)*, 1969. The contrast between the dour-faced elderly husband and the inscrutable, unlined face of his obviously younger wife says much about arranged marriages. Their stiff hieratic pose is reminiscent of subjects before a village photographer. Ndabagoye never 'studied' art so his work has no obvious models, though he imbibed the Makerere ethos that art was not about the art market.

120. Cover for *Transition* 32, 1967. Michael Adams drew the cover illustration for Paul Theroux's lead article, 'Tarzan is an Expatriate'. Devoted in about equal measure to discussions about postcolonial politics and cultural criticism, and about attempts to annoy traditionalists of all types, *Transition* flourished until its editor Rajat Neogy was accused of treason by the Uganda government and made to stand trial. The magazine later moved to Ghana under the editorship of Wole Soyinka, but never took as well to West African soil. Since 1991 it has been successfully retooled as a more diasporic journal edited in the USA by Henry Louis Gates Jr and Kwame Anthony Appiah.

political journal founded by Rajat Neogy in Kampala in 1961 and supported by the same group of artists, writers and intellectuals who founded the Nommo Gallery and directed such projects as the National Theatre and the national dance troupe, 'Heartbeat of Africa'.

Unlike Nigeria, South Africa or Congo, Uganda is a small country with a single intellectual centre, Kampala. Every artist, poet, playwright, novelist, gallery director, newspaper journalist and public intellectual knows one another, creating a high level of cross-fertilization in the arts. In Paul Theroux's words it was, a 'small green city...full of distinguished people'. But while writers' work could be published and sold abroad, visual artists were dependent primarily on local patronage by élites and the government. This all evaporated with the coup d'etat of 1971 which brought Idi Amin to power in Uganda. Within a short time, all public criticism was stifled, and artists and intellectuals who survived – some did not – either went into exile or tried, like other Ugandans, to live by their wits. One effect of the Amin regime was to force the departure of expatriates, as well as politically outspoken Ugandans, from the University. As more and more Ugandans including the University's own vice chancellor 'disappeared' into Makindye or Luzira prison never to be seen again, Makerere struggled to stay open by employing its own recent BA graduates as teachers. So ironically this reign of terror became a time of opportunity for young artists, particularly if they were able to turn out commissions for the regime. One of the artists who narrowly escaped imprisonment was the Ugandan sculptor Francis Nnaggenda, whose large-scale sculptures in wood and metal explore the 'machine in the garden' metaphor, as well as the resilience of the human body and spirit under the assault of war, violence and technology.

Today internationalism is in the air once again, which worries some of the older artists who have lived through each of these phases in turn. Nnaggenda, who generally supports the international curriculum, also sees it as a process which inevitably erodes African systems of knowledge.

*FN: Today you'll find a young fellow, when you talk to him in Luganda, he will tell you that I don't understand what you're saying, please speak in English...even you may say a certain proverb and he has never heard of it.*

*SLK: Are you suggesting that there is now such a distance for this person from his own culture that he approaches it from the outside looking in?*

121. **Francis Nnaggenda**, untitled sculpture, Makerere studio, n.d. Nnaggenda prefers to work on a large scale in wood, scrap metal or a combination of both. Because of its size, his work exists mainly in public spaces or at the Makerere Art School, Uganda, where it has colonized the available space outside his studio. He also paints in a style reminiscent of later Cubism (see plate 104).

121

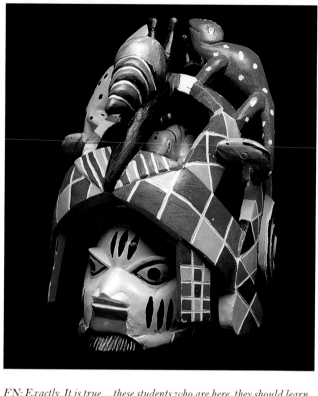

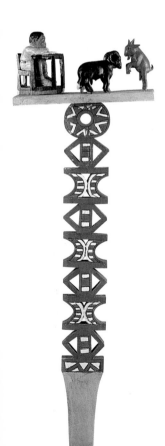

*FN: Exactly. It is true...these students who are here, they should learn about Yorubas, they should learn about Asantes, they should learn about Dogons, because when the Dogons talk, although we are distant here on the continent, I've come to realize that when you look at the core, we are the same, we are the same...if we can't learn from ourselves then we become, how do you call it, thin.*

A parallel set of pedagogic debates took place at the same time in Nigeria, first in what was to become the Fine Art Department at Ahmadu Bello University in Zaria, and then at the University of Nigeria at Nsukka (see Chapter six). In each of these countries – Sudan, Uganda, Nigeria – the actors and scenery changed, but the cultural script remained the same – how did one continue to be African and still be a modern artist? It was the burning question of the 1960s among artists across much of the continent. It is still salient for many artists who came of age during that period and is belatedly being played out in South Africa today, tied as it is to issues of cultural nationalism. But to even ask this question is to betray one's psychological distance from what Thomas Mukarobgwa referred to simply as 'the bush' – it is an intellectual's question.

122. (opposite, above) **Dossou Amidou**, Yoruba (Nago) Gelede mask, Benin, n.d. In the whole repertory of canonical Yoruba art, Gelede masks offer the greatest variety of inventive sculptural possibilities. Dossou Amidou, working in a village near Ketu in western Yorubaland, exemplifies this inventiveness. Yet, when his work was selected for the *Magiciens de la Terre* exhibition in Paris, he replied modestly, 'I only work, I can't define what you call art.'

123. (opposite, below) **Efiaimbelo**, *One is Never Better Served than by Oneself*, Mahafaly *aloalo* (funerary post), Madagascar, 1994. Like the Gelede mask sculptor above, Efiaimbelo is an innovator, whose *aloalo* include buses and aeroplanes as well as Zebu cattle, the Mahafaly symbol of prestige and wealth. These posts are planted in the ground surrounding the tomb of the deceased, and prior to the arrival of the French in Madagascar in 1904, were considered immovable. Now they are also collected.

*Consciousness and postcoloniality*

It would be wrong, however, to locate the issue of artistic consciousness solely in those who have studied art in universities and art academies. It requires an awareness borne out an engagement between self and world, and the postcolonial condition encourages this on a regular basis – particularly through museums, and their curators, which not only influence the way that artists such as Bouabré and Adeagbo work, but are also active agents themselves in constructing postcoloniality. By juxtaposing the work of Third and First World artists in a shared space, the curators of *Magiciens de la Terre* at the Centre Pompidou, Paris, for instance, suggested shared intentions between artists, whether a Navaho sand painter, a carver of Gelede masks from Benin, a 122 maker of funerary markers from Madagascar or a conceptual 123 artist from New York. Their side-by-side exposure conveys, promotes and mediates the claim for some common intelligence or consciousness.

Frédéric Bruly Bouabré, born in 1923, was a government 124 official in Côte d'Ivoire who worked for IFAN (The French Institute for Subsaharan Africa). The IFAN Museum was housed in the same building in Abidjan and although it was smaller than the one in Dakar it was nonetheless a major presence. Bouabré explained in a 1995 interview about the *Big City* exhibition featuring his work that he loves museums in the way that one loves old books. 'I do not work from my imagination. I observe, and what I see delights me. And so I want to imitate.' This imitation, despite Bouabré's declaration, is highly imaginative, yet meticulously controlled.

The archaeology of knowledge is also a long-standing preoccupation for Georges Adeagbo of the Republic of Benin, 125, 126

124. (right) **Frédéric Bruly Bouabré**, *Knowledge of the World – In the Bowels of the Verdant Earth, the Subterranean Blue Sea Washes Our 'Dead' Before Being Reborn as Drinking Water*, 1991. Drawn on 3" x 5" cards and using coloured pencils and a ballpoint pen – in other words, not the paraphernalia of the artist's studio but of the library – Bouabré's *Knowledge of the World* series is a compendium of ideas formed over a lifetime of observation mixed with poetic geological fantasy.

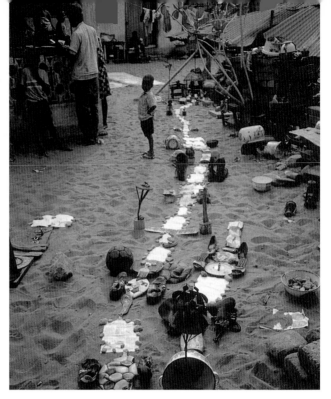

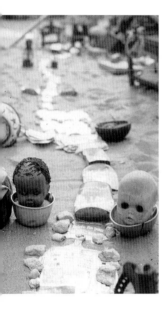

125 and 126. **Georges Adeagbo**, *Histoire de France*, Cotonou, 1992.

though his sensibility is bounded by a different set of experiences. Initially trained in law and political science in France, he returned to Cotonou, his birthplace, in 1971, where he constructs installations in the sandy courtyard of his compound. These collections of things, constantly being reconfigured and changed, include pages from newspapers held down by stones, enamel basins, deflated soccer balls, dolls' heads, small *asen* (Fon ancestral altars) and objects from *vodou* altars. He says he is 'fascinated by history', which seems to encompass Dahomean, French and postcolonial Beninois events and objects. But the train of his thought is not always readily transparent, and concerned relatives worried about his sanity have admitted him to mental hospitals several times.

Postcoloniality in what was French West Africa has had a generation to sink into peoples' consciousness. But in South Africa, it is a very new condition, having only been achieved by the first free elections of 1994. The period between the Soweto Uprising (1976) and the 1994 elections can be seen as a time of intense self-examination by artists and writers searching for a viable way to be South African, and also a part of the world. Artistic consciousness

has therefore been a constant symptom of South Africa's social fragmentation, both for white artists conditioned by their professional training to think in terms of self-realization, and for their black and other non-white counterparts because they moved within a society officially closed to their representations.

While there was a spectrum of possible alliances, both artistic and critical practice during the 1970s and 1980s responded to the African National Congress's Leninist-derived position that artists were 'cultural workers' who ought to be engaged in actively resisting an oppressive regime. Few artists or even critics were so explicitly doctrinaire, but there was nonetheless a clear recognition that the discourse about race was at the heart of the ANC's goal of a 'non-racial society' which, in turn, made it the recurrent theme of most art, whether by black or white artists. For the latter this forced upon them the contradiction between their professed political ideals and their privileged socio-economic position.

The response of some white artists was to incorporate their activism into the explicit content of their work. In 1982 Sue 127 Williamson began a series of screen-printed photographic collages honouring women involved in the apartheid struggle. Most of these were black women such as Annie Silinga, involved in the Defiance Campaign of the 1950s and Mamphela Ramphele,

127. **Sue Williamson,** *Jenny Curtis Schoon,* 1985

now one of South Africa's leading public intellectuals, who as a medical student had been an activist in the black consciousness movement with Steve Biko. Also included were Jenny Curtis Schoon, a young white political activist who died in 1984 when she and her small daughter were blown up by a parcel bomb.

William Kentridge's sensibility has been closely tempered by the city of Johannesburg, where he has always lived. In 1990 he wrote, 'In the end all the work I do is about Johannesburg, a rather desperate provincial city. I have never tried to make illustrations of apartheid, but the drawings are certainly spawned by and feed off the brutalised society left in its wake. I am interested in a political art, that is to say an art of ambiguity, contradiction, uncompleted gestures and uncertain endings. An art [and a politics] in which my optimism is kept in check and my nihilism at bay.' Kentridge began to combine drawing with animation in the 1980s. The government had declared a state of emergency in 1985 and had imposed press censorship resulting in newspapers with blank spaces where stories had been expunged. Expanding on this idea he created his own version:

*The film was made in my studio on one sheet of paper. It chronicles a history of images, events, people, and interactions, all of which are subsequently erased leaving a blank, but bruised sheet of paper. The sheet of drawing paper was exhibited…with the film projected alongside…. Subsequently, even blank spaces in newspapers were deemed to be subversive and prohibited.*

128. (right) **William Kentridge**, *Soho and Mrs Eckstein in the Landscape*, 1991. A drawing for the film *Sobriety, Obesity and Getting Old*. Kentridge depicts Soho Eckstein, an aging mining magnate and 'property developer extraordinaire', reunited with his long-neglected wife within a landscape that holds traces of what has been enacted upon it.

129. (opposite) **Penny Siopis**, *Cape of Good Hope – A History Painting*, 1989–90

130. **Alfred Thoba**, *Race Riots,*
1977

Kentridge initiated a six-film series in 1989 beginning with *Johannesburg, 2nd Greatest City After Paris.* Another was *Sobriety, Obesity and Getting Old* (1991). A recurrent image in these drawings is an empty advertising billboard set in a burnt-out landscape holding traces of what has happened, a powerful symbol also deployed by artists such as Jane Alexander.

Penny Siopis, an introspective painter concerned with the large themes of history has described her use of images of opulence – satin drapery, flowers, food – in the mid-1980s as a way of commenting upon the decadence of white South African society. Tiny figures and whole narratives are embedded almost microscopically in larger ones, creating an account baroque in its detail. They are rhetorical and require close reading – not an art for a broad public but one which is encrypted with meanings from literature, psychoanalytic theory and more localized South African history.

The issue of consciousness worked in reverse for non-white artists under apartheid: as the subjects of constant government surveillance they were always at risk of arrest and imprisonment; but as the disenfranchised they were impelled to find ways of expressing a political voice. Their artmaking was therefore always carried out in a state of intellectual tension. When Alfred Thoba painted the obviously political *Race Riots* (1977) he had to move it with him from place to place because it was incriminating

evidence. Willie Bester is one of many artists who occupy an inter- mediate position between the overly stereotyped polarities of the white, formally schooled artist with literary-philosophical leanings and the black, informally trained artist who depicts the reality of life under an apartheid regime. Designated 'coloured' in South African official parlance, he grew up in Montague, a section of Cape Town, but was 'removed' under the Group Areas Act that segregated residential areas. His formal instruction was minimal – he spent a year at CAP (Community Arts Project), the major training centre for non-white artists in Cape Town. Although his subject is township life, he is far less literal and more inclined towards layers of interpretation than either the earlier 'township artists' of the 1960s or the CAP poster artists working in the 'straight resistance mode'. Bester employs the detritus of the street along with oil or watercolour in a collage-like format augmented by minute calligraphic figures and symbols.

Finally, there is the expression of consciousness through satire, of which Tommy Motswai is South Africa's master practitioner, rivalling the best of the flour-sack painters in Kinshasa (see Chapter one). Informally trained at FUBA (the Federated Union of Black Artists) and in Bill Ainslie's studio, he has developed a richly descriptive style in which everyday urban life, as well as rituals such as the township wedding of an upwardly mobile politician,

131. **Tommy Motswai,** *Lenyalo at Home from Rockville,* 1988

reveal the borrowings of European custom – the tea party, the white wedding dress, figures with modish haircuts and clothing – but recontextualized into something uniquely South African.

The unifying agenda of art as a form of cultural resistance came to an end in 1994 with the beginning of majority rule. Resistance art's first major repositioning as a critical response to the New South Africa took place in 1996 in *Faultlines*, an exhibition organized by playwright-curator Jane Taylor in Cape Town Castle, the Intelligence Headquarters for the South African Defence Force. *Faultlines* invited activist artists to work with the Mayibuye (the Xhosa term for 'come back') Archive, an extraordinary collection of purloined and donated photographs, videos and paper documents gathered by friends and members of the ANC while in exile and returned to South Africa after independence. The exhibition also reflected the controversies surrounding the formation of a Truth and Reconciliation Commission to hear accounts of government-perpetrated atrocities under the apartheid regime. The exhibits included Siopis's *Mostly Women and Children* (1996), a room installation depicting the aftermath of violence, featured a body cast of an African woman lying amidst a scene of destruction, while a fire flickered and cast shadows over the room. It continued her longstanding focus on women as victims and witnesses in South African society and her penchant for layers of historical

133

132. (left) **Willie Bester**, *Semekazi (The Story of a Migrant Worker)*, 1993

133. (below) **Penny Siopis**, *Mostly Women and Children*, 1996

134. (above) **Alfred Thoba,**
*White Nation Has Ill-treated*
*Blacks. Thank You Mr F W de*
*Klerk for Handing Over South*
*Africa to Nelson Mandela. Your*
*Kindness is So Handy*, 1996

135. (opposite, above)
**Moshekwa Langa,** *Untitled,*
1996

136. (opposite, below) **Kevin**
**Brandt,** *Pieta,* 1996

meaning (the body cast was taken from an ethnology museum storeroom). Alfred Thoba's *White Nation Has Ill-treated Blacks.* *Thank You Mr F W de Klerk for Handing Over South Africa to Nelson Mandela. Your Kindness is So Handy.* (1996) continued his earlier political activist stance, but with an added element of scepticism for the new political order. Kevin Brandt's *Pieta* (1996), a duct-tape mosaic on an outside wall of the Castle became, at the proper distance, a pixillated TV image of the first student killed in the Soweto riots of 1976. At the other end of the spectrum from these graphically realist works was Moshekwa Langa's untitled installation (1996) of ghostly paper shapes putrefying with organic garbage, suggesting the fate of forgotten people not at the centre of the political stage. But the most controversial piece, Clive van den Berg's *Men Loving* (1996), dealt not only with political violence of the past, but also with the homophobia of both black and white South Africans. Two male figures, one black and one white, lay together on a shared grave with grass growing over them, a reference to an infamous event in South African history when just such a pair were punished by being tied together and drowned off the coast of Robben Island. The *Faultlines* exhibition opened up both artists' and the South African public's consciousness to a much broader range of conflicting issues.

Prior to the partial lifting of the ANC's cultural boycott in 1987, even the most recognized South African artists worked in cultural isolation from the rest of the world, but that began to change with the *Art from South Africa* exhibition held at the Museum of Modern Art in Oxford in 1990, followed by the first Johannesburg Biennale in 1995 and the second in 1997. The South Africa-centred view of art as a form of struggle, upheld by the ANC's Cultural Desk and various Party committees, began to be destabilized in the more international critical climate ushered in by non-South African intellectuals, first by David Elliott at Oxford and then by visiting curators and art critics such as Rasheed Araeen and Thomas McEvilley in 1995 and Okwui Enwezor in 1997. These outside critics are the newest brokers on the scene. While they are unlikely to replace more knowledgeable South African critics and curators such as Colin Richards, David Koloane and Ivor Powell, their operational bases in New York, Oxford and London mean that their opinions will be taken seriously by a non-South African audience. Enwezor, a founding editor of the influential contemporary African art journal *Nka*, was artistic director of the Johannesburg Biennale in 1997. He brought an awareness of the cultural politics of artmaking in both the USA and Nigeria,

137. **Clive van den Berg,**
*Men Loving,* 1996

138. Photograph of Kendell Geers' performance piece, *Mandela Mask*, 1996

both of which gave him reason to see South Africa differently from most South Africans. His position that white South African artists frame black subjects as voiceless and passive, or sentimentalize them as victims, essentially parallels the 1980s critique by Native American artists in the USA that white culture is only capable of representing them as stereotypes. In turn, it spawned newspaper and internet debates which ranged from sharply worded denials by some white artists to calculated self promotion by others. If South African artists were seemingly moving towards 'one South Africa' in 1994, that sense of common identity has now been ruptured by global art institutions such as the Biennale and their accompanying critiques.

# Chapter 6 The Idea of a National Culture: Decolonizing African Art

If most of the new African art of the 1950s was born through the agency of European midwifery, a second, decolonizing stage led by African intellectuals began soon afterwards. This counter-movement, which peaked in the 'independence decade' of the 1960s and has levelled off since, attempted to create national identities and public cultures which would reflect a distinctively African art, literature, theatre and music. Its rhetorical underpinnings were very different from place to place, some Marxist or Pan-Africanist, others Négritudist, or in large postcolonies such as Nigeria, a whole spectrum (including those that were expressly anti-ideological). There was also a move to divest intellectual institutions – universities, museums, theatres – of their late-colonial aura. When Okot p'Bitek, a Ugandan poet, took over as Director of the National Theatre in Kampala in 1967, he promptly and ceremoniously replaced the British Council's grand piano with a drum post driven into the ground outside, announcing, 'Our national instrument is not the piano – tinkle, tinkle, tinkle – but the drum – boom, boom, boom!' Such pronouncements fed debates over neo-colonial, national and pan-African identity which punctuated the first decade of political independence.

But beyond anti-colonial rhetoric, the very idea of a national culture raised difficult issues for the practising artist: was the art of Oshogbo not demonstrably 'Yoruba' before all else? The more specifically an art and its practitioners are identified with a particular culture, the harder it would seem to replace this identity with a more inclusive national one. Conversely, it has been easier to create a Senegalese or a Ugandan national art than a Nigerian one, because Senegal and Uganda did not possess the elaborate and complex traditions of pre-twentieth-century image-making found in Nigeria. But despite these major differences, all African countries have felt a similar need at the time of political independence to refashion their cultural identities – not only to distance themselves from the British Council's piano, but also to move

139. **Bacary Dieme**, *Water Carrier*, c. 1970

beyond perceptions of the tribal and traditional towards a much-vaunted but tentative modernity in the form of the nation state. However, unlike ethnicities formed over generations through a continual process of local fission and fusion, the idea of a post-independence national identity had to be imposed all at once from the top down, by political leaders, government bureaucrats and intellectuals. Not surprisingly, this produced a wide gap between official and unofficial versions of a national culture, with most of its visibility confined to urban centres where universities, news-papers, museums and other institutions were clustered. In rural areas where most of the arts were produced by the peasantry who had minimal contact with either the colonial or the postcolonial state, being Tiv, Dogon or Acholi had a far greater immediacy than being Nigerian, Malian or Ugandan.

But beyond the urban–rural contrast, the divergent colonial experiences of anglophone and francophone African countries also mattered a great deal. The British principle of Indirect Rule meant that there was little interference in the day-to-day cultural life of the colonized, while all French colonial subjects were technically citizens of France and in some urban centres were even represented in the French parliament. While the British actively discouraged the idea of creating 'black Englishmen', France regarded assimilation of French cultural values as its greatest gift to its colonies. These attitudes – both of which were predicated on the idea of European superiority – deeply affected colonial subjectivity and the postcolonial construction of national cultures. Nowhere were these differences as obvious as in Nigeria and Senegal.

*Inventing a national art in Senegal*
The primary ingredients of post-1960 Senegalese art were initially pictorial, and within that framework, much more abstract and decorative than the narrative realism which defines so much post-colonial African art. The group of artists who came to be called the 'Ecole de Dakar' were the exemplars of this art in the 1960s and 1970s, when it enjoyed strong government patronage and international recognition. Although its subject matter was ostensibly 'traditional', the cultural distance of many artist-intellectuals from such traditions often turned them into decorative motifs. Boubacar Coulibaly's *Meeting of the Masks* (1976) typifies this approach in the hands of a sophisticated artist, for whom masks have no independent reality, but are objects of compelling design. In like fashion, tapestry artist Bacary Dieme's *Water Carrier* (*c.* 1970) assimilates both mask faces and pottery silhouettes into a highly decorative, but also very structured composition, in which traditional life is 'referenced' but not narratively described. The tapestry medium itself, both in its decorative regularities and its very large scale, further objectifies and distances the subject. Where this art came from, and how it earned its 'Senegalese' identity reveals the powerful role a well-placed African intellectual can play in the game of cultural politics.

Whereas artists, poets and philosophers in most African countries find themselves outside the centres of power, Léopold Senghor was a major African poet, an eloquent spokesman for the philosophy of Négritude, and the President of Senegal between 1960 and 1980 – the embodiment of what today would be called a 'public intellectual'. This unusual juxtaposition allowed him to play a decisive part in constructing a national cultural policy which

140. (above, left) **Boubacar Coulibaly**, *Meeting of the Masks*, 1976

141. (above, right) **Boubacar Coulibaly**, *Le Masque I*, 1973

recuperated 'tradition' (in its Négritudist reading as the primordial African past) and at the same time pragmatically embraced modernism (particularly in the acceptance of European-derived techniques and genres). At the opening of the Musée Dynamique during the historic Premier Festival Mondial des Arts Nègres (First World Festival of Black Arts) held in Dakar in 1966, Senghor stressed the longevity of the arts of Africa as well as their ability to 'deepen our vision by setting the imagination free, by putting it back in touch with its intuitive qualities'. For more than a generation he continued to speak of a pan-African aesthetic based in the same Négritudist philosophy, but also continued to uphold the complementarity between African and European artmaking as an essential basis for the birth of a national Senegalese art:

> [*Black African aesthetics*] *are the aesthetics of feeling, are object-related, harmonious, and are images impregnated with rhythm.... They offered* [*to European artists*] *a revolutionary example.... If Western art has changed under the influence of African sculpture, then contemporary African painting has cultivated a symbiosis between its own graphic tradition and the techniques of European cultures.*

Senegal's artists and its national cultural agenda also had to resolve its anomalous position *vis-à-vis* African art history itself. As the historian Cheikh Anta Diop had observed in 1948, in

*169*

Senegal, 'sculpture had disappeared and painting had not yet developed'. Into this gap, which was occupied by textile arts, fine metalworking and other genres and on the eve of independence in 1960, Senghor proposed the establishment of a national art curriculum which would pursue both the conventional topics covered in the French academies and the more elusive subject of African aesthetics. In what is now the Ecole National des Beaux-Arts du Sénégal, Senghor's dual agenda was made concrete by the establishment of the Department of Fine Arts (Section Arts Plastiques) which taught drawing from plaster models, still life, anatomy, perspective, painting, sculpture and European and African art history, and the Workshop for Research in Black Visual Arts (Atelier de Recherches Plastiques Nègres) which was more experimental and amorphous.

The Department of Fine Arts was headed by Iba N'diaye, an 14 extraordinary master of line who had trained in Paris at the Académie de la Grande Chaumière and was an independent artist not associated with the Négritude movement. Sceptical of its ideology and the dangers of its confirmation of European stereotypes about Africans, he refused to 'serve up folklore' or the naive or bizarre – a position echoed by those artists today who resist the association of African art with primitivism. The workshop was headed by Papa Ibra Tall, also Paris-trained and, like Senghor, committed to the exploration of African expressive values in art and literature. Tall had studied not only painting, but also tapestry and ceramics while in France and wanted to incorporate them into the curriculum to develop 'Art Nègre' by modernizing African textiles and pottery arts.

The tapestry workshop was moved out of Dakar to Thiès in 1965 and the following year was inaugurated by President Senghor as the Manufacture Nationale de Tapisserie. In his speech he situated the origin of the tapestry technique in ancient Egypt, thus providing it with an African pedigree. It was to become the major artisanal technique by which contemporary Senegalese art made its début internationally, in the form of large-scale public commissions. Most of the tapestry designers, such as Bacary Dieme, Ibou Diouf and Ousman Faye had been practising painters as well.

Tall was assisted by Pierre Lods, the Belgian expatriate who had founded the Poto-Poto School of Art in Brazzaville, Congo, and who was later recruited personally by Senghor. Ima Ebong, in *Africa Explores*, has pointed out the inherent irony in bringing a European expatriate to help artists find the African essence in Senegalese creativity, but this flows from the importance of the

142. **Iba N'diaye**, *Blues Singer*, 1986. The artist studied in Paris from 1949 to 1958 – sculpture at the studios of Coutin and Ossip Zadkine and painting at the Académie de la Grande Chaumière before returning to Senegal, where he was head of the Fine Arts Department of the newly formed Ecole des Arts de Senegal from 1959 to 1967. Although he distanced himself from the Négritude aesthetic, he shared with its practitioners a thorough grounding in French intellectual life which gave his art a sophisticated internationalism.

colonial metropole, especially Paris, to the intellectual project of African modernism and the forming of national cultural identities. There African, African diaspora and European artists, students, critics and curators defined and contested the theories of Art Nègre, primitivism and modernism in ways which would dictate the framework of creative experiments in Africa during the years to follow.

Senghor experienced much the same Paris as McEwen, and formed his early intellectual agenda in encounters with many of the same artists and writers as McEwen had, including Picasso. He was fond of later recounting Picasso's statement to him that, 'We must remain savages', to which Senghor says he replied, 'We must remain negroes', and then '[Picasso] burst out laughing, because we were on the same wavelength'. Senghor later used Picasso as an example of the dialectic he hoped Senegalese art would engage: an artist who, although at the forefront of modernism, never forgot his Andalusian ancestry, and who after seeing the African masks at the Musée Trocadéro in Paris remarked, '[Painting] is not an aesthetic process; it is a type of magic which stands between the hostile universe and us, a way of seizing power, by giving shape to our fears and our desires'. The philosophical principles of Négritude made the parallel claim that African art was anti-rational and deeply intuitive. In fact, both Picasso's 'magic' and the 'intuition' of the Ecole de Dakar painters were often challenged by their obvious formalist concerns, but the homage Senghor felt for Picasso was personal and deep.

143. (above) **El Hadji Sy** in his studio in Dakar, Senegal, with one of his works on jute, 1992. While El Hadji Sy is formally far removed from the meticulously detailed tapestry designs of the Ecole de Dakar, he has retained an interest in works which are large scale and decorative.

144. (opposite) **El Hadji Sy,** *Mother and Child*, 1987. The rough, wide horizontal brushstrokes suggest wrapping and binding, as with infants' swaddling clothes or a mummy bundle.

On the one hand, the kind of sustenance that artists enjoyed under Senghor's patronage was extraordinary, but, on the other, it contained serious limitations, because to receive full government support, artists had to subscribe to the official ideology of Négritude, which when translated into a set of formal practices eventually produced its own form of academicism. What began as an open-minded experiment evolved and hardened into official cultural policy. Meaningful criticism faded. Two things were inevitable – that the support would one day cease when Senghor left office, and that an artistic counter-movement would develop among those who refused to conform to the official ideology. This counter-movement began to gain momentum in the 1970s as new initiatives were launched by artists in the converted army barracks which came to be known as Dakar's 'Village des Arts', among them theatre workshops, films and jazz performances.

Out of this creative ambience, which was largely unofficial, Galerie TENQ (a Wolof word for 'connection') was inaugurated and staged four annual events between 1980 and 1983. Laboratoire AGIT-Art, a loose collective of visual artists and intellectuals involved in performance and led by El Hadji Sy, Issa Samb (Joe Ramangelissa Samb), Amadou Sow and Bouna Seye also worked in the Village during those years. But despite Senghor's attempts to protect the Village in the future, in 1983 the new government evicted the artists from their subsidized living quarters and studios, unceremoniously tossing their possessions into the street. In 1988, the Musée Dynamique which had held the major Salons of the past twenty years was handed over to the Department of

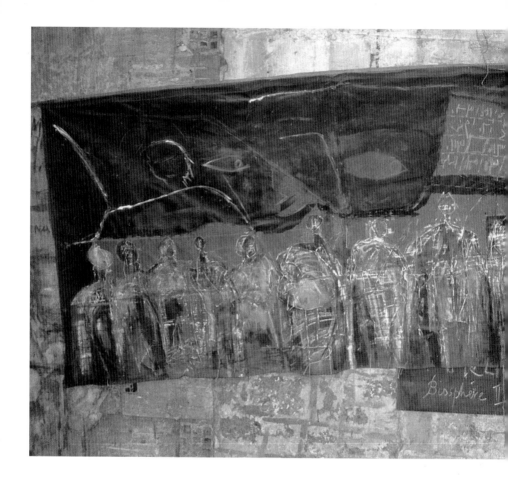

145. Issa Samb, *Untitled*, 1992

Justice who needed the site for a new building. Ultimately, the fragility of political patronage had proved to be as much a problem for artists in Senegal as elsewhere in Africa.

The AGIT-Art group first included artists trained during the 1970s who distanced themselves from the apolitical and often lushly decorative work of the Ecole de Dakar painters and tapestry designers and experimented instead with conceptual art forms with explicit political and social content. El Hadji Sy is a multifaceted artist whose work bridges that of Négritudist philosophy and the conceptualist and performance-centred AGIT-Art group which he co-founded. 'For the black African', he wrote in 1995, 'the visible is merely a manifestation of the invisible, which informs surface appearances, giving them color, rhythm, life and meaning'. Issa Samb, trained originally in philosophy and law, is both activist

146. (above, right) **Issa Samb**, untitled collage, 1986. Issa Samb's work typifies the difference between artists working in Africa and the West and their attitudes towards 'the new'. Conceptual art had its 'decade' (the 1970s) in the West and collages have been being made for most of the century, but in Africa, all Western-derived movements are recatalogued into a repertory which acts as a giant filing cabinet of ideas. The peculiarly Western obsession with newness and obsolescence has little meaning in such a situation.

and group theorist, eclectically reworking an early modernist anti-aesthetic based in collage and *objets trouvés* or more recently, conceptual strategies such as blackboard sketches or handwriting combined with figuration.

Following the AGIT-Art example and inspired by the music of Youssou N'Dour's *Set*, a spontaneous youth movement called *Sét Sétal* (Wolof for the act of cleansing) emerged in 1990 and in the space of a few weeks erected sculptures and covered hundreds of walls in and around Dakar with impromptu murals. Reminiscent of the Peace Parks that youths erected in certain South African townships towards the end of 1985, these artworks, wildly variable as they were, bridged the gap between aesthetics and social activism. They were 'popular' art, in the intellectual's sense of a politically charged people's art.

146

145

147

But the Senegalese genre that has been most 'popular' in the rather different sense of appealing to the broadest public is *Souwer* (glass painting), which more than either Négritudist painting or avant-garde AGIT-Art could lay claim to being a 'national' art form in the years preceding and following Senegal's independent statehood. The glass-painting technique was imported from North Africa in around 1900 and the first examples were brought back to Senegal as souvenirs from religious pilgrimages. This accounts for the most popular subjects, which derive from the Koran or portray charismatic religious leaders. Prior to their discovery by collectors, they appeared in many homes as devotional images, though there was also a genre of satirical and decorative subjects, and they were used to frame photographs. Gora MBengue's *Le Grand Marabout* (1984) exemplifies the most prevalent iconic style among superior artists – it employs large areas of flat but strongly coloured shapes which take on the luminosity of the glass. More recently Anta Gaye has used glass painting as a more experimental medium in which she employs collage and embeds fabric or small boxes behind the glass. While Senegalese cultural institutions have resisted attempts to include glass painting in their 'fine art' collections and exhibitions, it has been eagerly bought by tourists and foreign collectors.

147. *Sét Sétal* mural, Dakar, 1991 (detail)

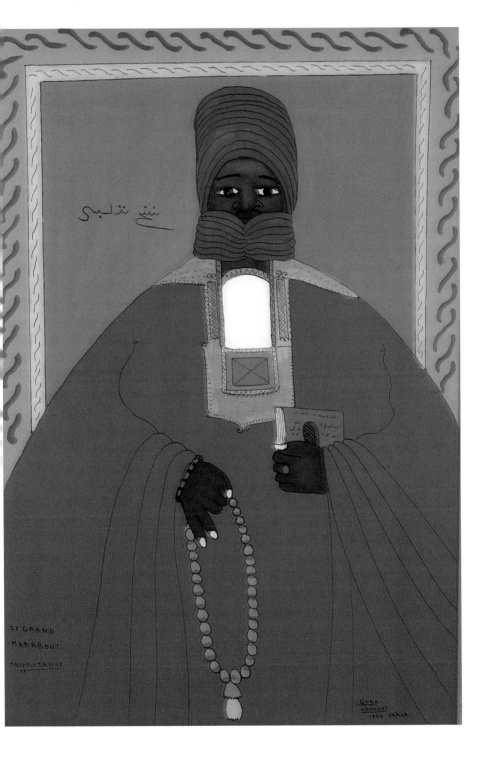

شيخ تلبى

LE GRAND
MARABOUT
MAURITANIE

GORA
MBENGUE
1984 DAKAR

Senegal is the best example of a country where a national art was brought into being through the efforts of African intellectuals, but it happened partly because there was no strong competing interest from indigenous art forms at the eve of independence in 1960. It was also, however, because one cultural ideology, that of Négritude, had its strongest voice in President Léopold Senghor himself, and for twenty years this ideology was synonymous with Senegalese national culture. In contrast, Nigeria was a country with a multitude of pre-independence plastic arts. The second major difference was that in Nigeria, artists and writers were not running the government. A third factor, which sets Nigeria apart from all other African states, was its sheer size and cultural diversity. There were more than two hundred languages spoken (each with several dialects) and many of these were paralleled by distinctive traditions of artmaking. All of this worked towards a lively (and often competitive) heterogeneity at the time of independence, making any smooth transition to a 'national' art, culture or identity exceedingly complex.

Nigerian intellectuals themselves (helped or hindered by the politicians) have been central to the forming of new artistic identities, whether national, pan-African, international, counter-national or simply modern. But the example of the original Mbari movement and its subsequent transformation in Oshogbo demonstrates the complexity of cultural politics in Nigeria and the way in which internal dynamics eventually outdistance the initial plans of the organizers. Although it ended up as a primarily Yoruba cultural phenomenon, Mbari began as something else, intended to be much more broadly Nigerian and even Pan-African. A generation later, Mbari (which ceased to exist as an organization in the early 1970s) has entered oral tradition and acquired its own mythologies, each version reflecting the memories and positional role of its narrator. In some accounts, the initial impetus in 1960 came from Wole Soyinka, then a young playwright who had returned from studying in the UK and hoped to set up an acting company. But having learned of the Bauhaus and other European experiments, he says he was equally fascinated by the idea of artists coming together and creating 'a mini culture of their own, apart from the general political culture...but always in relation to [it]'. The other crucial actor, cast in the role of fundraiser and facilitator, was Ulli Beier, who had been in Nigeria since 1950. Beier had extracted a promise of foundation support for new cultural initiatives, and urgently needed a concrete arts funding proposal to give them. Soyinka, then based

in Ibadan, called together a group of young writers including the South African Ezekiel (Es'kia) Mphalele and Nigerians Cyprian Ekwensi and John Pepper Clark, the composer Akin Euba, and artists including Demas Nwoko, Uche Okeke and Bruce Onobrakpeya. At this stage, the group was still a loose collection of artists and writers from various parts of Nigeria or abroad, most of whom shared an interest in performance genres. Had it continued in this vein, the Mbari Club might have remained a group of intellectuals interested in developing a public culture through performances, exhibitions and workshops.

But through a series of chance happenings, a different version of Mbari was developed and transformed into something Yoruba-centred and primarily a means of expression for unschooled artists and performers. Beier, then an extra-mural teacher at the University of Ibadan, was living in the Yoruba town of Oshogbo in the compound of Duro Ladipo, a primary school teacher. Ladipo, who was also a mission-educated Christian, first revealed his prodigious musical talent in an Easter Cantata he composed and performed for the Anglican church in Oshogbo and then, at Beier's invitation, at the Mbari Club in Ibadan. In the flush of this initial success Ladipo returned to Oshogbo with the idea of forming his own opera troupe under the organizational umbrella of Mbari.

The Oshogbo outpost was therefore also called Mbari – as was another centre begun in Enugu – but this unfamiliar Igbo word was translated by the local townspeople into the Yoruba term *mbari* (said with a different tone pattern) which meant 'if I were to see or encounter' to which was later added *mbayo*, 'I would rejoice'. Because the new Mbari Mbayo was located in an up-country Yoruba town – slightly down-at-the-heels economically but an important ritual centre because of the Oshun river and sacred groves – rather than in the culturally heterogeneous and sophisticated Ibadan it attracted a broad cross section of the young and jobless from the community rather than the artist-intellectuals usually found in university settings. They were all Yoruba, and few had been educated beyond primary school. Their 'Yorubaness' was both vital and unselfconscious, and formed the context for the images and narratives they created. Unlike élites, they did not have to unlearn European teaching. At the same time, the commitment to a national cultural identity was now being filtered through a specifically Yoruba sensibility.

The other point to note about the Mbari example is the crucial role played by Ulli and Georgina Beier, and also Susanne Wenger (see Chapter two). They were not the only expatriates involved:

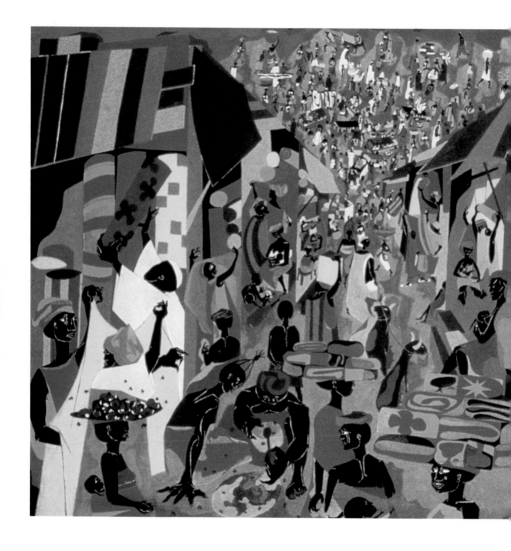

149. **Jacob Lawrence**, *Nigerian Series, Street to Mbari*, 1964. By the time he participated in the 1964 Mbari workshop, Lawrence had been an established artist in the USA for more than twenty years. He frames a crowded Yoruba textile market with brightly coloured bolts of cloth in a wide, shallow space which narrows abruptly into a funnel to suggest the street behind it.

the format of a brief workshop to teach techniques was dependent on a synergy created by bringing in a stranger to work with local participants. These included the African-American artist Jacob Lawrence, the Guyanese artist and art historian Denis Williams and the Mozambiquan painter Valente Malangatana. These expatriate artists, many of them black, were also interested in using the workshops as a stimulus for their own work. Mbari Mbayo was later criticized by some Yoruba intellectuals for being too much of an expatriate creation. Conversely, it has been criticized by other Nigerians for being too Yoruba-centric. The right circumstances to produce a modern, but also Nigerian, art have proved to be

elusive. Such a scenario would have to be culturally heterogeneous, unofficial (to avoid becoming overly institutionalized), participatory (from the bottom up, instead of top down) and with a healthy dose of past artisanal traditions thrown into the mix.

A Nigerian movement that comes somewhat closer to this ideal is a group of artists based mainly at the University of Nigeria at Nsukka, loosely known as the Nsukka Group. Like the Mbari Clubs and the Ecole de Dakar of the 1960s, the Nsukka development has been fed by the encounter of a group of academically trained modernist intellectuals with their ethnic identities and ancestral past. The central figure in the early stages was Uche Okeke. In 1958, while an art student at what later became Ahmadu Bello University in Zaria, northern Nigeria, he and fellow students formed their own unofficial organization called the Zaria Art Society (aka the Zaria Rebels) which tried over the next four years to structure a new approach to art by moving beyond the Eurocentric art academy curriculum. At least three of its leading members – Uche Okeke, Demas Nwoko and Bruce Onobrakpeya – became part of the Ibadan Mbari Club, and have continued to be major influences in Nigerian culture for over a generation. While still a student, Okeke became spokesman for the Rebels' position:

*Nigeria needs a virile school of art.... Whether our African writers call the new realisation Negritude, or our politicians talk about the African Personality, they both stand for the awareness and yearning for freedom of black people all over the world.... I disagree with those who live in Africa and ape European artists.... Our new society calls for a synthesis of old and new, of functional art and art for its own sake.*

But what soon divided Nigeria sharply from the other newly independent states was the experience of Biafra: a war of secession that isolated the Igbo and their Eastern Region neighbours. Nigeria's first military coup in January 1966 was soon followed by pogroms by northern Muslims against the Igbo and other Christian southerners living in the northern cities, forcing the Igbo in these cities to return to their Eastern Region homeland. In the early 1960s the new University of Nigeria at Nsukka, in northern Igbo country, had adopted an American-style curriculum as an alternative educational model to the British one. But the pogroms of 1966 forced Igbo students studying in Zaria to return to the safety of Nsukka, while non-Igbo teachers and students at Nsukka did the opposite and returned to their home regions. This quickly 'Igbo-ized' what had been an American-style art department and

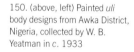

150. (above, left) Painted *uli* body designs from Awka District, Nigeria, collected by W. B. Yeatman in c. 1933

151. (above, right) **Uche Okeke**, *Mma-Nwa-Uli*, 1972

also brought the Natural Synthesis ideology from Zaria to it. The northern massacres and then the bombing raids by federal planes forced these artists, along with everyone else, to come to terms with their Igbo identity. While the war forced the closing of the University from 1967 until 1970, artists such as Okeke were involved in the Biafran war propaganda effort. When the war ended, the badly damaged university reopened and Okeke became the acting head of the Department of Fine and Applied Arts.

How did the Civil War experience affect the earlier idea of Natural Synthesis? Okeke's Zaria group was multi-ethnic, like the Ibadan Mbari Club of the same period, so it was important to lay claim to *all* of the Nigerian past, not just one piece or another, as a context for their modernity. But a decade later at Nsukka, everything had been reconfigured – just as the change of location from Ibadan to Oshogbo inevitably changed the focus of the Mbari workshops, so the transition of artists and art education from Zaria to Nsukka did the same. After finishing at Zaria, Okeke had travelled in 1962 to Germany and returned to Enugu where he directed the local Mbari cultural centre from 1964 to 1967. Okeke's interests at Enugu centred on a revival of precolonial Igbo art forms, especially the *uli* designs painted by women on the female

15

body and on the walls of houses and shrines. These differed from one part of Igboland to another, ranging from semi-abstract representations such as the sacred python to non-figural graphic symbols and free-form curvilinear patterns. The ropey, calligraphic lines of the *uli* designs were reinterpreted by Okeke in his *Mma-Nwa-Uli* (1972), although he added a coloured ground and reversed the *uli* patterns from the usual deep blue or black to white.  151

Okeke introduced this interest in specifically Igbo forms such as *uli* into a department where both teachers and students had experienced the extremes of ethnic violence and displacement. The initial interest in *uli* was both aesthetic and political – it linked their modern intellectualism to a specifically Igbo subjectivity. But in the university and on the streets, this was now tempered by the fact that the Igbo had lost the war and that they were all Nigerians now. This mattered because it opened people's minds up to other kinds of experimentation. Only a few of the Nsukka-based artists who became known as *ulists* have continued to use *uli* as their main design source.

Obiora Udechukwu was drawn to *uli* when he was one of Okeke's students, but he was also influenced by the calligraphic style of the Sudanese artist Ibrahim El Salahi (see Chapter five) with whose work his own pen and ink drawings display a deep  152

152. **Obiora Udechukwu,** *Road to Abuja*, 1982. In the words of the artist, 'Abuja, the new capital of Nigeria, is synonymous with large scale building projects, contractors, political patronage and corruption. The drawing, which exploits minimalization of details and large airy spaces, exposes the two faces of Nigeria – affluence and abject poverty – and the contradiction reflected in Nigeria's enormous resources and her dismal socio-economic condition.'

affinity. Udechukwu was forced to leave Zaria in 1966 and return to the Eastern Region where he began studying at Nsukka. His studies were interrupted by the war, but later he was awarded two degrees and eventually replaced Okeke as the most influential teacher in the department along with Chike Aniakor, another significant *uli* artist. Aniakor's best work is also strongly calligraphic, and like Udechukwu's goes well beyond the straightforward replication of *uli* symbols in a new context. If Okeke's work can be compared with Chinua Achebe's concern for the survival of Igbo culture in his early novels such as *Things Fall Apart* and *Arrow of God*, the comparable literary genre for the work (particularly drawings) of Aniakor and Udechukwu would be found in Igbo poetry. Nearly all of the Nsukka artists have written poetry themselves, which suggests that it is the lyric quality of line as well as its concise narrative ability which seem to connect poetry and drawing.

Udechukwu has also drawn freely on the script and secret sign system known as *nsibidi* from the neighbouring Cross River region of Nigeria, sometimes using one or two isolated signs, such as the spiral or mirror, and at other times creating a band of *nsibidi* signs resembling a cartouche of Egyptian hieroglyphs. In *Writing in the Sky* (1989), a group of unidentified people are silhouetted against the background of the Nsukka hills while above their heads a large sun-like spiral hangs in the sky with an attached band of *nsibidi*, like an unreadable message or prophecy.

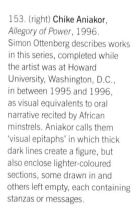

153. (right) **Chike Aniakor**, *Allegory of Power*, 1996. Simon Ottenberg describes works in this series, completed while the artist was at Howard University, Washington, D.C., in between 1995 and 1996, as visual equivalents to oral narrative recited by African minstrels. Aniakor calls them 'visual epitaphs' in which thick dark lines create a figure, but also enclose lighter-coloured sections, some drawn in and others left empty, each containing stanzas or messages.

154. (opposite) **Obiora Udechukwu**, *Writing in the Sky*, 1989

Udechukwu is an artist of complexity as well as a highly perceptive critic and intellectual, which has made him the central figure in the Nsukka Group after Okeke's premature retirement in 1986.

Not all the Nsukka artists are Igbo or even Nigerian, though they all trained or taught at Nsukka so share a common set of experiences. Younger artists who have become known through the Nsukka connection include Tayo Adenaike, who is Yoruba but studied under Udechukwu, Okeke and Aniakor between 1974 and 1982. Although he briefly worked with acrylic, he has developed as a fully realized watercolourist, beginning from a strong connection with the work of his mentor Udechukwu. Adenaike's *Evolving Cosmos* (1996) deals with the event of cosmic creation through the use of overlapping planes of cloud-like colour pierced by a central opening and embellished with *uli* dots (*ntupo*), suggestive of a face or human presence. He is also a successful commercial designer.

Barthosa Nkurumeh, another protégé of Udechukwu, has created a highly decorative style reminiscent not only of his mentor's, but of both Beardsley drawings and tapestry designs by

155. (right) **Barthosa Nkurumeh**, *Nna Mbe*, 1991. In the artist's own words, 'In Igbo folktales, Mbe the tortoise is a trickster. Thus I imposed him on a fan-like composition portraying aspects of the Igbo world. A cord links him with a ritual pin and people telling the tales.'

156. (opposite) **Tayo Adenaike**, *Evolving Cosmos*, 1996. The artist has at his disposal a large inventory of myths, legends and symbols from both Yoruba and Igbo culture, and as he says, 'stylistically the Igbo *uli* rhythmic elements have [been] and still remain a source of fascination to me. Circles in my work have always been used to depict the "single eye of heaven" that lights and perhaps makes us see the world.'

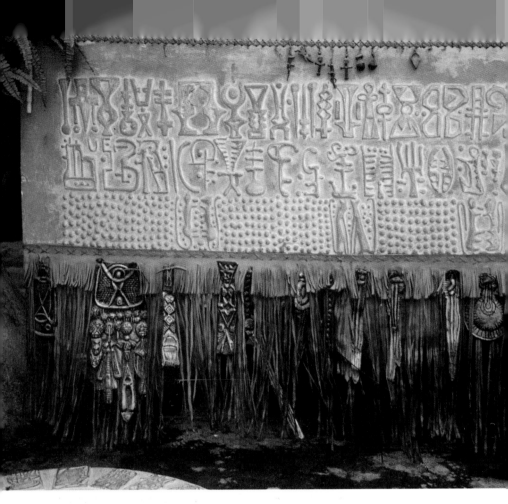

157. (above) **Bruce Onobrakpeya**, *Shrine Set*, n.d. (detail). Low-relief symbols are set densely in horizontal registers recalling decorated lintels or Asante *forowa* vessels, but with a leather-like bottom fringe. Chika Okeke remarks on the interface which is created between 'subject and object', 'artist and priest'.

158. (left) **Bruce Onobrakpeya**, *Emeravwe (Lunar Myths)*, 1983. The artist has gradually moved away from printmaking and into sculptural relief through the use of plastocasts further enhanced by coloured shapes in this depiction of an Urhobo myth.

Senegalese artists such as Bacary Dieme. Nkurumeh employs references not only to *uli*, but also to a wide variety of textile and weaving patterns combined with a calligraphic linear style.

El Anatsui, a Ghanaian, joined the teaching staff at Nsukka in 1975 and has been there ever since. He is exceptional not just because he is an expatriate, but also because he is deeply involved with wood as a medium. However, like the others, he shares a strong commitment to working with an African visual grammar and extending it into new techniques and media. He has identified this principle with the Twi expression *Sankofa* ('go back and pick'). The 'going back' includes, in his visual repertory, the patterns of Ewe weaving and the *adinkra* and *kente* cloth designs which he absorbed during his student days at the College of Art, Science and Technology in Kumasi.

Combining his interest in cloth and wood, he has produced a series of relief panels made from narrow vertical strips of wood cut with a power saw on which designs are burned in and sometimes overpainted. The strips, which are analogues of strip-woven cloth, can be reassembled in different orders and relative heights, a process meant to involve the viewer in making aesthetic decisions. His monumental 1992 installation *Erosion* is constructed from a central stepped pillar and pieces at the base which appear to have fallen off. Although produced for an environmental art workshop which preceded the Earth Summit in Brazil, El Anatsui told the critic Chika Okeke that it was not about soil erosion, but something more basic – the erosion of cultures. The small details of these sculptural pieces often reveal burned-in *nsidibi*, *uli* and *adinkra* designs. While the visual referencing of African signs is important to a close reading of El Anatsui's work, his increasing interaction with artists abroad has attentuated his Nsukka connections and moved him into a threshold where nationalism and Africanity give way to the diasporic and international.

Although not a member of the Nsukka Group, former Zaria Rebel and Mbari Club member Bruce Onobrakpeya's work as an independent printmaker has a strong affinity with Nsukka-produced graphics and has undoubtedly influenced many Nsukka students and teachers. His recent installation work converges in interesting ways with that of El Anatsui, imprinting small written symbols on larger, harder materials such as wood. If there is any single shared preoccupation in this group of artists it is the liberating use of symbols of a West African past plucked from numerous artisanal traditions and reworked as a form of modern cryptography.

7

158

157

# Chapter 7    Migration and Displacement

*Out of Africa: migration and displacement*
The condition of displacement or exile is not simply the reverse of
the romantic impulse that has propelled certain Western artists
out of their own milieu into a more exotic one, but most often is a
response by African artists to debilitating political repression or
economic chaos at home. However, these journeys have in fact only
been possible for a small minority – fluency in an international
language, recognized paper qualifications, enough money to
travel and a network of crucial contacts abroad all define who is
able to travel. Most paths have led to the former colonial metro-
pole or another country in the same language sphere. And over-
whelmingly, it has been university-trained artist-intellectuals
rather than untutored artists who have either settled permanently
or spent substantial periods outside their own countries.
Everything about their lives and careers has better prepared them
to survive in a wider world than, say, the Kuru artists of rural
Botswana or street painters in Lubumbashi.

The creation of the conditions of exile has had two major his-
torical thrusts, one fed by late-colonial education following World
War II and the other by political and economic crises following
the transition to independence in the 1960s. The inadequacy of
art schooling was initially responsible for a small cadre of extra-
ordinary African artists – mainly born in the 1930s and 1940s –
being sent to training institutions in the colonial capitals: the
Slade School of Fine Art in London, the Ecole des Beaux-Arts in
Paris and several other European academies. The postcolonial
migration that came later due to political instability and economic
decline has affected certain African countries much more starkly
than others. A few of the artists involved had initially travelled
abroad as students, enabling them to develop contacts in the West
and to serve later as contacts themselves for their counterparts
still in Africa. Aside from those in London and Paris, one particu-
larly cohesive group of artist-emigrés has been Ethiopian artists
in the USA, while a more recent diaspora has been formed there by
Nigerian artists. They have clustered in and around universities as
postgraduate students and later, as teachers, and a new vocational

space has emerged since 1990 for African intellectuals outside the university, as freelance critics and curators.

*The mind–body problem: Ethiopian artists abroad*

The experience of exile is a little like a painful divorce or bereavement – the individual is forced to confront a new identity. Yet some migratory artists remain firmly or tenuously attached to their former local, national or regional identities and traditions all their lives. As the South African writer Njabulo S. Ndebele has observed, his overseas experience in the UK and the USA afforded him 'a necessary distancing from South Africa. This, paradoxically, served as means of recall, of retaining a kind of distilled memory.' In a similar comment, the Sudanese artist Ibrahim El Salahi remarked, 'the locality of one's own home becomes almost a past dream, very, very dear. You have a longing for it, nostalgia, as if it were something from a distant past.' But on a more pragmatic level, 'When I was growing up I thought that England, France, the Philippines were on some remote periphery of Khartoum, which was at the centre of everything. But as I moved out to London [to attend the Slade], my new home then became the centre of the world.'

This push and pull of memory and sensibilities can have many outcomes. Skunder (Alexander) Boghossian trained in London

159. Skunder (Alexander)
Boghossian, *Climatic Effects*,
1984–85

and Paris and spent only four years teaching in Ethiopia (1965–69) before migrating to the USA in the early 1970s, but he is nonetheless very much an 'Ethiopian' artist in the sense of what he draws upon. His visual vocabulary – while it has changed over the past thirty years and at one time encompassed neo-surrealist elements developed in response to his early years in Paris – has re-created the memory of the monastic scriptorium in contemporary artistic practice. It is relatively easy to isolate the factors which make this so – luminosity (which recalls the illuminated manuscript tradition of the Ethiopian Church), the preeminence of drawing, and a technique which involves the suspension of molecules of paint on a water-soaked surface, creating a strong sense of fission and fusion of forms within an embryonic mass.

But it is considerably more difficult to explain what these paintings are about. Some of his earlier surrealist work has evoked cosmogonic events wrapped in delicate tissues of animals and birds, such as *Rhonda's Bird* (1974). His other major direction has been to 16 improvise upon the parchment scroll lettered in Ge'ez (guèze) – the liturgical script of the Ethiopian Church – or Amharic and decorated with intertextual figures, at first creating painted versions and later turning these into three-dimensional assemblages using other traditional scriptorium materials such as stretched goat skin. Yet these are in no sense simply referential works; they take off simultaneously forwards and backwards in art history. In *Climatic Effects* (1984–85), a sun effaced by droplets of 15

160. Skunder (Alexander) Boghossian, *Rhonda's Bird*, 1974

precipitating pigment is suspended above a line of scroll-shaped painted images which at first look like colourful neckties hung up to dry.

Skunder left Ethiopia before the 1974 revolution which overthrew the monarchy, but the repressive military junta known as the Derge soon made returning home an unlikely possibility, and remaining there became an equally uninviting prospect for younger artists who were pressured by the government to produce works of formulaic socialist realism. The extraordinary outcome was the migration of an important stream of Ethiopian painters to Howard University in Washington, D.C., where Skunder began teaching in 1972. A diaspora of Ethiopian painters devoted to him as a colleague or teacher and attracted to the advantages of studying and working in the USA formed around him.

A second example is Wosene Kosrof, who like most migratory Ethiopian artists, first studied at the School of Fine Arts in Addis Ababa. He then taught there before going to Howard on a fellowship in 1978. After eight years of teaching at Goddard College in Vermont, he moved to California where he says he was forced to confront sky and water and their effects on light. Even more than Skunder, Wosene has explored both the graphic and talismanic aspects of writing as well as the illusion of multiple overlapping 162, 163 surfaces in his painting. His models include the two Sudanese artists Ibrahim El Salahi and Ahmad Muhammad Shibrain, whose explorations of Arabic script in the early 1960s parallel and in  161

161. **Ahmad Muhammad Shibrain**, *Calligraphy*, early 1960s

162 and 163. **Wosene Kosrof**, *Almaz*, 1982 (opposite) and *Dancing Spirits*, 1996 (above). In the early 1980s the artist's focus was on the exploration of the abstract dimensions of Amharic writing or *fiedel*. But the artist has said about *Dancing Spirits*, 'In this [more recent] work I disassemble, exaggerate and distort the Amharic calligraphy... I let the *fiedel* free-float and dance in space.'

some cases predate those by Ethiopian artists with reference to Amharic manuscript traditions. El Salahi and Shibrain were in turn the students of Osman Waqialla whose training abroad included the School of Arabic Calligraphy in Cairo and who by the late 1950s had established calligraphy as an important artistic genre within what came to be called the Khartoum School.

Girmay Hiwet, whose early education parallels Wosene's, 164 chose to migrate to Switzerland instead of the USA, though he spent 1983 in Washington, D.C., where his contact with African-

164. Girmay Hiwet, 1989

American artists was as important as his membership in the Ethiopian circle. His 1983 portrait of his Swiss-Ethiopian son Ezana both alludes to the child's dual identity and on another level, illustrates the strategy of double meanings known metaphorically as 'wax and gold' when writing Amharic poetry.

*It shows my son: this is the obvious – the wax. There is a saying in Ethiopia which goes: when you have a child, this is the only real way of seeing yourself eye to eye. In this sense the painting really represents me. This is the hidden content: the gold.*

The incorporation of both Swiss and Ethiopian symbols in the portrait is a reminder that there are two sides to the question of personal agency raised by cultural nomadism: not only is the migratory artist uprooted from a familiar environment and set down in a different artistic scenario far from home, but he or she both affects and is affected by the practising artists who are already there. Through his presence at Howard University, a major centre of African American intellectual life, Skunder has influenced not only fellow Ethiopian exiles, but a whole generation of African American artists, including the AFRI-COBRA group who consciously sought from 1969 to create what they have termed a 'transAfrican' movement or style. Conversely, transplanted Ethiopian artists such as Wosene were encouraged by their African American students and colleagues to explore their African artistic sources. This means that work such as Skunder's has come to be identified not only as 'Ethiopian' art in a sense which other Ethiopians and art historians would understand, but also as 'black' and as 'African' in the culturally mediated sense that is understood by critics and public in the African diaspora and in relation to important exhibition spaces such as the Studio Museum in Harlem. And even beyond this, once his work entered the collection of the Museum of Modern Art in New York and the Musée d'Art Moderne in Paris, he reached another level of cultural abstraction for a much wider audience as a 'modern' artist. Each of these identities coexists in a sometimes uneasy relationship with the others. For example, to be 'Ethiopian' was a positive attribute in the 1970s, but such labels are now criticized by many younger artists as part of a Western discourse of modernity which continually revisits ethnicity as a form of primitivism.

Elisabeth Atnafu, another Ethiopian artist to have come through the Howard University system, partakes of the same culturally mediated identities. And as a woman artist in a

165. (opposite) **Girmay Hiwet**, *To See Your Own Eyes With Your Own Eyes*, 1983

primarily male circle, living in New York instead of Addis Ababa, 'gender' also becomes for her one more publicly marked category. In 1976, she won the United Nations' International Women's Artist Award. Although initially a painter, she has more recently done installation work such as *A Shrine for Angelica's Dreams* (1994) which transforms the white dress worn by highland Ethiopian women into an evocative, lace-edged 1920s Western-style dress and uses it as a framing device hung with memorabilia which evoke trans-cultural memories. Her paintings of the 1980s identify her more closely with the Howard-Ethiopian circle in their use of paper, a luminous palette of colours and fine, sgraffito-like line.

But their diasporic experience has not been the only formative influence for these artists. Several were trained first by Gebre Kristos Desta at the School of Fine Arts in Addis Ababa before migrating abroad. Born five years earlier, Gebre Kristos's early career paralleled that of Skunder, training in Germany and returning to Ethiopia in the early 1960s at a time of cultural florescence across much of the continent. Desta continued to teach at the School long after Skunder had left, making his influence felt on many artists including Achamyeleh Debela and Alemayehou Gabremedhin. Although the son of a manuscript illuminator, he

166. (below) **Elisabeth Atnafu**, *The Year of Love*, 1984

167. (opposite) **Gebre Kristos Desta**, *Golgotha*, 1963

disclaimed the religious aspect of art in his own work, which was aggressively non-traditional and ranged from painterly abstraction to an emphasis on drawing and figural themes focused on poverty and oppression. Nonetheless, one of his seminal works, *Golgotha* (1963), uses the crucifixion of Christ as the metaphor for this oppression.

Debela, Desta's former student, migrated to the USA in 1972 where he rejoined Skunder's circle and later studied for a doctorate in computer art. He has embraced technology in a way that reflects both the iconoclasm of his early teacher and the traditionalizing modernism of the Washington group. Alemayehou, who also studied with Desta and Skunder, works in Maryland and exemplifies the culturally balanced 'transAfricanism' which AFRI-COBRA artist Jeff Donaldson has described as originating with the Cuban painter Wifredo Lam (1902–82). The genealogical connection in Alemayehou's case can be traced through Skunder, who with Lam was part of a group of French, African and African diaspora artists, poets and intellectuals who interacted together in Paris during the late colonial period, experimenting with surrealism and the transcultural literary project of Négritude.

167

168

169

168. **Achamyeleh Debela,** *A Song for Africa*, 1992–93

169. Wifredo Lam surrounded by
his paintings in his studio at 8,
rue Armand Moisant, Paris, 1940

The careers of these Ethiopian artists exemplify one kind of
diasporic movement of African art out of its place of origin and
primary cultural identity. Theirs are richly textured narratives of
displacement, the classic material out of which art histories are
usually constructed. But what of those who didn't leave? Zerihun
Yetmgeta attended the School of Fine Arts in Addis Ababa between
1963 and 1968, first taught by the German woodcut artist Karl
Heinz Hansen (known as Hansen-Bahia) and then by Skunder. This
resulted eventually in mixed-media works made from long narrow
panels of painted skin, framed on bamboo strips and depicting the
history of Christian religion, the art of magic, the evolution of

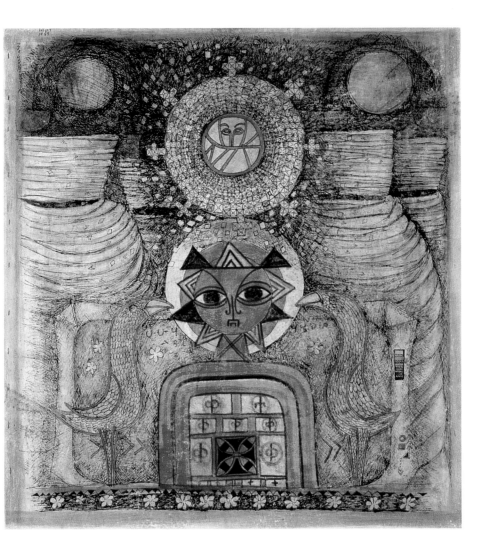

170. (opposite) **Zerihun Yetmgeta**, *Research from the Art of Magic*, 1988

171. (above) **Zerihun Yetmgeta**, *Fishing the Evil Eye*, 1989

animal life, science, and even women's fashions. A fundamental theme in his work is enigma, suggested by the white-clad priest figures whose faces are hidden in *Research from the Art of Magic* (1988). To these are added the strange juxtapositions found in *Fishing the Evil Eye* (1989) – a Solomonic icon which masks the hidden meaning which is that it is actually Jesus Christ, situated before a large television screen (an icon of competing but lesser power), guarded on both sides by birds while the sun with its aureole of crosses hovers above as another hidden symbol of Christ. Yetmgeta stayed on at the School as an instructor in woodcutting after Hansen-Bahia had left. He considers this fact crucial to his development:

170

171

*It is a good thing I did not go abroad to study art…my studies…would have filled me with rules and beliefs which would have prevented me from being fully Ethiopian and unabashedly African, which is to say, I would not have been able to be fully myself as an artist.*

Yet without these biographical details, it would be difficult for the spectator to single out Yetmgeta's work among that of a group of Ethiopian artists of his generation as the only one not living abroad. This suggests right away that the model of how art actually 'travels' globally is much too simplistic if assumed to involve only artists who themselves circulate. Clearly Yetmgeta saw illustrations of the work of Skunder or Wosene or Hiwet from time to time, and they saw illustrations of his. Cross-fertilization, as is clear with the case of Picasso and so many African artists, does not necessarily require rubbing shoulders.

Yetmgeta and many of the Ethiopian artists who formed the Washington diaspora employ talismanic signs and certain materials and techniques of the monastic scriptorium as points of connection to a cultural matrix which they claim, much as the Nsukka group of artists use *uli* or *nsibidi* (see Chapter six). But just as there are still 'real' *uli* artists – the women who decorate compound walls and their own bodies – so there are also 'real' makers of talismanic art in the Ethiopian Orthodox Church. The artist known as Gedewon lives in Addis Ababa and makes what he calls 'talismans of research and study' as well as others which have a direct protective function – prayers, lists of evils and names of God written in ink on pieces of paper which have been divided into sections each containing a text in Ge'ez (guèze), embellished by human and animal figures. The boundary between the sacred art of a practitioner and an art which references the same forms in order to evoke that world is sometimes sharply clear and at other times blurred. Gedewon seems part-artist, part-priest.

*Beyond nationalism: new maps, new rules*
The Ethiopian case is unusually complex because it involves so many artists in close contact with one another, but there is another form of artistic migration which is much more solitary, itinerant and hand to mouth, and which follows the model of the lone entrepreneur. Some migratory art is carried by African artists who travel, rather than it making its way into New York or London or Johannesburg through the curatorial route of international exhibitions. Tunde Odunlade, once apprenticed to Oshogbo artist Yinka Adeyemi in Nigeria, combines the roles of artist and entrepreneur

by travelling frequently from city to city in the USA attempting to exhibit and sell not only his own work, but also that of several others from Ife and Oshogbo such as Tayo Awoyera. He says he comes by this nomadism naturally, since his mother is a trader in Nigeria.

One of the original group of Oshogbo artists, Jimoh Buraimoh, travelled to Atlanta in the USA to exhibit his bead mosaics in the 1996 Olympic Games Cultural Olympiad. Since then he has worked part-time, teaching children in Atlanta schools and has just completed a mosaic commission for the city's Bureau of Cultural Affairs. These kinds of connections are more difficult for

172. (left) **Tunde Odunlade** in Atlanta with his work *Happy Faces*, 1995

173. (above) **Tayo Awoyera**, *Lagos Life*, 1995

workshop-trained artists to sustain than they are for artists who have the paper qualifications to enter the university teaching circuit. Buraimoh was an electrician for the Duro Ladipo theatre company in Oshogbo when he attended Georgina Beier's second workshop in 1964. As the only artist emerging from that milieu to work in the bead medium, his production was distinctive, yet shared with the others the boldness and rough energy of the early linocuts and paintings. A decade later he completed a certificate course in design at Ahmadu Bello University, but it is his entrepreneurial skills that have enabled him to travel abroad – before embarking on this nomadic stage of his career, he opened a restaurant and music club in Oshogbo which supports his family in his absence.

174 and 175. **Jimoh Buraimoh**, bead mosaic in progress in the artist's studio, Atlanta, 1997 (below) and *Untitled*, 1964 (right). Buraimoh now works frequently on large compositions in either beads or tile mosaic. One effect of this change of scale from his work of the 1960s at Oshgobo has been the imposition of regularities and a stricter geometry.

Another category of migrants are women who find it difficult to be taken seriously as artists in their own cultures. Sokari Douglas Camp, a Nigerian sculptor who lives and works in the UK, is one of them. She was interviewed by Wendy Belcher in 1988 prior to the opening of her exhibition at the National Museum of African Art in Washington, D.C.:

176

*WB: What are the major influences on your work?*

*SDC: The major influences are the Kalabari festival and the fact that in the West women are allowed to make sculptures. In my own situation in Nigeria, I would not be given the opportunity to make art, because objects in my part of Nigeria are religious. If I were making objects in Nigeria, I would be a priestess. I wouldn't be talking about art. I'd be talking about curing people or talking to spirits....*

176. **Sokari Douglas Camp**, *Clapping Girl (Small Iriabo)*, 1986. In the 1980s, Camp experimented with motorized metal sculptures. This one is of a young Kalabari initiate (*Iriabo*) clapping, while dressed for her coming-of-age ceremonies in thickly wrapped layers of cloth and traditional waistbeads. Of the use of movement in her sculpture Camp has said, 'Movement I find very amusing, and I think you need humor.... The serious side of it is that I would like to shock.'

*WB: Do you see yourself primarily as a Western artist or as an African artist?*

*SDC: I see myself as an artist. Being an African artist or being a Western artist has got nothing to do with it. I think that being an artist overrides all that.*

It would be hard to imagine another answer to this question from an artist who was trained at the California College of Arts and Crafts and then in London, and has never practised art in her own country. At the same time, the thematic repertory for her work comes from Kalabari culture and is very strongly situated within it. Beyond this, the process of fabrication itself is tied in her memory to such things as helping her mother make thatching. She says, 'I find myself preparing things in my work as if I am making the things I've seen women make. I am forever binding my stuff, cutting it into little bits, and fixing it into something else. I think my art has something to do with cooking or cleaning the house.' In saying this, she revives the domestic artisanship of Kalabari women as something of relevance, yet reserves the right to be 'just an artist', neither African nor Western – she uncouples her past, yet keeps it close to hand, like a particularly useful workshop tool.

These identity claims sometimes have more to do with artists' everyday conditions of production than with their cultural memories, but it can also be the reverse. Magdalene Odundo of Kenya and Mohammed Ahmed Abdalla of Sudan are cases in point. Both are superb contemporary potters, African ceramic artists who live and work in the UK. Despite this, Abdalla has consciously worked within a formal tradition associated with the Nile Valley while adapting it to high-temperature firing and the wheel-thrown technique. Odundo, on the other hand, has chosen to do the reverse: her minimalist pottery style is completely her own and bears no formal resemblance to traditional Kenyan pots, but her technique combines the hand-building typical of African clay vessels with a variety of firing methods. Furthermore, to learn traditional techniques (having been trained initially in Western ones) she not only returned to Africa and observed Kenyan and Nigerian women potters at work, but she also studied the potters of San Ildefonso in the American Southwest. Her relation to any particular tradition is therefore much more ambiguous than either Abdalla's or Sokari Douglas Camp's, although she – unlike they – has chosen to employ an ancient technology.

Western collectors, cultural institutions and audiences are decidedly more at ease with artists who lay claim to their African

17

identity than with those who do not. For one thing, this identity is made to seem natural in the discourse of many African diaspora artists and critics and in the popular interpretation of multi-culturalism. For another, it appears to provide some kind of necessary formula for decoding work that is assumed by critics and publics to be otherwise resistant to interpretation. In purely pragmatic terms, it is therefore easier for an African artist abroad to make use of this circumstance than to fight it. Nonetheless several do, using some of the same arguments made by artists of Native American ancestry such as Jimmie Durham and James Luna in, for example, *The Decade Show* (1990). While there are many important differences between them and African artists working in the international arena, Native American artists have also had to position themselves for or against an artworld discourse which assumes any approach to their work must centre on their own relation to a primordial 'tradition'. In 1992, Billy Soza War Soldier spoke for many of these artists when he said, 'I really consider myself an American painter, although I am an Indian. No one calls Picasso and Dali Spanish painters.'

177. **Magdalene Odundo**, *Untitled #12* (front) *and #8* (back), 1995

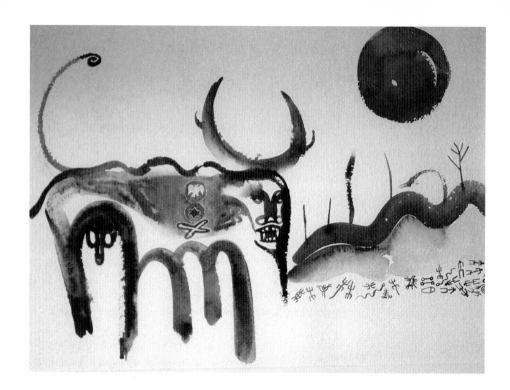

178. **Olu Oguibe**, *The Emperor, or The Beast in Landscape*, 1990. The double title connects the image of a long-horned bull with aggressive political power, but the visual power of this image lies in its extreme economy, with the barest suggestion of a burnt-out landscape and a relentless red sun accompanying this emperor-destroyer.

Olu Oguibe, a young painter and writer living and working in the USA, has gone even further in distancing himself from his previous identification with Ulism, Nsukka and Nigeria:

*An artist as transitory as myself would not fit into a style. I have referenced Uli, Nsibidi, Adinkra, Adire, Mbari, Dogon sculpture, Ndebele murals, San rock art, Maya and Inca textile art, European abstract expressionism, postmodernism, social realism and conceptualism, in addition to my own forms and ideas.*

Part of this, as Simon Ottenberg suggests, is a conscious strategy to work through the implications of a collapse-of-history post-modernism. Another part is likely to be the constant exploration of new sources that characterize the trajectory of any inventive artist's career. But both the strategy and the pursuit, when focused upon concrete cultural references such as *nsibidi* signs or San rock art (as opposed to less specific cross-cultural phenomena such as social realism or conceptualism) suggest a further motive, which could be summarized as the African artist-intellectual's search for a 'usable past'. That usable past becomes an encyclopedic

referencing of history in the work of Ouattara, an Ivoirian painter who lives in New York. In *Samo the Initiated* (1988), said to memorialize diaspora artist Jean-Michel Basquiat, a partly mummified Egyptian lies inside a casket over which are suspended two divination boards with different messages encrypted, while a small lizard hangs upon the upper left corner.

London, once the centre of the British Empire, is closer to Africa than New York is, both geographically and psychologically. Yinka Shonibare, a Yoruba artist born in London, creates installation pieces there, using as a medium the printed cotton (*kitenge*) derived originally from Dutch Java wax batik prints and factory-made in Manchester, England, for the African market. The transnational character of the designs (Indonesian transformed by British manufacturers to be generically African) and their tracing of colonial trade routes (Indonesia–Holland–England–Africa) gives them a vocality of their own which interacts with the installation's other messages. *Five Undergarments and Much More* was created for the *Imagined Communities* exhibition (London, 1995), itself a comment on Benedict Anderson's 1983 study of the same title. Anderson argued that representations of all kinds (artworks, flags, stamps, uniforms, etc.) are constitutive of, not merely reflections of, communities and more broadly, nationalisms. Kobena

179

180

179. (below) **Ouattara**, *Samo the Initiated*, 1988

180. **Yinka Shonibare,**
*Five Undergarments and
Much More,* 1995

Mercer in the catalogue essay extends this point to the shaping of
'counter-nationalisms' – imaginary cultural maps with no corre-
sponding territories, just emotional ties with a once-shared past
or a fragmented present. In this sense both Nigerian and
Ethiopian artists abroad are part of imagined communities.

But not to claim one's Africanness may be, ultimately, an
impossible choice to make. In *Nationalism, Colonialism, and
Literature,* Marxist critic Terry Eagleton has put the nature of the
dilemma succinctly in relation to another problem, that of the
equality of women: 'Women are not so much fighting for the free-
dom to be women…as for the freedom to be fully human; but that
inevitably abstract humanity can be articulated in the here and
now only through their womanhood, since this is the place where
their humanity is wounded and refused.' In almost the same way,
one can say that African artists are not so much fighting for
the freedom to be 'African' (whatever that may mean), but to be
fully accepted as artists, though this can only be articulated
*through* their Africanness, since that is the site of their categorical
exclusion from a global art discourse in the first place.

# Bibliography

Introduction

Appiah, Kwame Anthony, *Is the Post- in Postmodern the Post- in Postcolonial?*, in *Critical Inquiry*, 17, winter 1991, pp. 336–57

Bal, Mieke, and Inge E. Boer (eds), *The Point of Theory*, New York, 1994

Clifford, James, *The Predicament of Culture*, Cambridge, MA, 1988

Giddens, Anthony, *The Constitution of Society: Outline of the Theory of Structuration*, Cambridge, c. 1984

———, *The Consequences of Modernity*, Stanford, CA, 1990

Greenberg, Clement, *The Collected Essays and Criticism*, John O'Brian (ed.), Chicago, 1986

Harvey, David, *The Condition of Postmodernity*, Oxford, 1989

Kasfir, Sidney Littlefield, *Taste and Distaste: the Canon of New African Art*, in *Transition* 57, new series vol. 2, no. 3, 1992, pp. 52–70

Lazarus, Neil, *Comparative Modernities? Marxism and the Critique of Eurocentrism in Postcolonial Studies*, Crossing Borders Seminar, Emory University, Atlanta, 1998

McEvilley, Thomas, *The Selfhood of the Other: Reflections of a Westerner on the Occasion of an Exhibition of Contemporary Art from Africa*, in Susan Vogel et al., *Africa Explores: 20th Century African Art* (exh. cat.), The Center for African Art, New York, 1991

Mudimbe, V. Y., *The Idea of Africa*, Bloomington and London, 1994

Nunley, John W., *Moving with the Face of the Devil: Art and Politics in Urban West Africa*, Urbana, 1987

Strother, Z. S., *Inventing Masks: Agency and History in the Art of the Central Pende*, Chicago, 1998

Tilley, Christopher (ed.), *Reading Material Culture: Structuralism, Hermeneutics and Post-structuralism*, Oxford, 1990

Vansina, Jan, *Arts and Society Since 1935*, in Ali Mazrui (ed.), *UNESCO General History of Africa*, vol. 8: *Africa Since 1935*, London and Berkeley, 1993, pp. 582–632

Willett, Frank, *African Art: an Introduction*, London and New York, 1971, rev. edn 1993

Chapter 1

*Art from South Africa* (exh. cat.), Museum of Modern Art, Oxford, 1990

Barber, Karin, *Popular Arts in Africa*, in *African Studies Review*, vol. 30, no. 3, 1987, pp. 1–78

Beier, Ulli, *Middle Art: the Paintings of War*, in *African Arts*, vol. 9, no. 2, 1976, pp. 20–23

Fabian, Johannes, *Popular Culture in Africa: Findings and Conjectures*, in *Africa*, vol. 48, 1978, pp. 315–34

———, *Remembering the Present: Painting and Popular History in Zaire*, Berkeley, 1996

Gilbert, Michelle, *Concert Parties: Paintings and Performance*, in *Journal of Religion in Africa*, vol. 28, no. 1, 1998, pp. 62–92

Jewsiewicki, Bogumil, *African Historical Studies: Academic Knowledge as 'Usable Past' and Radical Scholarship*, in *The African Studies Review*, vol. 32, no. 3, 1989, pp. 1–76

———, *Painting in Zaire: From the Invention of the West to the Representation of the Social Self*, in Susan Vogel et al., *Africa Explores: 20th Century African Art* (exh. cat.), The Center for African Art, New York, 1991

Jules-Rosette, Bennetta, *The Messages of Tourist Art: an African Semiotic System in Comparative Perspective*, New York, c. 1984

Lods, Pierre, *The Painters of Poto-Poto*, in Clémentine Deliss (ed.), *Seven Stories about Modern Art in Africa* (exh. cat.), Whitechapel Art Gallery, London, 1995

Magnin, André (ed.), *Seydou Keita*, Zurich, Berlin and New York, 1997

Mudimbe, V. Y., *'Reprendre': Enunciations and Strategies in Contemporary African Arts*, in Susan Vogel et al., *Africa Explores: 20th Century African Art* (exh. cat.), The Center for African Art, New York, 1991

Nettleton, Anitra, *The Myth of the Transitional: Black Art and White Markets in South Africa*, in *South African Journal of Cultural and Art History*, vol. 2, no. 4, 1988, pp. 301–10

Pritchett, Jack, *Nigerian Truck Art*, in *African Arts*, vol. 12, no. 2, 1979, pp. 27–31

Richards, Colin, *Desperately Seeking 'Africa'*, in *Art from South Africa* (exh. cat.), Museum of Modern Art, Oxford, 1990

Sack, Steven, *The Neglected Tradition: Towards a New History of South African Art (1930–1988)* (exh. cat.), Johannesburg Art Gallery, Johannesburg, 1988

Szombati-Fabian, Ilona, and Johannes Fabian, *Art, History and Society: Popular Painting in Shaba, Zaire*, in *Studies in the Anthropology of Visual Communication*, vol. 3, 1976, pp. 1–21

Tonkin, Elizabeth, *Narrating Our Past: the Social Construction of Oral History*, Cambridge, 1992

Vogel, Susan, et al., *Africa Explores: 20th Century African Art* (exh. cat.), The Center for African Art, New York, 1991

Younge, Gavin, *Art of the South African Townships*, London and New York, 1988

Chapter 2

Beier, Ulli, *Art in Nigeria*, Cambridge, 1960
———, *Contemporary Art in Africa*, London, 1968
Carroll, Kevin, *Yoruba Religious Carving: Pagan and Christian Sculpture in Nigeria and Dahomey*, New York, 1967
De Jager, E. J., *Images of Man: Contemporary South African Black Art and Artists*, Cape Town, 1992
Horton, Robin, *The Kalabari Ekine Society: a Borderland of Religion and Art*, in *Africa*, vol. 33, no. 2, 1963, pp. 94–114
Kasfir, Sidney Littlefield, *Apprentices and Entrepreneurs: The Workshop and Style Uniformity in Sub-Saharan Africa*, in Christopher D. Roy (ed.), *Iowa Studies in African Art: The Stanley Conferences at The University of Iowa*, vol. 2, 1985
———, *Remembering Ojiji: Portrait of an Idoma Artist*, in *African Arts*, vol. 22, 4, summer 1989, pp. 44–51, 86–87
Kennedy, Jean, *New Currents, Ancient Rivers: Contemporary African Artists in a Generation of Change*, Washington, D.C., 1992
Nettleton, Anitra, and David Hammond-Tooke (eds), *African Art in Southern Africa: From Tradition to Township*, Johannesburg, 1989
Oyeneye, Olatunji, *Factors Influencing Entry into the Informal Sector Apprenticeship System: the Nigerian Case*, in *African Social Research*, vol. 32, 1981, pp. 1–27
Rankin, Elizabeth, *A Mission for Art: the Evangelical Lutheran Church Art and Craft Centre at Rorke's Drift*, in John Picton (ed.), *Image and Form: Prints, Drawings and Sculpture from Southern Africa and Nigeria*, London, 1997
Rousseau, Jean-Jacques, *Discourse on the Origins of Inequality (second discourse); Polemic; and Political Economy*, in *The Collected Writings of Rousseau*, vol. 3, Roger D. Masters and Christopher Kelly (eds), Hanover, NH, 1992
Sack, Steven, *Common and Uncommon Ground: South African Art to Atlanta* (exh. cat.), City Gallery East, Cultural Olympiad, Atlanta, 1996
Wenger, Susanne, *The Timeless Mind of the Sacred: Its New Manifestations in the Osun Groves*, Ibadan, 1977

Chapter 3

Agthe, Johanna, *Wegzeichen: Signs: Art from East Africa (1974–1989)* (exh. cat.), Museum für Völkerkunde, Frankfurt-am-Main, 1990

Arnold, Marion, *Zimbabwe Stone Sculpture*, Bulawayo, Zimbabwe, 1986
Comaroff, Jean, *Body of Power, Spirit of Resistance: the Culture and History of a South African People*, Chicago, 1985
Court, Elspeth, *Pachipamwe: the Avant-Garde in Africa?*, in *African Arts*, vol. 25, no. 1, 1992, pp. 38–49, 98
Jung, Carl G., *Psychology of the Unconscious*, trans. by Beatrice M. Hinckle, New York, 1916
Koloane, David, *The Polly Street Art Scene*, in Anitra Nettleton and David Hammond-Tooke (eds), *African Art in Southern Africa: From Tradition to Township*, Johannesburg, 1989
———, *The Thupelo Art Project*, in *Art from South Africa* (exh. cat.), Museum of Modern Art, Oxford, 1990
———, and Ivor Powell, *In Conversation*, in Clémentine Deliss (ed.), *Seven Stories about Modern Art in Africa* (exh. cat.), Whitechapel Art Gallery, London, 1995
Lutz, Catherine A., and Jane L. Collins, *Reading National Geographic*, Chicago, 1993
McEwen, Frank, *The African Workshop School* (pamphlet), Mardon Printers, Rhodesia, 1967
———, *New Art from Rhodesia* (exh. cat.), Salisbury, Rhodesia, n.d.
———, *Shona Art Today*, in *African Arts*, vol. 5, no. 4, 1972
Rankin, Elizabeth, *Teaching and Learning: Skotnes at Polly Street*, in Frieda Harmsen (ed.), *Cecil Skotnes*, South African National Gallery, Cape Town, 1996
Rosen, Rhoda, *Art History and Myth Making in South Africa: the Example of Azaria Mbatha*, in *Third Text*, no. 23, 1993, pp. 9–22
Rushing, W. Jackson, *Native American Art and the New York Avant-Garde*, Austin, 1995
Stanislaus, Grace, *Contemporary African Artists: Changing Tradition* (exh. cat.), The Studio Museum in Harlem, New York, 1990
Sultan, Olivier, *Life in Stone: Zimbabwe Sculpture, Birth of a Contemporary Art Form*, Baobab Books, Harare, 1992
Walker, David A. C., *Paterson of Cyrene: A Biography*, Mamba Press, Gweru, Zimbabwe, 1985
Winter-Irving, Celia, *Stone Sculpture in Zimbabwe: Context, Content and Form*, Roblaw Publishers, Harare, 1991
Younge, Gavin, *Inventing South African Art*, in *Art from South Africa* (exh. cat.), Museum of Modern Art, Oxford, 1990

Chapter 4

Appadurai, Arjun, *Commodities and the Politics of Value*, in *The Social Life of Things: Commodities in Cultural Perspective*, Cambridge, 1986
Ben-Amos, Paula, *Professionals and Amateurs in Benin Court Carving*, in Daniel McCall and Edna Bay (eds), *African Images: Essays in African Iconology*, New York, 1974
———, *A la Recherche du Temps Perdu: On Being an Ebony Carver in Benin*, in Nelson Graburn (ed.), *Ethnic and Tourist Arts: Cultural Expressions from the Fourth World*, Berkeley, 1976
———, *Pidgin Languages and Tourist Arts*, in *Studies in the Anthropology of Visual Communication*, vol. 4, no. 2, 1977, pp. 128–39
Comaroff, Jean and John (eds), *Modernity and its Malcontents: Ritual and Power in Postcolonial Africa*, Chicago, 1993
Gore, Charles, *Casting Identities in Contemporary Benin City*, in *African Arts*, vol. 30, no. 3, 1997, pp. 54–61, 93
Graburn, Nelson (ed.), *Ethnic and Tourist Arts: Cultural Expressions from the Fourth World*, Berkeley, 1976
Jules-Rosette, Bennetta, *Aesthetics and Market Demand: the Structure of the Tourist Art Market in Three African Settings*, in *The African Studies Review*, vol. 29, no. 1, 1986, pp. 41–59
Kasfir, Sidney Littlefield, *Patronage and Maconde Carvers*, in *African Arts*, vol. 13, no. 3, spring 1980, pp. 67–70, 91–92
———, *African Art and Authenticity: a Text with a Shadow*, in *African Arts*, vol. 25, no. 2, spring 1992, pp. 41–53, 96–97
———, *African Art in a Suitcase: How Value Travels*, in *Transition* 69, new series vol. 6, no. 1, 1996, pp. 146–58
———, *Samburu Souvenirs: Representations of a Land in Amber*, in Ruth M. Phillips and Christopher B. Steiner (eds), *Unpacking Culture: Art and Commodity in Colonial and Postcolonial Worlds*, Berkeley, 1999
Kingdon, Zachary, *Chanuo Maundu: Master of Makonde Blackwood Art*, in *African Arts*, vol. 29, no. 4, 1996
Kopytoff, Igor, *The Cultural Biography of Things: Commoditization as Process*, in Arjun Appadurai (ed.), *The Social Life of Things: Commodities in Cultural Perspective*, Cambridge, 1986
Lincoln, Bruce, *Discourse and the Construction of Society*, Oxford, 1989
MacCannell, Dean, *The Tourist: a New Theory of the Leisure Class* (2nd edn), New York, 1989
Nevadomsky, Joseph, *Contemporary Art and Artists in Benin City*, in *African Arts*, vol. 30, no. 4, 1997, pp. 54–63, 94–95

Noy, Ilse, *The Art of the Weya Women*, Baobab Books, Harare, 1992

Phillips, Ruth M., and Christopher B. Steiner (eds), *Unpacking Culture: Art and Commodity in Colonial and Postcolonial Worlds*, Berkeley, 1999

Richter, Dolores, *Art, Economics and Change: The Kulebele of Northern Ivory Coast*, La Jolla, CA, 1980

Steiner, Christopher B., *African Art in Transit*, Cambridge, 1994

Stewart, Susan, *On Longing: Narratives of the Miniature, the Gigantic, the Souvenir, the Collection*, Baltimore, 1984

Chapter 5

*Africus*, 1st Johannesburg Biennale, Johannesburg, 1995

Araeen, Rasheed (ed.), special issue on *Magiciens de la Terre* exhibition, *Third Text*, no. 6, 1989

———, *What is Post-apartheid South Africa and its Place in the World?*, in *Africus*, 1st Johannesburg Biennale, Johannesburg, 1995

Atkinson, Brenda, *Routes to Global Culture*, in *Electronic Mail & Guardian*, Johannesburg, 9 October 1997

———, *Borrowed Images: Johannesburg Biennale – Good Works, Heated Debate*, in *Electronic Mail & Guardian*, Johannesburg, 30 October 1997

Beier, Ulli, *The Right to Claim the World: Conversations with Ibrahim El Salahi*, in *Third Text*, no. 23, 1993, pp. 23–30

Breton, Patrick, *Vodun: Land of Night, Land of Day*, in *Revue Noire: African Contemporary Art/Art Contemporain Africain*, vol. 18, 1995, pp. 34–43

Buchloh, Benjamin, and Jean-Hubert Martin, *Interview* in special issue on *Magiciens de la Terre* exhibition, *Third Text*, no. 6, 1989

Chinweizu, *The West and the Rest of Us*, New York, 1975

Elliott, David, *Babel in South Africa*, in *Art from South Africa* (exh. cat.), Museum of Modern Art, Oxford, 1990

Enwezor, Okwui, and Octavio Zaya, *Colonial Imaginary, Tropes of Disruption: History, Culture and Representation in the Works of African Photographers*, in *In/sight: African Photographers, 1940 to the Present* (exh. cat.), Solomon R. Guggenheim Museum, New York, 1996

Friedman, Hazel, *The Curator as God: At the Johannesburg Biennale*, in *Electronic Mail & Guardian*, Johannesburg, 9 October 1997

Geers, Kendell, *Art as Propaganda Inevitably Self-destructs*, in *Art from South Africa* (exh. cat.), Museum of Modern Art, Oxford, 1990

Gilroy, Paul, *The Black Atlantic: Modernity and Double Consciousness*, Cambridge, MA, 1993

Hall, Stuart, *What is This 'Black' in Black Popular Culture?*, in Gina Dent (ed.), *Black Popular Culture*, Seattle, 1992

Hassan, Salah M., *The Modernist Experience in African Art: Visual Expressions of the Self and Cross-Cultural Aesthetics*, in *Nka: Journal of Contemporary African Art*, no. 2, 1995, pp. 30–33, 72

Kasfir, Sidney Littlefield, *Nnaggenda: Experimental Ugandan Artist*, in *African Arts*, vol. 3, 1, autumn 1969, pp. 8–13, 88

———, *Richard Ndabagoye: Kampala Printmaker*, in *African Arts*, vol. 5, 3, spring 1972, pp. 33–36

*Magiciens de la Terre* (exh. cat.), Centre Georges Pompidou, Paris, 1989

Magnin, André, *Big City: Artists from Africa* (exh. cat.), Serpentine Gallery, London, 1995

——— (ed.), with Jacques Soulillou, *Contemporary Art of Africa*, London and New York, 1996

Matshikiza, John, *White Art, Black Themes*, in *Electronic Daily Mail & Guardian*, Johannesburg, 6 May 1999

Nsibambi, Ssengendo P. (Pilkington Ssengendo), *Contemporary Painting in Uganda*, in *Modern Art in Uganda: Fabian Mpagi, Geoffrey Mukasa, Francis Nnaggenda* (exh. cat.), Galerie am Stubentor, Vienna, 1992

Nyachae, Wanjiku, *Concrete Narratives and Visual Prose: Two Stories from Kenya and Uganda*, in Clémentine Deliss (ed.), *Seven Stories about Modern Art in Africa* (exh. cat.), Whitechapel Art Gallery, London, 1995

Powell, Richard J., *Black Art and Culture in the 20th Century*, London and New York, 1997

Rychner, Rose-Marie, *Contemporary Art in Uganda* (exh. cat.), Kunsthaus am Schloss, Aschaffenburg (Germany), 1996

Sachs, Albie, *Preparing Ourselves for Freedom*, in *Art from South Africa* (exh. cat.), Museum of Modern Art, Oxford, 1990

Williamson, Sue, *Resistance Art: South Africa*, New York, 1989

Chapter 6

Adenaike, Tayo, *The Oshogbo Experiment*, in Clémentine Deliss (ed.), *Seven Stories about Modern Art in Africa* (exh. cat.), Whitechapel Art Gallery, London, 1995

Anatsui, El, *Sankofa: Go Back an' Pick: Three Studio Notes and a Conversation*, in *Third Text*, no. 23, 1993, pp. 39–52

Axt, Friedrich, and El Hadji Moussa Babacar Sy (eds), *Anthology of Contemporary Fine Arts in Senegal*, Museum für Völkerkunde, Frankfurt-am-Main, 1989

Césaire, Aimé, *Discourse on Colonialism*, trans. by Joan Pinkham, *Monthly Review Press*, New York, 1972

Deepwell, Katy (ed.), *Art Criticism in Africa*, London, 1997

Deliss, Clémentine (ed.), *Seven Stories about Modern Art in Africa* (exh. cat.), Whitechapel Art Gallery, London, 1995

Ebong, Ima, *Négritude: Between Mask and Flag – Senegalese Cultural Ideology and the 'Ecole de Dakar'*, in Susan Vogel et al., *Africa Explores: 20th Century African Art* (exh. cat.), The Center for African Art, New York, 1991

Fanon, Frantz, *The Wretched of the Earth*, trans. by Constance Farrington, New York, 1963

———, *Black Skin, White Masks*, trans. by Charles Lam Markmann, New York, 1967

Jegede, Dele, *Introduction*, in Bruce Onobrakpeya, *The Spirit in Ascent*, Ovuomaroro Gallery, Lagos, 1992

Okeke, Chika, *The Quest: From Zaria to Nsukka*, in Clémentine Deliss (ed.), *Seven Stories about Modern Art in Africa* (exh. cat.), Whitechapel Art Gallery, London, 1995

Okeke, Uche, *Natural Synthesis* (1960), in Clémentine Deliss (ed.), *Seven Stories about Modern Art in Africa* (exh. cat.), Whitechapel Art Gallery, London, 1995

Onobrakpeya, Bruce, *The Spirit in Ascent*, Ovuomaroro Gallery, Lagos, 1992

———, *The Zaria Art Society*, in Clémentine Deliss (ed.), *Seven Stories about Modern Art in Africa* (exh. cat.), Whitechapel Art Gallery, London, 1995

Ottenberg, Simon, *New Traditions from Nigeria*, Washington, D.C., 1997

Samb, Issa, *The Painters of the Dakar School*, in Clémentine Deliss (ed.), *Seven Stories about Modern Art in Africa* (exh. cat.), Whitechapel Art Gallery, London, 1995

Senghor, Léopold S., *Picasso en Nigritie*, in Clémentine Deliss (ed.), *Seven Stories about Modern Art in Africa* (exh. cat.), Whitechapel Art Gallery, London, 1995

———, *The Role and Significance of the Premier Festival Mondial des Arts Nègres*, in Clémentine Deliss (ed.), *Seven Stories about Modern Art in Africa* (exh. cat.), Whitechapel Art Gallery, London, 1995

Chapter 7

Anderson, Benedict, *Imagined Communities: Reflections on the Origins and Spread of Nationalism*, London and New York, 1983

———, *Census, Map, Museum*, in *Imagined Communities* (rev. edn), London and New York, 1991

Appadurai, Arjun, *Modernity at Large: Cultural Dimensions of Globalization*, Minneapolis and London, 1996

Araeen, Rasheed, *New Internationalism, or the Multiculturalism of Global Bantustans*, in Jean Fisher (ed.), *Global Visions: Towards a New Internationalism in the Visual Arts*, London, 1994

Berns, Marla C., *Ceramic Gestures: New Vessels by Magdalene Odundo* (exh. cat.), National Museum of African Art, Smithsonian Institution, Washington, D.C., 1996

Bhabha, H. K., *The Location of Culture*, London and New York, 1994

Biasio, Elizabeth, *The Hidden Reality: Three Contemporary Ethiopian Artists* (exh. cat.), Ethnological Museum of the University of Zurich, Zurich, 1989

Bonami, Francesco, *The Electronic Bottle: Dreaming of Global Art and Geographic Innocence*, in *Trade Routes: History and Geography* (exh. cat.), 2nd Johannesburg Biennale, Johannesburg, 1997

Cassel, Valerie, *Convergence: Images and Dialogue; Conversations with Alexander 'Skunder' Boghossian*, in *Third Text*, no. 23, 1993, pp. 53–68

Donaldson, Jeff R., *AfriCobra and TransAtlantic Connections*, in Clémentine Deliss (ed.), *Seven Stories about Modern Art in Africa* (exh. cat.), Whitechapel Art Gallery, London, 1995

Durham, Jimmie, *Here at the Centre of the World*, in *Third Text*, no. 5, 1988–89, pp. 21–32

Eagleton, Terry, Fredric Jameson and Edward W. Said, *Nationalism, Colonialism, and Literature*, Minneapolis, 1990

Enwezor, Okwui, *Travel Notes: Living, Working and Travelling in a Restless World*, in *Trade Routes: History and Geography* (exh. cat.), 2nd Johannesburg Biennale, Johannesburg, 1997

———, *A Question of Place: Revisions, Reassessments, Diaspora*, in *Transforming the Crown: African, Asian and Caribbean Artists in Britain 1966–1996*, New York, 1997

Fisher, Jean (ed.), *Global Visions: Towards a New Internationalism in the Visual Arts*, London, 1994

Foster, Hal, *The Artist as Ethnographer?*, in Jean Fisher (ed.), *Global Visions: Towards a New Internationalism in the Visual Arts*, London, 1994

Gilroy, Paul, *'There Ain't No Black in the Union Jack': the Cultural Politics of Race and Nation*, London, 1987

Hassan, Salah M., *The Khartoum and Addis Connections*, in Clémentine Deliss (ed.), *Seven Stories about Modern Art in Africa* (exh. cat.), Whitechapel Art Gallery, London, 1995

———, and Achamyeleh Debela, *Addis Connections: the Making of the Modern Ethiopian Art Movement*, in Clémentine Deliss (ed.), *Seven Stories about Modern Art in Africa* (exh. cat.), Whitechapel Art Gallery, London, 1995

Hylton, Richard, and Kobena Mercer, *Imagined Communities* (exh. cat.), Cornerhouse Publications, Manchester, 1995

Mercer, Kobena, *Welcome to the Jungle: New Positions in Black Cultural Studies*, London and New York, 1994

Morgan, Stuart, *Out of Order* (exh. cat.), London, 1996

Mosquera, Gerardo, *Some Problems in Transcultural Curating*, in Jean Fisher (ed.), *Global Visions: Towards a New Internationalism in the Visual Arts*, London, 1994

———, *Important and Exportant*, in *Trade Routes: History and Geography* (exh. cat.), 2nd Johannesburg Biennale, Johannesburg, 1997

Nicodemus, Everlyn, *The Center of Otherness*, in Jean Fisher (ed.), *Global Visions: Towards a New Internationalism in the Visual Arts*, London, 1994

Oguibe, Olu (ed.), *In the 'Heart of Darkness'*, special issue on Africa, *Third Text*, no. 23, 1993, pp. 3–8

———, *A Brief Note on Internationalism*, in Jean Fisher (ed.), *Global Visions: Towards a New Internationalism in the Visual Arts*, London, 1994

———, *Forsaken Geographies: Cyberspace and the New World 'Other'*, in *Trade Routes: History and Geography* (exh. cat.), 2nd Johannesburg Biennale, Johannesburg, 1997

*Otropais: Escalas Africanas* (exh. cat.), Centro Atlantico de Arte Moderno, Las Palmas, 1995

Parry, Benita, *Signs of Our Times: A Discussion of Homi Bhabha's The Location of Culture*, in *Third Text*, no. 28–29, 1994, pp. 5–24

Sassen, Saskia, *Whose City Is It? Globalisation and the Formation of New Claims*, in *Public Culture*, vol. 8, no. 2, 1996, pp. 205–23

Siopis, Penny, and Elizabeth Harney, *Between the Internal and the International*, in *Metronome*, no. 10, 1996, pp. 14–19, 49, 51

Trackman, Dean (ed.), *Echoes of the Kalabari: Sculpture by Sokari Douglas Camp* (exh. cat.), National Museum of African Art, Smithsonian Institution, Washington, D.C., 1988

*Trade Routes: History and Geography* (exh. cat.), 2nd Johannesburg Biennale, Johannesburg, 1997

Williams, Denis, *A Sudanese Calligraphy*, in *Transition*, June 1963

Conversations with artists, 1996–99

Group meeting with fifteen artists, tape and video recording, 9 June 1996, Kampala, Uganda

Abdalla, Mohammed Ahmed, telephone interview, 18 December 1998

Adenaike, Tayo, internet conversations, 2, 4 and 10 April 1999

Buraimoh, Jimoh, tape and video recording, November 1997, Atlanta, USA

Gwichiri, Paul, tape recording, 5 July 1996, National Gallery, Harare, Zimbabwe

Kirumira, Namubiru Rose, tape recordings, 11 June 1996 and 6 July 1997

Kyeyune, Eli, tape recording, 11 June 1996, Kampala, Uganda

Mpagi, Fabian, tape recording, 9 June 1996

Mukarobgwa, Thomas, tape recording, 5 July 1996, National Gallery, Harare, Zimbabwe

Nkurumeh, Barthosa, telephone interview, 3 March 1999

Nnaggenda, Francis, tape recordings, 10 June 1996 and 7 July 1997, Kampala, Uganda

Nsibambi, P. Ssengendo, conversation, 8 July 1977, Kampala, Uganda

Odunlade, Tunde, tape recording, 22 November 1995, Atlanta, USA

Soyinka, Wole, tape recording, 15 October 1997, Emory University, Atlanta, USA

Udechukwu, Obiora, conversation, 25 November 1998, Atlanta, USA

Wenger, Susanne, letters, December 1998 and February 1999

Wosene (Wosene Kosrof), conversation, 11 November 1998, Atlanta, and telephone, 2 May 1999, USA

# List of Illustrations

The publishers would like to thank Philippe Boutté, Frances Marks, and Jessica Gerschultz for her invaluable assistance in contacting artists in Kenya.

Sizes are given in centimetres, followed by inches, height before width before depth

1. Cheri Samba, *Why Have I Signed a Contract?*, 1990. Acrylic on canvas, 130 × 180 (51¼ × 70⅞). Courtesy N.O.M.A.D.E.-Patras-Paris, J. M. Patras

2. Trigo Piula, *Materna*, 1984. Oil on canvas, 122 × 88 (48 × 34⅝). Private Collection

3. Gedewon, *Cherchebbi*, 1977. Ink on paper, 32 × 24 (12⅝ × 9⁷⁄₁₆). Musée National des Arts d'Afrique et d'Océanie, Paris

4. John Goba, *Odeh-E-Lay (No.1)*, 1992. Painted wood and porcupine quills, 110 × 70 × 60 (43¼ × 27½ × 23¾). © C.A.A.C. The Pigozzi Collection, Geneva. Photo Claude Postel

5. Pende blacksmith at work, July 6, 1987, Ndjindji, Democratic Republic of the Congo. Photo Z. S. Strother

6. Pende carvers at work from *L'Art Pende* by Pierre Sousberghe, 1958

7. El Anatsui, *Patches of History III*, 1993. Wood relief, oyili-oji, opepe and akparata woods, 140 × 69 × 2.5 (55¼ × 27⅛ × 1). Private Collection. Photo courtesy October Gallery, London

8. Seydou Keita, untitled portrait, 1958. © Seydou Keita Bamako, 1958. Courtesy C.A.A.C. The Pigozzi Collection, Geneva

9. Kurmi Market, Kano, Nigeria. Photo Sidney Littlefield Kasfir, 1989

10. Barber's sign, Ghana. Photo Sidney Littlefield Kasfir

11. Signpainter's kiosk, Mombasa, Kenya. Photo Sidney Littlefield Kasfir, 1991

12. Chin in front of his studio, Kinshasa, Congo. Photo Bogumil Jewsiewicki, 1990

13. Tshibumba Kanda-Matulu, *The Historic Death of Lumumba*, 1970s. Paint on flour sack, 36 × 45 (14¼ × 17¾). Collection and photo Bogumil Jewsiewicki

14. Cheri Samba, *La Seduction*, 1984. Acrylic on canvas, 81 × 60 (31⅞ × 23⅝). Courtesy N.O.M.A.D.E.-Patras-Paris, J. M. Patras

15. Cheri Samba, *The Draughtsman Cheri Samba*, 1981. Paint on canvas, 135 × 101 (53¼ × 39¾). Collection Jean Pigozzi. Courtesy N.O.M.A.D.E.-Patras-Paris, J. M. Patras

16. Moke, *Motorcade with Mitterand and Mobutu*, 1989. Oil on canvas, 114 × 184 (44⅞ × 72¾). © C.A.A.C. The Pigozzi Collection, Geneva. Photo Claude Postel

17. Stephen Kappata, *A Country without Her Own Traditional Culture is Dead Indeed*, 1987. Oil on canvas or calico, 43 × 93 (17 × 36¾). Private Collection. Photo courtesy of Hugh Macmillan

18. *Landscape*, early 1970s. Originally attributed to Tshibumba Kanda-Matulu, but thought to be by Burozi. Collection and photo Bogumil Jewsiewicki

19. Joel Oswaggo, *The Stoolmaker*, c. 1987. 32 × 42 (12½ × 16½). Collection Museum für Völkerkunde, Frankfurt-am-Main (Reg. No. N.S.57448). Photo Maria Obermaier

20. Carved door on Lamu Island. Photo Sidney Littlefield Kasfir, 1987

21. Mark Anthony, *Farmer Saved by an Angel*. Super Yaw Ofori's band poster, Ghana, 1995. Poster paints, dimensions unknown. Collection and photo Michelle Gilbert

22. Django truck mural, late 1970s. Photo Lawrence Manning

23. *Mikiya* truck mural, Abdullahi "O", late 1970s. Photo Lawrence Manning

24. 'Plastic Boys', *Babie Coach*, 1996. Maralal, northern Kenya. Photo Sidney Littlefield Kasfir

25. Middle Art (Augustine Okoye), *'Oh! God Bring Peace to Nigeria' said Bello in Praying*, 1970s. Enamel on plywood, 110 × 46.5 (43¼ × 18¼). Courtesy of Iwalewa Haus, University of Bayreuth

26. Dr Phutuma Seoka, *Dog/Leopard*, 1989. Corkwood, enamel paint and nails, 55 × 115.8 × 32.5 (21⅝ × 45¾ × 12¾). Photo Museum of Modern Art, Oxford

27. Mutunga, *Cheetah Chair*, 1998. Wood and pigment, approx. height 122 (48). Collection Cultural Arts Gallery, Nairobi. Photo Sidney Littlefield Kasfir

28. Jackson Hlungwane, *Throne*, 1989. Wood construction, 256 × 160 (100¾ × 63). Private Collection. Photo John Riddy

29. Sunday Jack Akpan, *Traditionally Dressed Figure, Soldiers, Businessman*. Sculptures in front of Akpan's studio, Ibesikpo-Uyo, Nigeria, 1993. Photo © Jean-Michel Rousset

30. Samuel Kane Kwei, *Mercedes Benz-Shaped Coffin*, 1993, in workshop. Enamel paint on wood, 70 × 270 × 70 (27½ × 106¼ × 27½). © C.A.A.C. The Pigozzi Collection, Geneva. Photo © Jean-Michel Rousset

31. Seydou Keita, *Untitled Portrait of a Woman*, 1956–57. © Seydou Keita Bamako, 1956–57. Courtesy C.A.A.C. The Pigozzi Collection, Geneva

32. *Soba ou Autoridade Tradicional* (*A Traditional Chief or Authority*), Benguela, Angola, 1958. CITA photographer

33. Lawrence Alaye's apprentice working on a relief panel in his workshop, Ile-Ife, Nigeria, 1978. Photo Sidney Littlefield Kasfir

34. PiliPili Molongoy, *Termites and Birds*, c. 1970. Acrylic on hardboard, dimensions unknown. Bildnachweis, Ubersee-Museum, Bremen

35. Yoruba children carrying Christian images at Christmas in Oye Ekiti, Nigeria, 1951, from *Yoruba Religious Carving* by Kevin Carroll, 1967

36. Lamidi Fakeye, *Flight into Egypt*, 1956. Detail of panel carved in the doors of St Mary's Roman Catholic Church, Oke Pade, Ibadan. Photo David Curl

37. Susanne Wenger, *Temple of Obatala, Oshogbo*, 1966. Photo Ulli Beier. Courtesy of the artist

38. Susanne Wenger, *Shrine for Iya Mapo at Ebu Iya Mapo near Oshogbo*, 1970s. Cement-coated (adobe-like) clay. Courtesy of the artist

39. Shangodare standing before Adebisi Akanji's cement screen at Susanne Wenger's residence, Oshogbo, 1978. Photo Sidney Littlefield Kasfir

40. Adebisi Akanji, detail of petrol station screen, Oshogbo, 1966. Photo Ulli Beier

41. Adebisi Akanji, *Entrance Gate to the Oshun Grove*, 1966. Photo Ulli Beier

42. Dan Rakgoathe, *Mystery of Space*, 1975. Linocut, 45 × 54 (17¾ × 21¼)

43. Azaria Mbatha, *The Greetings – Nativity*, 1964. Linocut, 30 × 44 (11¾ × 17¾). © DACS 1999

44. John Muafangejo, *Zulu Land*, 1974. Linocut, 46 × 68.3 (18⅛ × 26⅞). © copyright 1998 John Muafangejo Trust, Oxford

45. Fulai Shippia, *Two Rosaries and an Eel*, c. 1994. Lithograph, dimensions unknown. Collection !Xu and Khwe Cultural Project

46. Thaulu Bernardo Rumao, *Tent Town*, c. 1994. Linoprint, dimensions unknown. Collection !Xu and Khwe Cultural Project

47. Julieta Calimbwe and Zurietta Dala, *Nests, Landmines and Plants*, 1995. Lithographic print, 42 × 52 (16½ × 20½). Collection !Xu and Khwe Cultural Project

48. Igbo Mask with Crucifixion and Mami Wata, Nigeria. Collection Dr and Mrs Bernard Wagner. Photo courtesy of Eric Robertson

49. Lega carver at work, Kampala, Uganda, 1997. Photo Sidney Littlefield Kasfir

50. Mushaba Isa with carved chairs, Kampala, Uganda, 1997. Photo Sidney Littlefield Kasfir

51. Jak Katarikawe, *People Happy at Christmas*, c. 1986. 61 × 100 (24 × 39¾). Collection Museum für Völkerkunde, Frankfurt-am-Main (Reg. No. 55081). Courtesy of the artist. Photo Maria Obermaier

52. Henry Moore, *Divided Head*, 1963. Height 35 (13¾). Private Collection. Reproduced by permission of the Henry Moore Foundation

53. Thomas Mukarobgwa, *Suggest Paintings: Adam and Eve*, 1963. Oil on cloth, 69.2 × 106 (27¼ × 41¾). Permanent Collection, National Gallery of Zimbabwe, Harare, Zimbabwe. Photo Mark Bradshaw

54 and 55. Samuel Songo, chapel doors at the Cyrene Mission, Bulawago, Zimbabwe, early 1950s. Photo Sidney Littlefield Kasfir

56. Nicholas Mukomberanwa, *Man*, 1969. Steatite, 65 × 38 (25⅝ × 15). Collection National Gallery of Zimbabwe, Harare, Zimbabwe. Photo courtesy of Baobab Books, Harare

57. Joram Mariga, *Anteater*, 1990. Lepidolite, 44 × 55 × 18 (17⅜ × 21⅝ × 7⅛). Location unknown. Photo courtesy of Olivier Sultan

58. Josia Manzi, *Baboon Stealing the Crop Guard's Child*, n.d. Permanent Collection, Chapungu Sculpture Park. Photo courtesy Chapungu Sculpture Park

59. Amali Mailolo, *Man and Crocodile*, n.d. Permanent Collection, Chapungu Sculpture Park. Photo courtesy Chapungu Sculpture Park

60. Damien Manuhwa, *Creation of a Woman*, n.d. Permanent Collection, Chapungu Sculpture Park. Photo courtesy Chapungu Sculpture Park

61. Joram Mariga, *Chief Chirorodziwa*, n.d. Permanent Collection, Chapungu Sculpture Park. Photo courtesy Chapungu Sculpture Park

62. Ruth Schaffner on location in Cote d'Ivoire filming *Sorcerer's Village*, early 1950s. Photo Hassoldt Davis

63. Kivuthi Mbuno, *Mutinda*, 1992. Crayon on paper, 51 × 76 (20¼ × 30). © C.A.A.C. The Pigozzi Collection, Geneva. Photo Claude Postel

64. Sane Wadu, *Waiting*, 1991–92. Oil on canvas, 102 × 180 (40¼ × 70¾). Private Collection

65. Lucy Njeri, *Can the Landers Invert?*, 1998. Oil on canvas, 54 × 56 (21¼ × 22). Collection of the artist. Photo Sidney Littlefield Kasfir

66. Ngecha Group (Eunice Wairimu Wadu, Sebastian Kiarie, Sane Wadu, Chain Muhandi, King Dodge, Wanyu Brush), untitled village scene, 1995. Oil on canvas, 122 × 135 (48 × 53¼). Collection of the artists. Photo Sidney Littlefield Kasfir

67. Cartoon Joseph, untitled village scene, 1998. Oil on board, 50.8 × 81.3 (20 × 32). Collection and photo Sidney Littlefield Kasfir

68. 'Shine Tani', *Homestead Acrobats*, 1997. Photo Heidi Ernst-Luseno

69. Dumisani Mabaso, *Untitled*, 1988. Acrylic and cloth on canvas, 169 × 183 (66½ × 72). Made in the Thupelo Workshop. Private Collection. Photo Christopher Moore

70. Bill Ainslie, *Pachipamwe No. 3*, 1989. Acrylic on canvas, 141 × 181 (55½ × 71¼). Made in the Pachipamwe Workshop. Collection of Mr and Mrs McMillan. Photo courtesy of Fieke Ainslie

71. Namubiru Rose Kirumira, *Untitled*, 1996. Wood construction, dimensions unknown. Collection the artist. Photo Sidney Littlefield Kasfir

72. Qmao Nxuku, from the Thapong Workshop catalogue, 1992

73. Qmao Nxuku, *!Xrii*, 1992. Acrylic on canvas, 200 × 123 (78¾ × 48½). Private Collection

74. Misheck Gudo, *The Squatter Camp*, 1996. Oil on canvas, 81.5 × 91.5 (32⅛ × 36). Collection and photo Pip Curling

75. Givas Mashiri, *Reading the Standard*, 1997. Papier-mâché, dimensions unknown. Collection and photo Pip Curling

76. Richard Onyango, *Day of Permission*, 1990. Acrylic on canvas, 119 × 158 (46¾ × 62¼). © C.A.A.C. The Pigozzi Collection, Geneva. Photo Claude Postel

77. Ephraim Ngatane, *Washerwomen*, c. 1970. Watercolour on paper, dimensions unknown. Collection University of Witwatersrand Art Gallery

78. Cecil Skotnes, *Procession*, 1963. Painting on incised panel, 122 × 122 (48⅛ × 48⅛). Private Collection. Photo South African National Gallery, Cape Town

79. Louis Maqhubela, *Master*, late 1960s/early 1970s. Oil on canvas, dimensions unknown. Private Collection.

80. Durant Sihlali, *Graffiti Signatures*, 1997. Composition on coloured rag cotton fibres, 191 × 126 (75¼ × 49½). Collection of N.A.P.P.O., Johannesburg (under the direction of Mr Jarma and Mrs Barbara Holland). Photo courtesy of the Goodman Gallery, Johannesburg

81. Durant Sihlali in his studio with one of his bronze sculptures, 1996. Photo Sidney Littlefield Kasfir

82. Sydney Kumalo, *Horse*, c. 1963–65. Bronze, length 21.6 (8½). Courtesy Grosvenor Gallery, London

83. Ezrom Legae, *The Assassinator*, 1996. Ink drawing, dimensions unknown. Collection and photo Sidney Littlefield Kasfir

84. Contemporary Benin head. Cast bronze, height approx. 30.5 (12). Collection of the Carter Collection, Emory University. Photo Michael C. Carlos Museum

85. Kulebele artist carving Dan-style mask in Korhogo, Côte d'Ivoire, 1988. Photo Christopher B. Steiner

86. Kamba carvers in the cooperative at Changamwe, Kenya, 1991. Photo Sidney Littlefield Kasfir

87. Samaki Likankoa (Maconde sculptor), 1970, Dar es Salaam. Photo Sidney Littlefield Kasfir

88. Makonde *mapico* mask (Mozambique). Wood, hair, wax, 30 × 26 (11¾ × 10¼). Collection W. and U. Horstmann, Zug, Switzerland

89. Maconde sculpture in the National Arts of Tanzania Gallery (NAT), Dar es Salaam, 1971. Photo Nelson Kasfir

90. Cotton appliqué banner, Fon, Republic of Benin, 1982. Length 177 (69). © British Museum

91. Enesia, *Drinking Beer*, 1989. Painting on board, 50 × 40 (19⅝ × 15¾). Photo Calvin Dondo and Duplex Repro. From *The Art of the Weya Women* (Harare, 1992) by Ilse Noy. Reproduced by kind permission of Baobab books, Box 567, Harare, Zimbabwe

92. Nerissa Mugadza, *Life of an Unmarried Woman Who Has No Child, c.* 1987. Cloth appliqué, 55 × 55 (21⅝ × 21⅝). Photo Christoph von Haussen. From *The Art of the Weya Women* (Harare, 1992) by Ilse Noy. Reproduced by kind permission of Baobab books, Box 567, Harare, Zimbabwe

93. Mary Chitiyo, *Kuoma Rupandi and Committing Suicide, c.* 1989–92. Sadza painting, 220 × 150 (86⅝ × 59). Photo Christoph von Haussen. From *The Art of the Weya Women* (Harare, 1992) by Ilse Noy. Reproduced by kind permission of Baobab books, Box 567, Harare, Zimbabwe

94. Valente Malangatana, *The Last Judgement*, 1961. Oil on canvas, 92 × 122 (36¼ × 48). Private Collection

95. Filis, *Village Life, c.* 1987. Painting on board, 30 × 30 (11⅞ × 11⅞). Photo Calvin Dondo and Duplex Repro. From *The Art of the Weya Women* (Harare, 1992) by Ilse Noy. Reproduced by kind permission of Baobab books, Box 567, Harare, Zimbabwe

96. Mary, *Problems of Transport, c.* 1989. Poster paint on board, 30 × 30 (11⅞ × 11⅞). Photo Christoph von Haussen. From *The Art of the Weya Women* (Harare, 1992) by Ilse Noy. Reproduced by kind permission of Baobab books, Box 567, Harare, Zimbabwe

97. Moke, *Street Scene*, 1990. Paint on flour sack, 60 × 80 (23⅝ × 31½). Collection Jean Pigozzi

98. Abishell Risinamhodzi, *Chimurenga, c.* 1989. Painting on board, dimensions unknown. Photo Weltfriedensdienst. Reproduced by kind permission of Baobab books, Box 567, Harare, Zimbabwe

99. Student in painting studio, Makerere, Kampala, Uganda, 1996. Photo Sidney Littlefield Kasfir

100. Objects of Performance, Laboratoire AGIT-Art, Dakar, 1992. Photo Clémentine Deliss

101. Thomas Mukarobgwa, untitled serpentine work in progress, 1996. Photo Sidney Littlefield Kasfir

102. Kizito Kasule Maria, studio work in progress, 1997. Collection of the artist. Photo Sidney Littlefield Kasfir

103. Picasso, *Seated Woman*, 1927. Oil on wood, 129.9 × 96.8 (51⅛ × 38⅛). The Museum of Modern Art, New York. Gift of James Thrall Soby. Photo © 1999 The Museum of Modern Art, New York. © Succession Picasso/DACS 1999

104. Francis Nnaggenda, untitled sketch on paper, 1997. Collection of the artist. Photo Sidney Littlefield Kasfir

105. Adebisi Fabunmi, *The Birth of Oshogbo*, 1977. Coloured yarns on board, 105.4 × 58.4 (41½ × 23). Collection Nelson and Sidney Littlefield Kasfir. Photo Sidney Littlefield Kasfir

106. Yinka Adeyemi, *Baboon Hunter and Magical Antelope*, 1977. Batik, dimensions unknown. Photo Sidney Littlefield Kasfir

107. Theodore Koudougnon, *Beads*, 1988. Papier-mâché, oil paint and beads, 68 × 115 (26¾ × 45¼). © Theodore Koudougnon

108. Bodys Isek Kingelez, *Kimbembele Ihunga (Kimbéville)* (detail), 1993–94. Paper, cardboard, plastic and mixed media, 120 × 240 × 184 (47¼ × 94¼ × 72¾). © C.A.A.C. The Pigozzi Collection, Geneva. Photo Claude Postel

109. Ibrahim El Salahi, *Calligraphy*, n.d. Ink on paper, 40.5 × 23.5 (16 × 9¼). © Ibrahim El Salahi 1999. All rights reserved DACS. Photo courtesy of Iwalewa Haus, University of Bayreuth

110. Ibrahim El Salahi, *Head*, early 1960s. Oil on canvas, 30.5 × 40.5 (12 × 16). © Ibrahim El Salahi 1999. All rights reserved DACS. Photo courtesy of Iwalewa Haus, University of Bayreuth

111. Ibrahim El Salahi, *Faces*, early 1960s. Ink on paper, 37 × 53 (14½ × 20¾). Private Collection. © Ibrahim El Salahi 1999. All rights reserved DACS. Photo courtesy of Iwalewa Haus, University of Bayreuth

112. Peter Mulindwa, *The Owl Drums Death (the Uganda Martyrs)*, 1982. Oil on board, 122 × 244 (48 × 96). Private Collection. Photo Clémentine Deliss

113. Gregory Maloba, *Death, c.* 1940. Wood, dimensions unknown. Collection Uganda Museum, Kampala. Photo Sunanda Sanyal

114. Shangodare, *The Triumphant Return of Shango from Battle*, 1977. 182.9 × 152.4 (72 × 60). Collection Nelson and Sidney Littlefield Kasfir. Photo Sidney Littlefield Kasfir

115. Gregory Maloba teaching at the Margaret Trowell School of Fine Arts, Makerere University, Kampala. Photo courtesy of Clémentine Deliss

116. Ben Enwonwu with one of his works in his London studio, 1957. Photo *West African Review*

117. Michael Adams, *View from Fazal Abdullah's Mother's House, Lamu, c.* 1966. Watercolour, 45.7 × 35.6 (18 × 14). Collection Nelson and Sidney Littlefield Kasfir. Photo Sidney Littlefield Kasfir. © DACS 1999

118. Elimo Njau, *Milking*, 1972. Oil on cloth, 40 × 51 (15¾ × 20⅛). Collection Museum für Völkerkunde, Frankfurt-am-Main (Reg. No. 57438). Photo Maria Obermaier

119. Richard Ndabagoye, *Mume na Mke (Husband and Wife)*, 1969. Etching, 30.5 × 29.2 (12 × 11½). Collection Nelson and Sidney Littlefield Kasfir. Photo Sidney Littlefield Kasfir

120. Michael Adams, *Tarzan is an Expatriate*, from the cover of *Transition 32*, 1967. © *Transition*. Design by Michael Adams. © DACS 1999

121. Francis Nnaggenda in his Makerere studio with his untitled sculpture. Mixed media. Photo Sidney Littlefield Kasfir

122. Dossou Amidou, untitled Yoruba (Nago) Gelede mask, Benin. Wood, paint, 45 × 43 × 32 (17½ × 17 × 12½). © C.A.A.C. The Pigozzi Collection, Geneva. Photo Claude Postel

123. Efiaimbelo, *On n'est jamais mieux servi qui par soi-même (One is Never Better Served than by Oneself)*, 1994. Mahafaly (funerary post), wood and paint, height approx. 200 (78¾). © C.A.A.C. The Pigozzi Collection, Geneva. Photo Claude Postel

124. Frédéric Bruly Bouabré, *Knowledge of the World – In the Bowels of the Verdant Earth, the Subterranean Blue Sea Washes Our 'Dead' Before Being Reborn as Drinking Water*, 1991. Coloured pencil and ballpoint on cardboard, 15 × 9.5 (5⅞ × 3¾). © C.A.A.C. The Pigozzi Collection, Geneva. Photo Claude Postel

125. Georges Adeagbo, *Histoire de France*, Cotonou, 1992. © ADAGP, Paris and DACS, London 1999. Photo © Jean-Michel Rousset. Courtesy Galerie Nathalie Obadia, Paris

126. Georges Adeagbo, *Histoire de France*, Cotonou, 1992 (detail). © ADAGP, Paris and DACS, London 1999. Photo © Jean-Michel Rousset. Courtesy Galerie Nathalie Obadia, Paris

127. Sue Williamson, *Jenny Curtis Schoon*, 1985. Photo etching, screenprint collage, 70 × 64 (27½ × 25⅛). Collection South African National Gallery, Cape Town. Photo by Hirt and Carter. Courtesy of the artist

128. William Kentridge, *Soho and Mrs Eckstein in the Landscape*, 1991, from the series *Sobriety, Obesity and Growing Old* (drawings for projection). Charcoal drawing on paper, 120 × 150 (47⅜ × 59¼). Courtesy of the artist and The Goodman Gallery, Johannesburg

129. Penny Siopis, *Cape of Good Hope – A History Painting*, 1989–90. Oil, wax and collage on board, 182 × 123.9 (71⅞ × 48¾). Courtesy of the artist and The Goodman Gallery, Johannesburg

130. Alfred Thoba, *Race Riots*, 1977. Oil on board, 147 × 151 (57⅞ × 59¼). Courtesy of the artist

131. Tommy Motswai, *Lenyalo at Home from Rockville*, 1988. Pastel on paper, 68 × 114 (26¾ × 44¾). Photo Museum of Modern Art, Oxford. Courtesy of the Everard Gallery, Johannesburg

132. Willie Bester, *Semekazi (The Story of a Migrant Worker)*, 1993. Oil, enamel paint and mixed mediums on board, 125 × 125 (49¼ × 49¼). © C.A.A.C. The Pigozzi Collection, Geneva. Photo Claude Postel

133. Penny Siopis, *Mostly Women and Children*, 1996. Installation at the *Faultlines* exhibition, Cape Town, 1996. Photo Mark Lewis

134. Alfred Thoba, *White Nation Has Ill-treated Blacks. Thank you Mr F W de Klerk for Handing Over South Africa to Nelson Mandela. Your Kindness is So Handy*, 1996. Oil on board, 123 × 190 (48½ × 75). Exhibited at the *Faultlines* exhibition, Cape Town, 1996. Courtesy Natalie Knight Gallery, Johannesburg. Photo Mark Lewis

135. Moshekwa Langa, *Untitled*, 1996. Installation at the *Faultlines* exhibition, Cape Town, 1996. Photo Mark Lewis

136. Kevin Brandt, *Pieta*, 1996. Duct-tape on brick installation at the *Faultlines* exhibition, Cape Town, 1996. Photo Mark Lewis

137. Clive van den Berg, *Men Loving*, 1996. Installation at the *Faultlines* exhibition, Cape Town, 1996. Photo Mark Lewis

138. Photo of Kendell Geers' performance piece, *Mandela Mask*, 1996. Courtesy of the artist and The Goodman Gallery, Johannesburg. Photo Mark Lewis

139. Bacary Dieme, *Water Carrier, c.* 1970. Tapestry, 292 × 200 (115 × 78⅞). Photo courtesy of the Ministry of Culture, Dakar

140. Boubacar Coulibaly, *Meeting of the Masks*, 1976. Oil on canvas, 116.2 × 88.9 (45¾ × 35). Collection of the Government of Senegal

141. Boubacar Coulibaly, *Le Masque I*, 1973. Gouache, 65 × 60 (25½ × 23¾)

142. Iba N'diaye, *Blues Singer*, 1986. Ink on paper, 77 × 56 (30¼ × 22). Private Collection, Paris. © ADAGP, Paris and DACS, London 1999. Photo courtesy of the artist

143. El Hadji Sy in his Dakar studio with one of his works on jute from 1992. Photo Clémentine Deliss

144. El Hadji Sy, *Mother and Child*, 1987. Courtesy of Friedrich Axt. Photo Schwitz-Fabri

145. Issa Samb, *Untitled*, 1992. Mixed media on tarpaulin, 100 × 260 (39¾ × 102¾). Collection of the artist. Photo Clémentine Deliss

146. Issa Samb, untitled collage, 1986. Photo Friedrich Axt

147. Sét Sétal mural (detail), Dakar, 1991. Photo Clémentine Deliss

148. Gora MBengue, *Le Grand Marabout*, 1984. Collection of Friedrich Axt. Photo Schwitz-Fabri

149. Jacob Lawrence, *Nigerian Series, Street to Mbari*, 1964. Gouache on paper, 56.5 × 76.5 (22¼ × 30¼). Courtesy of the artist and Francine Seders Gallery, Seattle

150. Painted *uli* body designs from Awka District, Nigeria, collected by W. B. Yeatman in *c.* 1933. 33.7 × 21 (13¼ × 8¼). Collection and photo Pitt-Rivers Museum, University of Oxford

151. Uche Okeke, *Mma-Nwa-Uli*, 1972. Celotex board cut print on paper, 45.4 × 45.9 (17⅞ × 18). Collection of Joanne B. Eichner. Photo courtesy of the artist

152. Obiora Udechukwu, born 1946, Nigerian. *Road to Abuja*, 1982. Paper, ink, 54.4 × 44.2 (21⁷⁄₁₀ × 17¾) (framed). National Museum of African Art, Washington D.C. Bequest of Bernice M. Kelly, 98–20–7. Photo by Franko Khoury

153. Chike C. Aniakor (b.1939), Nigerian. *Allegory of Power*, 1996. Pen and ink on paper, 61 × 45.7 (24¹⁄₁₀ × 18). National Museum of African Art, Washington D.C. Purchased with funds provided by the Smithsonian Collections Acquisition Program, 96–18–3. Photo by Franko Khoury

154. Obiora Udechukwu, *Writing in the Sky*, 1989. Silkscreen on paper, 55 × 36.5 (21¾ × 14⅜). Collection of the artist

155. Barthosa Nkurumeh, *Nna Mbe*, 1991. Serigraph, 66.8 × 37.8 (26⁹⁄₁₀ × 14.⅞). Collection and photo courtesy of the artist

156. Tayo Adenaike, *Evolving Cosmos*, 1996. Watercolour. Collection National Museum of African Art, Washington D.C. Photo courtesy of the artist

157. Bruce Onobrakpeya, *Shrine Set* (detail, wall piece), n.d. Plastocast, plastograph, copper foil, bronze, plywood and stainless steel, 305 × 305 × 183 (120 × 120 × 72). Collection of the artist. Photo Clémentine Deliss

158. Bruce Onobrakpeya, *Emeravwe (Lunar Myths)*, 1983. Plastocast, 65 × 94 (25¼ × 37)

159. Skunder (Alexander) Boghossian, *Climatic Effects*, 1984–85. Acrylic on canvas, 182.9 × 127 (72 × 50). Collection George Corinaldi

160. Skunder (Alexander) Boghossian, *Rhonda's Bird*, 1974. Mixed media on board, 34.9 × 55.9 (13¾ × 22). Location unknown

161. Ahmad Muhammad Shibrain, *Calligraphy*, early 1960s. Ink on paper, 75 × 45 (29½ × 17¾). Courtesy of Iwalewa Haus, University of Bayreuth

162. Wosene Kosrof, *Almaz*, 1982. Acrylic on goatskin, 30.5 × 40.6 (12 × 16). Collection of Kiros W. Selassie. Photo courtesy of the artist

163. Wosene Kosrof, *Dancing Spirits*, 1996. Mixed media on goatskin, 61 × 71.1 (24 × 28). Collection and photo courtesy of the artist

164. Girmay Hiwet, 1989. Photo Peter Nebel. Völkerkundemuseum der Universität Zürich

165. Girmay Hiwet, *To See Your Own Eyes With Your Own Eyes*, 1983. Acrylic on canvas, 90 × 70 (35⅜ × 27½). Courtesy of the artist. Photo Peter Nebel

166. Elisabeth Atnafu, *The Year of Love*, 1984. Mixed media, 152.4 × 101.6 (60 × 40). Location unknown. Courtesy of the artist

167. Gebre Kristos Desta, *Golgotha*, 1963. Oil on canvas. Photo courtesy of Achamyeleh Debela

168. Achamyeleh Debela, *A Song for Africa*, 1992–93. Cibachrome print, a digital painting, 76 × 101.5 (29⅞ × 40). Courtesy Contemporary African Art Gallery, New York, NY

169. Wifredo Lam with his paintings in his studio at 8, rue Armand Moisant, Paris, 1940. Courtesy of S.D.O. Wifredo Lam ©, Paris

170. Zerihun Yetmgeta, *Research from the Art of Magic*, 1988. 110.5 × 64 (43½ × 25¼). Collection Völkerkundemuseum der Universität Zürich (Inv. Nr. 20999). Courtesy of the artist. Photo Peter Nebel

171. Zerihun Yetmgeta, *Fishing the Evil Eye*, 1989. 79 × 74 (31¼ × 29¼). Courtesy of the artist. Photo Peter Nebel

172. Tunde Odunlade in Atlanta with his work *Happy Faces*, 1995. Batik. Collection of the artist. Photo Sidney Littlefield Kasfir

173. Tayo Awoyera, *Lagos Life*, 1995. Ink and wash. Collection of the artist. Photo Sidney Littlefield Kasfir

174. Jimoh Buraimoh, recent bead mosaic in studio, Atlanta, 1997. Photo Sidney Littlefield Kasfir

175. Jimoh Buraimoh, *Untitled*, 1964. Beadwork on cloth. Photo courtesy of the artist

176. Sokari Douglas Camp, *Clapping Girl (Small Iriabo)* 1986. Mild steel, copper, electric motor, 140 × 43 × 30 (55⅛ × 17 × 11¾). Museum of African Art, Washington D.C. Photo Sokari Douglas Camp

177. Magdalene Odundo, *Untitled #12 and #8*, 1995. © Gerry Mendelez 1995. Assassi Productions

178. Olu Oguibe, *The Emperor*, or *The Beast in the Landscape*, 1990. Watercolour on paper. Collection and photo the artist

179. Ouattara, *Samo the Initiated*, 1988. Sculpture and acrylic on canvas, 216 × 360.7 (85 × 142). Collection Vrej Baghoomian. Courtesy of the artist

180. Yinka Shonibare, *Five Undergarments and Much More*, 1995. African fabric, Rigilene, fishing line, interlining. Tailored by Sian Lewis. 95 × 130 (37 × 51). Courtesy of the artist and Stephen Friedman Gallery, London. Photo Stephen White

# Index

Figures in *italic* refer to
illustrations

Abdalla, Mohammed Ahmed 208
Abdullahi "O" 38; *23*
Abstract Expressionism 10, 210
Adams, Michael 149; *117, 120*
Adeagbo, Georges 153–54; *125, 126*
Adenaike, Tayo 186; *156*
Adeyemi, Yinka 133, 204–05; *106*
advertising 34, 37–38, 40, 41; *10, 12, 20*
AFRI-COBRA 196, 200
African diaspora 13, 19, 40, 171, 189, 196, 200, 209
Ainslie, Bill 66, 101, 159; *70*
'airport art' 71
Akanji, Adebisi 53, 54–56; *39–41*
Akpan, Sunday Jack 44–45; *29*
Alaye, Lawrence 48–49
Amidou, Dossou *122*
ANC (African National Congress) 85, 93, 97, 155
Angola 47, 75, 87; *32*
Aniakor, Chike 184, 186; *153*
Anthony, Mark 34; *21*
apartheid 57, 62, 93, 96, 156, 159
Appiah, Kwame Anthony 14; *120*
apprenticeship 13, 48–49, 52–53, 107, 125, 126; *6, 33*
Areogun 48, 52–53
art–commodity distinction 102, 103, 104
art–craft distinction, boundary 102, 103, 104, 112
art market 14, 18, 34, 40, 44, 48, 73–74
Art Nègre 170–71
art schools, departments and academies 29, 48, 57, 59, 79–80, 83, 97
 – Académie de la Grande Chaumière, Paris 170; *142*
 – Ahmadu Bello University, Zaria, Nigeria 152, 181, 206
 – College of Art, Science and Technology, Kumasi, Ghana 189
 – Ecole des Beaux-Arts, Paris, France 190
 – Ecole National des Beaux-Arts du Sénégal 128, 170
 – Howard University, Washington, D.C. 193, 196, 198; *153*
 – Margaret Trowell School of Fine Arts, Makerere University, Kampala, Uganda 141–42, 151; *99, 121*
 – Royal Academy of Arts, London 146
 – School of Arabic Calligraphy, Cairo 195
 – School of Fine Arts, Addis Ababa 193, 198, 201
 – Slade School of Fine Art, London 143, 146, 149, 190–91
 – University of Ife (Awolowo University), Nigeria 38, 48–49
 – University of Nairobi, Kenya 144
 – University of Nigeria, Nsukka 152, 181, 182, 183, 184, 189
Atelier de Recherches Plastiques Nègres 170
Atnafu, Elisabeth 196–98; *166*
authenticity debates 48, 103–05

'autodidacts' 29, 48, 136
Awoyera, Tayo 205; *173*

Bandele of Osi 48–49, 52–53
Bantu Education Act 57
Barber, Karin 41
barbers' signs 38; *10*
Beier, Georgina 50, 52, 54, 66, 77–78, 179, 206
Beier, Ulli 7–8, 38, 50, 52, 54–56, 66, 77–78, 138–41, 142–43, 178–79
Benin, Republic of 32, 35, 108, 153–54; *122*
Benin bronzes, Nigeria 103; *84*
Bester, Willie 159; *132*
Blomefield, Tom 66, 75–76, 110
Boghossian, Skunder (Alexander) 191–93, 196, 200–01, 204; *159, 160*
Botswana 60–62, 87–89, 190; *72, 73*
Bouabré, Frédéric Bruly 153; *124*
Boycott, Cultural (South Africa) 85, 164
Brandt, Kevin 162; *136*
brokerage, cultural 64–67, 77, 89–91, 101
Brush, Wanyu 66
Buraimoh, Jimoh 133, 205–06; *174, 175*
Burnett, Ricky 41
Burozi (Lubumbashi artist) *18*
Bushmen, *see* Nharo San, and workshops and organizations for informal training: !Xu and Khwe Cultural Project, South Africa

Calimbwe, Julieta 63; *47*
calligraphy 139, 159; *109*
Camp, Sokari Douglas 207–08; *176*
Carroll, Father Kevin 48, 52–53, 54, 66–67, 101
Cartoon Joseph 83–84; *67*
Chapungu Sculpture Park, Zimbabwe 76
Chimurenga 76, 121; *98*
Chin (Kinshasa artist) *12*
Chitiyo, Mary 116; *93*
Christianity 19, 25, 37, 44–45, 48, 53, 64, 71, 74, 118, 201; *13, 14, 35, 36, 48, 51, 54, 55*
cinema 33, 34, 38
coffins 44–45; *30*
collage 159, 174–75; *146*
collective memory 30
collective unconscious 68
collectors 10, 34, 38, 41, 64, 68, 102, 135
colonialism 7, 9–13, 14, 18–22, 19, 20, 25, 28, 30, 32–33, 37, 38, 47, 48, 50, 51, 53, 62, 67, 93, 97; *6, 8*
 – art education 13, 124, 190
 – metropole 171
 – trade routes 211
commodity/commodification 8, 14, 22, 29, 38, 42, 83, 102, 104, 105, 109, 111, 123, 130
Concert Parties 34
Congo, Democratic Republic of (former Zaïre) 16, 20, 23–30, 50–52, 65, 80; *5, 12–16, 49*
Congo-Brazzaville (Congo Republic) 13

consciousness, artistic 130, 153, 158, 162
cooperatives 12, 48, 104, 105, 109, 112
Côte d'Ivoire, Ivoirian 16, 78, 134, 153
Coulibaly, Boubacar 168; *140, 141*
creolization 18, 38, 55–56
Cuba 135, 200
cubism 128, 139; *104*
cultural memory 208
cultural nationalism 152
cultural resistance 161
cultural theory 10–11
'cultural worker' 155
curios, curio markets 21, 44, 78, 109
Cyrene Mission, Rhodesia 71, 74, 87; *54, 55*

Debela, Achamyeleh 198, 200; *168*
Desta, Gebre Kristos 198–200; *167*
diaspora 193, 201, 204; *see also* African diaspora
Dieme, Bacary 168, 170, 189; *139*
Django 35; *22*
Dodge, King 66

Eagleton, Terry 213
Ebong, Ima 170–71
Ecole de Dakar, Senegal 126, 168, 171, 174, 181
Efiaimbelo *123*
Egypt 170, 184, 211
El Anatsui 17, 189; *7*
El Salahi, Ibrahim 128, 138–41, 183, 191, 193, 195; *109–11*
electronic media 161; *15*
 – films and film industry 20, 33–38
 – music recording industry 31–32
 – radios 19
 – record players 92; *15, 76*
 – television industry 20, 37, 38
 – television sets 27, 33–34, 92, 203; *15, 76, 171*
 – videotapes and VCRs 33–34; *20*
Elliott, David 164
emulation 83, 104, 125, 127, 129–30
enclaved commodities 102
Enesia (Weya artists) *91*
Enwezor, Okwui 13, 164–65
Enwonwu, Ben 144; *116*
Ethiopia 190–204
Evangelical Lutheran Art and Craft Centre, *see* Rorke's Drift
exhibitions
 – *Africa Explores* (New York, 1991) 44, 77, 126
 – *Africa Hoy!* (1991) 135
 – *Art from South Africa* (Oxford, 1990) 164
 – *Big City* (London, 1995) 136, 153
 – *The Decade Show* (New York, 1990) 209
 – *Faultlines* (Cape Town, 1996) 161–62
 – *Imagined Communities* (London, 1995) 211

– Johannesburg Biennale (*Africus*, 1995, *Trade Routes*, 1997) 164–65
– *Kunst Aus Afrika* (1979) 135
– *Magiciens de la Terre* (Paris, 1989) 24, 31, 44, 110, 126, 153
– *New African Art from the Central African Workshop School* (USA, 1968, 1969) 74–75
– *Seven Stories about Modern Art in Africa* (London, 1995) 136
– *Tributaries* (Johannesburg, 1985) 41

Fabian, Johannes 25, 29; *13*
Fabunmi, Adebisi 133; *105*
facture 112, 124
Fakeye, Lamidi 52–53; *36*
fashion 27, 45–47; *1, 8, 10, 15, 31*; *see also sapeur*
FESTAC, Nigeria (1977) 133
Filis (Weya artist) *95*
First International Congress of African Culture (Rhodesia, 1962) 74
First World Festival of Black Arts (Senegal, 1966), see Premier Festival Mondial des Arts Nègres (Dakar, 1966)
flour-sack painting 23–30, 31, 34, 40, 42, 80; *18*
France 10, 14, 20, 21, 66, 76, 110, 154, 191; *8, 16*

Galerie TENQ, Dakar, Senegal 172
galleries 8, 12, 27, 32–33, 38, 40–41, 78, 81, 88, 99, 131, 132; *27, 28, 74*
Gallery Shona Sculpture, Harare, Zimbabwe 76
Gallery Watatu, Nairobi, Kenya 65, 78–81
Gaye, Anta 176
Gedewon (Ethiopian artist) 204; *3*
Geers, Kendell *138*
Gelede masks 153; *122*
Germany 10, 61, 78, 110, 182, 198
Ghana 14, 17, 20, 34, 37, 44, 189; *10, 30*
glass painting, *see Souwer*
global market 12, 16, 21, 63, 87–88, 102, 103
globalization 8, 11–12
Goba, John 16–17; *4*
Gowenius, Ulla and Peder 59, 67
Great Zimbabwe 71, 74
Gudo, Misheck 91; *74*
Gutsa, Tapfuma 87

hairdressers' signs 38
Hammond-Tooke, David 126
Hansen-Bahia (Karl Heinz Hansen) 201, 203
Hassan, Salah 136
Hausa 21, 35, 37, 107; *9*
Hiwet, Girmay 195–96, 204; *164, 165*
Hlungwane, Jackson 41–42; *28*
Howard University, Washington, D.C. 193, 196; *153*
– Howard-Ethiopian circle 198
hybridity/hybridization 14, 134–35; *11*
Hylton, Richard 13–14

identity/identities
– culturally mediated 196
– ethnic 167, 196
– national 166–67, 171, 178
– pan-African 166, 178
– postcolonial 138
– primordial 141, 169
– transnational 211
IFAN (The French Institute for Subsaharan Africa) 153
Igbo 37, 40, 179, 181, 183; *48, 58*
Indirect Rule (British) 141, 168
internationalism 147, 151, 189
Islam 13, 35, 37, 56, 64, 139, 176, 193, 195; *25, 109, 161*
Iwalewa Haus, Bayreuth, Germany 61

Jamaica 38, 87
Jewsiewicki, Bogumil 22; *18*
Johannesburg Biennale 164–65
*Jua Kali* 22
Jules-Rosette, Bennetta 29
Jung, Carl 51–52, 68–70, 71, 73

Kahnweiler, Daniel Henry 68
Kalabari culture 49, 207–08; *176*
Kamba artists, cooperatives 41–44, 104, 107–09, 112; *27, 86*
Kanda-Matulu, Tshibumba *13, 18*
Kappata, Stephen 29; *17*
Katarikawe, Jak 65; *51*
Keita, Seydou 45–47; *8, 31*
Kentridge, William 156–58; *128*
Kenya 8, 16, 29, 37, 38, 42–44, 78–84, 91–92; *11, 20, 24*
Khartoum School 195
Kiarie, Sebastian 66
Kikuyu artists and workshops 80–84; *64–68*
– Banana Hill community, Nairobi 83–84
– Ngecha Artists' Association 81–83; *66*
Kingelez, Bodys Isek 136; *108*
Kirumira, Namubiru Rose 87–88; *71*
Kizito, Kasule Maria 130–31; *102*
Koloane, David 96, 98, 101, 136, 164
Kosrof, Wosene 193, 195, 196, 204; *162, 163*
Koudougnon, Theodore *107*
Kulebele artists, Senufo culture 107, 112; *85*
Kumalo, Sydney 96, 101; *82*
Kwei, Kane 44–45
Kwei, Samuel Kane 44; *30*

Laboratoire AGIT-Art, Senegal 126, 172, 174–76; *100*
Ladipo, Duro 78, 179, 206
Lam, Wifredo 200; *169*
Langa, Moshekwa 162; *135*
Lawrence, Jacob 180; *149*
Lega artists 65; *49, 50*
Legae, Ezrom 101; *83*
Likonkoa, Samaki 110; *87, 88*
Lincoln, Bruce 102
literacy 18, 33, 37, 38, 62
Loder, Robert 85, 87
Lods, Pierre 66, 174
Lumumba, Patrice 23; *13*
Lutheran Arts and Crafts Centre, *see Rorke's Drift*

Mabasa, Noria 41–42
Mabaso, Dumisani 59; *69*
Maconde art, artists and art dealers 109–11, 122–23; *87–89*
Madagascar 153; *123*
Magnin, André 7, 44, 134–36
Mailolo, Amali 75, 77; *59*
Makerere Art School (Margaret Trowell School of Fine Arts), Uganda *99, 121*
'Malangatana' compositions (Weya) 119; *95*
Malangatana, Valente 119, 180; *94*
Malawi 75
Mali 16, 20, 32, 38, 47, 167; *8*
Maloba, Gregory 144; *113, 115*
Manufacture Nationale de Tapisserie, Senegal 170
Manuhwa, Damien 77; *60*
Manzi, Josia 75; *58*
*mapico* (*mapiko*) masks *88*
Maqhubela, Louis 98; *79*
Margaret Trowell School of Fine Arts, *see* Makerere Art School (Margaret Trowell School of Fine Arts), Uganda
Mariga, Joram 71, 73–74, 76–77, 87; *57, 61*
Mary (Weya artist) 120–21; *96*
Mashiri, Givas 91; *75*
masks 9, 16, 48, 49, 56, 64, 74, 153; *48, 88, 122*
Matemera, Bernard 75, 87
Mbari Club, movement 178, 179, 181–82, 189, 210
Mbatha, Azaria 59; *43*
MBengue, Gora 176; *148*
Mbuno, Kivuthi 80; *63*
McEvilley, Thomas 164
McEwen, Frank 50, 51, 52, 66, 68–79, 99, 101, 102, 126, 171
Mercer, Kobena 211–13
mermaids 24–25, 30
– La Sirene 24–25, 30; *14*
– Mamba Muntu 24–25
– Mami Wata 24–25, 40, 65, 118; *48*
Middle Art (Augustine Okoye) 38–39, 135; *25*
Mobutu Sese Seko 28
modernism/modernity 10, 11, 19, 29, 37, 41, 64, 91, 142, 167, 169, 171, 196; *8, 15, 24, 67, 68*
Moke (Kinshasa artist) 28–29, 120; *16, 97*
Molongoy, PiliPili 51; *34*
monastic scriptorium 192, 204
Moore, Henry 69; *52*
Mosquera, Gerardo 135
Motswai, Tommy 92, 159–61; *131*
Mozambique 57, 66, 75, 87, 109, 180
Muafangejo, John 59; *44*
Mudimbe, V. Y. 50–51
Mugadza, Nerissa 115; *92*
Muhandi, Chain 66
Mukarobgwa, Thomas 68–73, 127, 152; *53, 101*
Mukomberanwa, Nicholas 69, 71, 73; *56*
Mulindwa, Peter *112*
multiculturalism 209
Munyaradzi, Henry 75
Murray, Kenneth 67, 101, 144

museums 40–41, 55, 61, 68–71, 102, 104, 131
– Musée d'Art Moderne, Paris 196
– Musée Dynamique, Dakar 169–72
– Musée Trocadéro, Paris, 128, 171
– Museum of Modern Art, New York 74–75, 196
– Museum of Modern Art, Oxford 164
– National Gallery of Zimbabwe, Harare 68–76
– National Museum, Botswana 88
– National Museum, Jos, Nigeria 133
– National Museum, Lagos, Nigeria 133, 144
– National Museum of African Art, Washington, D.C. 45, 207
– Studio Museum, Harlem 196
Mutunga (Kamba artist) 27

Namibia 62–63, 87
national culture, cultural policy 167, 168
Native American art 51, 93
– Navaho sand painting 153
Ndabagoye, Richard 149; *119*
Ndebele, Njabulo S. 191
N'diaye, Iba 170; *142*
Négritude/Négritudist 168–76, 178, 181, 200
neocolonialism/neocolonialist 146, 166
Neogy, Rajat 151
Ngatane, Ephraim 93–96; *77*
Nharo San 60–63, 88–89; *45–47, 72, 73*
Nicodemus, Everlyn 136
Niger 21
Nigeria 8, 13, 16, 20, 21, 32, 33–35, 37–38, 40, 44–45, 48–50, 52–56, 58, 66–67, 78, 99, 101, 103, 108, 123, 126, 133, 138, 144–45, 152, 164, 166–68, 178–82, 190, 204–05, 207–08, 210; *9, 25, 33, 35, 36, 39, 150*
Nigerian Civil War 40, 102, 181–82
Njau, Elimo 130, 147–49; *118*
Njeri, Lucy 82; *65*
Nkurumeh, Barthosa 186–89; *155*
Nnaggenda, Francis 87, 128, 151–52; *104, 121*
Nommo Gallery, Kampala, Uganda 131, 149, 151
Noy, Ilse 113, 115, 119, 123
Nsukka group 17, 179, 181–89, 204, 210; *7, 151–56*
Ntiro, Sam 144, 147, 149
Nwoko, Demas 179, 181
Nxuku, Qmao 89; *72, 73*
Nyachae, Wanjiku 80, 136

Odundo, Magdalene 208; *177*
Odunlade, Tunde 204–05; *172*
Oguibe, Olu 210; *178*
Okeke, Chika 136, 189; *157*
Okeke, Uche 179, 181–83, 186; *151*
Onobrakpeya, Bruce 78, 126, 132, 179, 181, 189; *157, 158*
Onyango, Richard 91–92; *76*

Oswaggo, Joel *19*
Ouattara 210–11; *179*
Ovuomaroro Art Studio, Nigeria 126, *132*

Pan-Africanism 169
patrons 8, 10, 12, 18, 21, 23–24, 31, 41, 49, 56, 64–67, 68, 102
Peace Parks 175
pedagogy 124, 126, 138, 141, 147, 152
Peera, Mohammed 110
Pende sculptors *5, 6*
photography 21, 45–47, 49, 78; *6, 8, 31, 32, 62*
– portrait photography 45–47; *8, 31, 32*
Picasso, Pablo 68, 69–71, 126–28, 139, 171, 204, 209; *103*
Piula, Trigo 13–14; *2*
Polly Street Centre, Johannesburg, *see* workshops and organizations for informal training: Polly Street Centre, Johannesburg
postcolonial/postcoloniality 7, 8, 9, 11, 12, 13–17, 25, 28, 33, 48, 64, 126, 135, 149, 153–54
poster art 34; *see also* workshops and organizations for informal training: CAP (Community Arts Project), South Africa
postmodern/postmodernism/ postmodernity 13, 14, 210
Poto-Poto School of Art, Brazzaville, Congo 170
pottery 9, 21, 44, 59, 208; *177*
Powell, Ivor 96, 164
precolonial art genres 9, 16, 40, 64
Premier Festival Mondial des Arts Nègres (Dakar, 1966) 169
primitivism 68, 80, 170–71, 196
printmaking 50, 59, 61; *42–44, 78*
public culture 166
public intellectual 168

Rakgoathe, Dan 59; *42*
Rastafarianism 38; *11*
recyclia 22
Richards, Colin 41, 164
Risinamhodzi, Abishell *98*
Romain-Desfossés, Pierre 50–52, 66; *34*
Rorke's Drift 59–60, 62
Rumao, Thaulu Bernardo 62; *46*

Sack, Steven 77
Samb, Issa 134, 172, 174–75; *145, 146*
Samba, Cheri 24–29, 31, 40; *1, 14, 15*

*sapeur* 20
Schaffner, Ruth 78–83; *62*
Second International Black and African Festival of Arts and Culture, *see* FESTAC, Nigeria (1977)
Senegal 16, 87–88, 107, 134, 166, 168–78
Senghor, Léopold 168–72, 178
Seoka, Dr Phutuma 41–42; *26*
Serima Mission, Rhodesia 71–74
*Sét Sétal* 175; *147*
Shangodare *39, 114*
Shibrain, Ahmad Muhammad 193–95; *161*
'Shine Tani' 83–84; *68*
Shipipa, Fulai 61; *45*
Shona culture 71, 74, 113
Shonibare, Yinka 211; *180*
Sierra Leone 16–17; *4*
sign painting 21, 34, 35, 36, 38, 39, 40, 41; *11, 12*
Sihlali, Durant 96, 98–100, 146; *80, 81*
Siopis, Penny 158, 161–62; *129, 133*
Skotnes, Cecil 66, 96, 97, 98–100, 101; *78*
Skunder, *see* Boghossian, Skunder (Alexander)
Songo, Samuel 71; *54, 55*
Soulillou, Jacques 134–35
South Africa 9, 16, 20, 38, 41, 42–44, 57–64, 66, 67, 85–87, 92, 93–101, 136, 146, 152, 154, 158–59, 162–65, 191; *83, 134*
souvenirs 65, 66, 71, 93; *49, 50*
*Souwer* 176; *148*
Soweto Uprising 154, 162
Soyinka, Wole 178
Sudan 128, 138, 143, 152, 183, 191, 208
Super Yaw Ofori's band *21*
surrealism 200
Swahili 22, 37; *11, 20*
Sy, El Hadji 136, 172, 174; *143, 144*

tailgate murals 36; *11, 22, 23*
Takawira, John 71
talismanic signs 12, 204; *3*
Tall, Papa Ibra 170
Tanzania 37, 108, 109, 122, 144, 147, 149
tapestry 168, 170; *139*
Thoba, Alfred 158–59, 162; *130, 134*
Todd, Sweeney (Cecil) 146–49
tourism 23–24, 29, 40–41, 42, 44
'township art' 57–58, 69, 93, 96–101, 159, 175; *77, 132*

training 57, 58–60, 79, 81, 125–27, 129, 130, 131
transAfrican movement 196, 200
*Transition* magazine 149–51; *120*
'transitional art' 41–47; *26–30*
Trowell, Margaret 141–49

Udechukwu, Obiora 183–86; *152, 154*
Uganda 8, 16, 29, 37, 65, 67, 87–88, 128, 130–31, 141–42, 151, 152, 166–67; *115*
Uganda Martyrs *112*
UK 191, 207–08
– England 61, 191
– Great Britain 14, 20, 68, 73, 85, 87, 93
*uli/ulists* 182–84, 186, 189, 204, 210; *150, 151*
USA 19, 51, 74–75, 85, 93, 190–95, 205
'usable past' 210

van den Berg, Clive 162; *137*
vehicles 34, 36–37, 41, 80, 91; *24*
– lorries 34–37
– *matatu* 36
– motorcars 55–56, 91
'Village des Arts', Dakar 172
Vohou-Vohou 134; *107*

Wadu, Sane 80–81; *64, 66*
Wairimu Wadu, Eunice *66*
Waqialla, Osman 195
'wax and gold' 196
Wenger, Susanne 52–54, 56, 66, 179; *37–39*
Weya artists 113–24; *91–93, 95, 96, 98*
Williams, Denis 78, 180
Williamson, Sue 155–56; *127*
women artists 50, 52, 54, 58, 63, 66, 71, 77, 78, 82, 87–88, 112–14, 122–23, 136, 141–49, 155, 158, 161, 179, 196–97, 206, 207–08
workshops and organizations for informal training
– Atelier d'Art 'Le Hangar', Congo 50–52
– Bag Factory Project, South Africa 87
– Banana Hill, Kenya 83–84
– CAP (Community Arts Project), South Africa 159
– FUBA (Federated Union of Black Artists), South Africa 159
– Kuru Development Trust, Botswana 60, 62, 89
– Mbile workshop, Zambia 87–88
– Namasagali workshop, Uganda 87–88

– Ngecha Artists' Association, Kenya 81–83; *66*
– Oshogbo workshops, Nigeria 105, 133, 178, 205–06; *105*
– Oye Ekiti workshop, Nigeria 48, 52–53; *35*
– Pachipamwe workshop, Zimbabwe 87
– Polly Street Centre, Johannesburg 57–58, 96–101
– Salisbury Workshop School, Rhodesia 50, 58, 69–74, 99
– Shave Farm workshop, UK 87–88
– Tengenenge workshop, Zimbabwe 75–76, 105
– TENQ workshop, Senegal 87–88
– Thapong workshop, Botswana 87–89
– Thulipamwe workshop, Namibia 87–88
– Thupelo Workshop, South Africa 85–87, 101
– Triangle Workshop, New York 65, 84–92, 105
– Ujamaa workshop, Mozambique 87–88
– Vukutu workshop, Zimbabwe 73–74, 77
– Weya Community Training Centre, Zimbabwe 112–13
– Xayamaca workshop, Jamaica 87–88
– !Xu and Khwe Cultural Project, South Africa 60–61

Yetmgeta, Zerihun 201–04; *170, 171*
Yoruba travelling theatre 118
Yoruba workshops (general) 106–08, 110, 122, 178–80
– *see* workshops and organizations for informal training: Oshogbo workshops, Nigeria
– *see* workshops and organizations for informal training: Oye Ekiti workshop, Nigeria

Zambia 29, **87**
Zaria Art Society 181, 189
Zimbabwe stone sculpture 16, 50, 51, 52, 57, 58, 66–67, 68–70, 87, 91, 99, 101, 127, 152; *54–61, 101*